ROBERTO VALENZUELA

WEDDING
STORYTELLER

VOLUME 1

ELEVATING THE APPROACH TO PHOTOGRAPHING WEDDING STORIES

rockynook

WEDDING STORYTELLER

Volume 1: Elevating the Approach to Photographing Wedding Stories

Roberto Valenzuela
www.robertovalenzuela.com

Editors: Christina Borchers Leung and Ted Waitt
Project manager: Lisa Brazieal
Marketing coordinator: Mercedes Murray
Interior design, layout, and type: WolfsonDesign
Cover design: Rebecca Cowlin
Cover photograph: Roberto Valenzuela
Cover photo editor: Rocco Ancora
Author photograph (back cover flap and About the Author page): Frances Iacuzzi
Indexer: James Minkin

ISBN: 978-1-68198-186-4
1st Edition (1st printing, August 2017)
© 2017 Roberto Valenzuela
All images © Roberto Valenzuela unless otherwise noted

Rocky Nook Inc.
1010 B Street, Suite 350
San Rafael, CA 94901
USA

www.rockynook.com

Distributed in the U.S. by Ingram Publisher Services
Distributed in the UK and Europe by Publishers Group UK

Library of Congress Control Number: 2016941043

To my precious wife and partner in life, Kim.

I will always hold dear to my heart all the long walks holding hands we went on every night together to discuss and brainstorm each chapter of this book. Our "short" walks unexpectedly turned into five or more miles. But I enjoyed every step because we were together. I love you so much!

To my son, Lucas.

As I write this dedication, you are only 24 weeks in the womb. Every day that goes by, your mom and I talk to you in the womb and tell you how excited we are to meet you! I'm also playing classical guitar for you because your ears have just developed. I hope you can hear me!

To Mutti.

Mom, I feel so blessed to have you in my life. You will always motivate me to do great things because I just want to make you proud. I love you Mom!

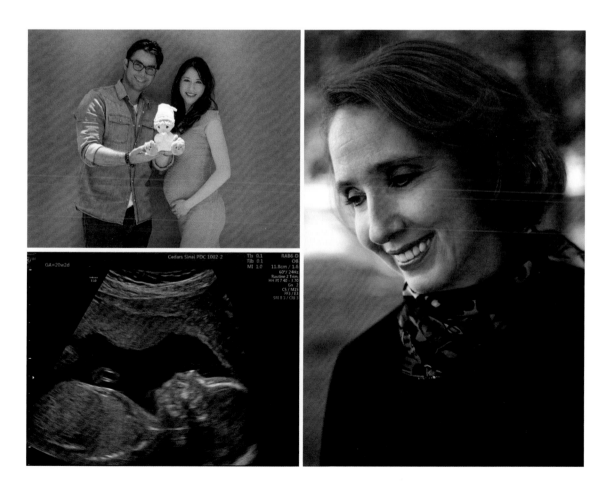

ACKNOWLEDGMENTS

I would like to begin by thanking the great people who made this book happen. Thank you to Scott Cowlin and Ted Waitt! Our working relationship and friendship keeps growing stronger and stronger. You both inspire me to push myself harder and come up with new, innovative ideas. Couldn't ask for a better team! I consider you both great friends.

A heartfelt thank you to my family for their love and support. My mom, my big brother Antonio, my sister Blanca, my little sister Susana, and my new awesome brother-in-law Daniel Yu. I would also like to thank my brother-in-law Kent (Pastor of the Bridge Church in Gilbert, Arizona) for always being a great listener and advisor in personal and business matters, and for being the best pastor anywhere! I thank my awesome nephew Ethan who has exceeded all expectations this year! I'm so proud of you, Ethan, for your amazing grades, your discipline in cross country and track, your guitar and drum playing, and most of all, for being a good person! To my little nephew Caleb, you are growing so fast! And to my amazing and super intelligent ballerina niece Ellie. I will always say, you are a soldier in a tutu.

To my mother-in-law Christina: You did it again Christina! I know this book was especially tough, but your dedication and love for the English language has made this book a true pleasure to read. I can't thank you enough for spending countless hours meticulously editing every chapter of this book. I love how this book project is as important to you as it is to me. I also want to thank my father-in-law Peter for always being there for me. Peter actually provided me with my very first copy of Photoshop as a gift, and it ignited my passion for photography. I am lucky to have you as my in-laws! To Amy, Sarah, and her husband Neal, who were among the very first subjects I photographed. They patiently allowed me to do many practice photo shoots with them to help me improve my skills as a new photographer. Thanks to my cute little niece Alexandra. I love you so much! You are so fun and full of life! To Wendy Wong, for always being so supportive of my career and all my endeavors. I also thank you for your honorable interest in my books even though you are not a photographer. You read every book I write, and I can't tell you how amazing that feels. Thank you!

To Arlene Evans: Arlene, just like Bill Hurter you believed in my career and in me. Thank you for being my Jewish mother! I am grateful to you every time I stand in front of a podium to teach a class anywhere in the world.

To Dan Willens: I will always be thankful for how supportive you are of my family and career! I will never forget how excited you were over the phone when you first heard the news about my son Lucas. I look up to you, Dan, because you are a true gentleman and treat everyone with the upmost respect. I hope to follow in your business footsteps soon.

To all my wonderful friends in the photography industry around the world. You keep me motivated and encouraged every year. I would like to especially thank the following people, listed in alphabetical order: Rocco Ancora, Jimmy Arroyo, Roy Aschen, Ado Bader, Jared Bauman, Michele Celentano, Joe Cogliandro, Skip Cohen, Blair DeLaubenfels, Dina Douglas, Andreina Duven, Marian Duven, Luke Edmonson, David Edmonson, Amy Feldman, Andrew Funderburg, Dave Gallegher, Jerry Ghionis, Melissa Ghionis, Rob Greer, Cami Grudzinski, Eric Joseph, Scott Kelby, Colin King, Gary Kordan, Paul Neal, Maureen Neises, Vicky Papas-Vergara, Collin Pierson, Andre Plummer, Ryan Schembri, Sara Todd, Justine Ungaro, Christy Webber, Lauren Wendle, Tanya Wilson.

To my good friends at Canon USA: Len Musmeci, Dan Neri, Mike Larson. You guys have been a real pleasure to work with. Being a Canon Explorer of Light is and will always be a great honor to me. Thank you for all that you do for the betterment of this wonderful industry. Dan, special thanks for your always encouraging words before I go on the Canon Main Stage! You sure know how to inspire someone through your eloquent pep talks. Love you man!

ABOUT THE AUTHOR

Roberto Valenzuela is a photographer based in Beverly Hills, California. He has been honored by Canon USA as one of the few chosen photographers to be part of their prestigious Canon Explorers of Light program.

Roberto developed his unique teaching style by following the same practice regimen he developed as a professional concert classical guitarist and educator before becoming a photographer. Roberto believes that it is not talent but deliberate practice that is at the core of skill and achievement. He has traveled to every corner of the world motivating photographers to practice and break down the various elements of photography in order to master them through goal-setting, self-training, and constant dedication.

Roberto serves as a chair and judge for some of the largest photographic print competitions in Europe, Mexico, South America, and the most celebrated international photography competitions held in the United States through Wedding and Portrait Photographers International (WPPI) in Las Vegas, NV.

Roberto teaches private workshops, seminars, and platform classes for the largest photography conventions in the world. He has been an international first-place winner three times and has been nominated by his peers as one of the ten most influential photographers and educators in the world. His first book, *Picture Perfect Practice*, quickly became the #1 bestseller in the wedding photography book category. His second and third books, *Picture Perfect Posing* and *Picture Perfect Lighting*, have also joined the ranks of their predecessor as international bestsellers. Roberto's books have been translated into Chinese, Portuguese, Spanish, Indonesian, and German, to name just a few, and they are sold in bookstores worldwide.

Aside from the world of photography, Roberto enjoys piloting high-performance remote-control helicopters. He is a (not so good anymore) classical guitarist and a table tennis fanatic, always on the lookout for a good challenge.

CONTENTS

chapter 15

TECHNICAL EXPERT TECHNIQUES: LENS CHOICE AND HELPER LIGHT 229

chapter 16

POSING AND EXPRESSION EXPERT TECHNIQUES 271

chapter 17

COMPOSITION EXPERT TECHNIQUES 291

FOREWORD By Michele Neal Celentano

Wedding Storyteller could not be a better title for this series of books. Storytelling requires unique gifts, such as being able to see more than what fills your camera frame. Masterful wedding storytelling encompasses more than just technical knowledge; it relies on an inquisitive mind, heart, and soul. A master must make the story about the subjects and not the photographer. A true storyteller brings to life what no one else sees. Roberto is a master storyteller in every sense of the word.

As a 30-year veteran in the photography business, I have seen it all and I have studied with the industry giants throughout the years. Monte Zucker was my first "giant" mentor. I was lucky enough to call Monte a friend, and I never thought I would see another mentor like Monte in my lifetime. That is until Roberto came along and made his own indelible mark that would change and advance the world of professional photography in new and exciting ways.

Roberto attended his first WPPI in 2006 (my 12th WPPI). I can only imagine the excitement and joy he felt attending this massive international convention. I'm sure I passed him in the halls of the greatest gathering of photographers around the world with no idea of how he would impact us all. He is now one of the most popular and attended speakers on the platform. If you know anything about Roberto, you know how insanely determined, passionate, and hungry he is for knowledge. I imagine he sat through many programs that year and thought to himself, "One day I will be teaching up on that stage." I can almost see the sparkle in his eyes.

Through the years we knew of each other and had met only a few times. Our friendship really began to blossom when my stepdaughter Alli announced she was getting married in Los Angeles. The moment I became aware of the wedding date I asked Alli for permission to hire the photographer. I had only one man in mind for the job: Roberto Valenzuela! As I was leaving a message for him (I'm sure Roberto did not recognize the Arizona phone number at the time), I was secretly hoping he would remember me. With anxiety I left the wedding date on his voicemail and asked if he would be available and how much my house would need to be mortgaged for. To my surprise and delight, Roberto called me back and was genuinely shocked that I asked him to photograph my daughter's wedding. The man was shocked.... His humility was sweet, perfect, and a true testament to the man I would grow to know and love.

It is such an honor to be writing the foreword for this book. I still have the photography books and materials that I purchased from Monte Zucker more than 20 years ago, and I know without a doubt you will have this book for 20, 30 years and beyond. The material you are about to learn and the journey you are about to embark on are timeless. Roberto has the rare gifts of talent and teaching. The book is broken down beautifully, and will be a resource for many years. Understanding fundamentals are the key to growing in any craft, and Roberto has presented the basics of wedding photography in a format that is easy to learn and understand. There isn't a photographer who will not benefit from this

book. Whether you haven't yet photographed a single wedding or you are about to shoot your 1,000th wedding, you will gain valuable insight into the wonderful world of wedding photography within the pages of this book.

Roberto, it has been my privilege to watch you grow into one of the greatest leaders in professional photography. Witnessing you teach in front of a group of either 20 or 2,000, you never cease to amaze me with your knowledge, humility, sense of humor, love of your craft, and most importantly, your love of your students. May you continue to shine your incredible light on photographers around the world. Thank you for your relentless pursuit of perfection and for becoming another great mentor and inspiration to me.

With great love and respect,
Michele Neal Celentano

INTRODUCTION (DON'T SKIP ME!)

I am writing this introduction with a true feeling of excitement! Taking on this book project has been on my to-do list for over five years. But every time I tried to tackle it, I didn't feel ready. I wanted to write a book that was really going to propel you to become a higher-skilled wedding storyteller, regardless of whether you are a beginner or a veteran wedding photographer. I was determined to cater to all levels, and I knew there was a way. I just had to find it. I discovered a new respect for the phrase "easier said than done."

What I did *not* want to do was write another book that tells you about the "must-have shot lists" or advises you to make sure you take a close-up of the rings during the ceremony, or worse, instructs you not to forget the traditional photo of the bride looking down, contemplating her bouquet. You get the idea, right? I was not going to write a single word until I felt I had something unique that could really help wedding photographers around the world who were determined and hungry for knowledge, regardless of skill level or experience. I ended up writing three books, *Picture Perfect Practice*, *Picture Perfect Posing*, and finally, *Picture Perfect Lighting*. I began each of those three books by attempting to write this one!

And it's a good thing. Because I discovered you can't write a book on wedding photography without discussing composition, posing, lighting, photojournalism, people skills, and other storytelling approaches that create a beautiful, cohesive, and comprehensive storyline throughout a wedding. Go figure. The crazy thing is that, during the course of shooting a wedding, all of those photographic elements are thrown at you at the same time! It's not a linear process; it's all at once, every time, and it's constantly changing! How fun is that?

I can't tell you how proud I am to be a wedding photographer. The photographic prints that result from our work become the most important possessions in a person's life. What we do matters! In a world where everyone with a smartphone is a photographer, I believe that excelling in the skills required to be a real wedding photographer is more important than ever. I wrote this book with that belief in mind.

For example, people skills are often regarded as second in importance in most photography disciplines, but in wedding photography, having great people skills can make the difference between doing well in this industry or being a total train wreck. People skills are a vital part of what it means to be a successful wedding photographer—so much so that I dedicated multiple chapters of this book to many of the experiences I've had that demonstrate how those skills had a strong impact on my performance as a wedding photographer. These chapters are very important, and I hope you read them very carefully. In fact, the entire book was written so that all the puzzle pieces come together at the very end. You are better off either reading the whole book from Chapter 1 through Chapter 18, or not reading it at all. If you decide to take it on, I suggest you read each chapter meticulously. A great deal of thought went into each chapter, regardless of its length. Remember that everything will tie together nicely at the end, and it will all make sense.

During the writing of this book, I realized that the topic of wedding photography was far too large to cover every aspect of it in a single book. I thought I could do so when I began the project, but soon it became apparent that it was just crazy to think so. Furthermore, I care way too much about this beautiful topic to try to cram everything into one book and end up doing a disservice to the industry and to you. So here is the breakdown of the three-volume *Wedding Storyteller* series:

Wedding Storyteller, Volume 1: This book introduces you to the "Wedding Storyteller Skill Components" program I created to help you understand the skills you need to harness or finesse in order to up your game. This is the foundational book in the series, and the other two books build upon it. This book must be the first one you read, or else the second book won't make sense, as it builds on the concepts written here.

Wedding Storyteller, Volume 2: This book will use case studies to cover in detail the entire skill components program, section by section, throughout the wedding: from the very beginning when the couple is getting ready until the very last part of the reception. I will go into further technical detail regarding how to apply the skill components program to help you photograph all aspects of an entire wedding. The book will also cover how to achieve a successful workflow and how to edit for speed and efficiency.

Wedding Storyteller, Volume 3: This book will cover the business, sales, and marketing aspects of what it takes to run a successful wedding photography business—from the psychology behind meeting your prospective clients for the first time, to understanding why people will choose to hire you versus someone else in your market. I'll cover the nuances that make the greatest impact on your prospective client's decision making. Furthermore, this book will cover how to increase the perceived value of your work in your clients' minds. Knowing this will help you increase your album and wall art sales to levels you never thought possible—and you can do all of this without ever coming across as a heavy-handed salesperson. It will be your client's decision, not your pushing them, that will get you the big sales. It all has to do with planting the seed from the very beginning.

It is my hope that the *Wedding Storyteller* book series will serve as a comprehensive guide to all aspects of wedding photography and the business of being a wedding photographer.

With that being said, I am truly excited for you! I find wedding photography to be one of photography's greatest disciplines. Photographing weddings has allowed me to travel the world and meet amazing people. I owe a lot to this wonderful industry, and these books are my way of paying it forward to an industry that has given me so much.

I hope you enjoy reading the book, but most of all, I really hope these pages help you on the exciting journey of becoming a great wedding storyteller!

part one

BECOMING A
WEDDING STORYTELLER

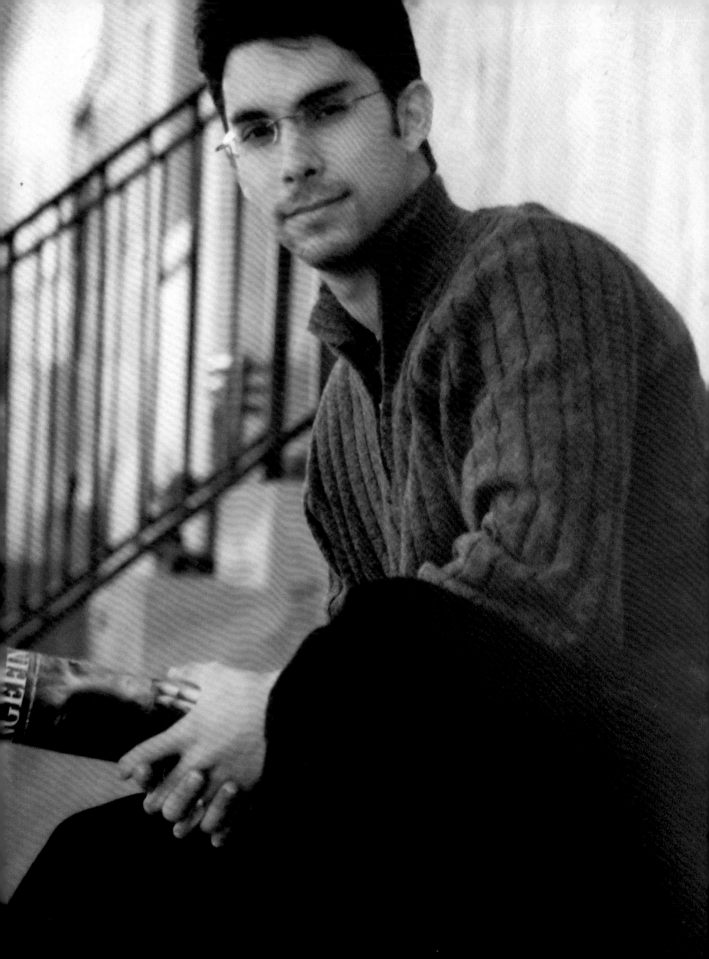

chapter 1
A VERY DIFFICULT AND RISKY DECISION

During my high school and college years, I pursued my wife Kim for over four years just to get her to go on a single date with me. She said "No!" over 200 times—to a movie, to a walk in the park, to a trip to the mall, to window shop. No matter how small my request, it was always met with a distinctive *no*, followed by a "Move on, you are not my type, and you never will be." How I went from four straight years of rejection after rejection to having Kim say yes to my marriage proposal is beyond the scope of this book. (And, to be fair, Kim was a young fourteen-year-old when we met.) But what I can tell you is that the journey to my wedding was so special that it sparked a series of events that forever changed my life.

I graduated from the University of Arizona with a degree in marketing with an emphasis on international economics. During my first job in corporate America as a marketing research specialist, I quickly learned that I did not want to sit in a claustrophobic cubicle for the rest of my life. There was nothing wrong with a good and reliable office job, but that lifestyle was simply not for me. Every day when I went to work, I felt as if the walls of my cubicle were moving closer and closer around me.

It did not take long for me to realize that it was inevitable that I had to find another career. I wanted a career that would give me freedom to move around, to interact with people, and most importantly, to give me a feeling that I was truly contributing something special to the world and not just working for "the man." It turned out that the career that fit the bill perfectly for me was as a high school teacher. I loved being around people with great energy, and who has more energy than high school students? By being a high school teacher, you can really have a profound impact on people's lives. That spoke to me. I wanted to be a great positive influence to as many students as possible.

My excitement was infectious! I couldn't smile any wider when I realized I had found my true calling. After all, I did have over 10 years' experience as a classical guitar private-lesson teacher to over 4000 guitar enthusiasts in Tucson, AZ. I knew that I could teach, but I didn't have the credentials to teach high school within the state of Arizona. But I wasn't going to let a piece of paper stop me now! Soon after discovering my calling, I went on an unplanned visit to my former high school with my brother Antonio, and I found out that administrators were planning on holding interviews for a new full-time business teacher position.

That was a dream position for many educators, and there was no doubt that the hiring process was going to be highly competitive. Looking back, the craziest part of it all was that the people applying for the job were mostly veteran educators who not only had between five and twenty years of teaching experience, but they also had strong connections within the Tucson Unified School District. As for me, I did not even have a teaching certificate! Any person with a brain would assume that I did not stand a chance. Not to mention, I still looked like a high school student myself. I thought there was no way anyone was going to take me seriously.

I had an honest, informal chat about my situation with the principal of the school. I could see her face changing the more she realized that it would be almost impossible to ask the school district to issue me a teaching certificate in less than two months. The application process and necessary testing in order to prove my knowledge of the subject matter could take a long time. It is a marathon of government red tape and endless paperwork. An applicant also has to pass a very strict background check, as well as earn other certifications, such as sanitation and CPR. The principal told me she would push for the committee to accept my application, and I would be interviewed for the position with the contingency that I would somehow perform a miracle and actually have the state of Arizona issue me a teaching certificate in less than 60 days. The principal went on to inform me that during her entire career in education, she had never known Arizona to issue a teaching certificate to a brand new teacher with no previous high school teaching experience in such a short time. I agreed to the terms, and the interview date was set.

The following week, the hiring committee began holding interviews with highly qualified and experienced teachers already working within the school district. During that time, I spent my time at home preparing a document outlining my plans for the business class, how I would go about teaching it, and what I planned to do to keep students highly interested in returning for an advanced course the following year. I focused on the fact that I had built a very successful private guitar lesson business from the ground up. I thought that a practical small business approach, instead of the traditional textbook approach, would be the way to have students hooked and excited about growing a small business of their own. I wanted students to be immersed in business, not just read about it. Finally, I took a quick trip to Kinko's and had the entire plan spiral-bound.

On the day of the interview, I walked in wearing a new pair of slacks, new shirt, and new tie that I purchased from Costco for the occasion. I think the committee could tell it was a new outfit because the crease lines were very much still there. How embarrassing! Anyway, I walked into a boardroom full of people, each with a pad of paper and a pen in front of them. I knew that my greatest weakness was that I did not have any prior high school teaching experience, so I focused on the fact that I was a young business owner who had learned from experience instead of simply from a textbook. I told them that I could make business education exciting and practical, and that it would teach students how to survive out in the real world. I genuinely felt empowered with regard to how my guitar lesson business had grown so much in Tucson. Then I placed my freshly spiral-bound plan in front of each of the committee members. I could see that either they were impressed or they thought it was cute that I had gone out of my way to prepare such a clearly laid-out plan for them to read. Whatever they thought, I talked about my plan with genuine passion and energy. I wanted them to feel it!

A week later, I received a call that the committee had reached a decision about who would take over the new business program. To my surprise, the hiring committee had chosen me! I tried to keep cool, but I began to cry with overwhelming emotion on the phone with the vice principal. Again, how embarrassing! To make a long story short, I had been chosen, but I still had to complete all the paperwork and certification exams to become fully qualified to teach in the state of Arizona within two months. I still feel bad when I look back at the lady who was my contact person to receive my certification. Coincidentally, her name was Roberta. She probably still has nightmares about me walking into her office every day. I needed a shortcut for everything. I needed her to figure out how to get me certified in no time at all. So much red tape! I exploited every loophole in the system she could think of. Lo and behold, a month and a half later, I walked into the principal's office with my teaching certificate stamped and sealed by the great state of Arizona. Against all odds, I was ready to receive the keys to my new classroom, a classroom that, I thought, would most likely be where I would spend the rest of my career.

The following year, I was given a federal grant to promote business education in high schools by giving students the resources to run an actual business. The day after the grant was received, I asked my students, "What kind of business would you like to run?" I gave them the night to think about it. The following day, we had a discussion, and the majority of the class decided to develop a photography business. That decision would later change

the course of my life. I had no clue what to do or how to work a camera. Using the federal grant, we purchased SLR cameras, lenses, strobes, backgrounds, light stands, computers with Photoshop, printers, etc. It was a very exciting time. I would stay after school with some of the biggest photography aficionados until 6:00 p.m. or, sometimes, even 8:00 p.m. We would just experiment with all the photographic equipment. Time flew by, and nothing else mattered.

The following year, Kim accepted my marriage proposal, and we set the wedding date for New Year's Eve. I began the process of looking for wedding vendors and, of course, a wedding photographer. We attended bridal fairs, and we visited many photographers in Tucson. I was still new to photography, and I found the process of finding the right person to capture such a special day overwhelming. After years of relentless pursuit and rejection, I managed to convince Kim not only to go on dates with me but to be my wife! That's quite the leap, and I took finding our wedding photographer extremely seriously!

It did not occur to me how important and personal the job of the wedding photographer is until I realized that the photographer's images become the record of the first day of your own new family. To say that every photo the photographer takes of your wedding is an emotional treasure would be an understatement.

As we visited many photographers around the city, I was exposed to the unfortunately repetitive nature of many wedding photographs. They were all basically the same set of photos, from the bridal party jumping, to the bride and groom kissing in front of various structures. As a future groom, I did not want to be treated just like any other couple that fit a mold or formula. I wanted the photos to be meaningful and to be a beautiful representation of a powerful story. I was no photographer, but I could still tell when a photograph's depth was only skin-deep or if the image captured a truly emotional and unique moment.

I politely nodded my head as I went through the photos, but in my mind I was asking a series of questions. Why can't wedding photos have depth? Why does it seem as if most wedding photographers simply repeat the same photos for every couple, regardless of who is in front of their camera? The repetitive nature of wedding photography was really upsetting me! Even the lighting in most photos was flat and unflattering. And a non-photographer noticing the flatness of the light should really tell you something. I imagined that my photos would have visual interest throughout the frame. I envisioned seeing photographs where I was surrounded by the most important people in my life sharing a special moment together. I yearned for my photos to capture raw emotion in the faces of my family and friends. Furthermore, through my own research, I had found some pretty amazing photographers who strategically used light to communicate a uniquely beautiful moment at a wedding, and their photos possessed vibrant light that drew one's eyes to the story being told.

After much deliberation, Kim and I agreed on a photographer we both liked and respected. Our wedding photographer did a fantastic job and beautifully captured the spirit of our wedding day.

But the federal grant given to me to have my students build a photography business, combined with the process of choosing a photographer for the most important and

emotional day of my life, pushed me to do something completely ludicrous: to try my hand at becoming a wedding photographer myself in order to take the types of photos I dreamed of.

At that time, I was the only income earner in our new family, because Kim was still finishing up her graduate degree in material science and engineering from the University of Arizona. We moved into our first house together and bought a new Honda Civic. It felt so good to be the provider and have medical insurance for the first time in my life. I was the happiest man in the world. I had my dream job, and I married the girl of my dreams. During the first few months after our wedding, I couldn't stop thinking about photography. It consumed me, and I was obsessed as I had never been before. I began to feel a bit guilty because I wasn't concentrating 100% on teaching my marketing and economics classes anymore. Instead, I imagined how I would light and photograph every person who crossed my path. Soon after, at home one afternoon with my sister-in-law Amy, she told me that one of her high school friends was planning her wedding in Tucson even though she lived out of state. Not knowing a single thing about how to photograph a wedding, I foolishly jumped out of my seat and asked Amy to ask her friend if she would be willing to take a chance and choose me to be her wedding photographer. Well, guess what? She said yes! I remember when I heard that she accepted my proposal, I immediately felt nauseous! What did I get myself into?

With a teacher's salary, I couldn't afford any gear of my own, so Kim let me borrow a little money from her savings account to buy the most basic gear, and I also borrowed the school's camera and flash. To make matters worse, I heard there was going to be a bridal fair in Tucson on Sunday, the very next day after my first wedding. Can you guess what I did? I used my paycheck from the school to book a booth at the bridal fair in Tucson. If you are wondering what photos I used to show my work at the booth, you would be correct to wonder. I did not have any.

I will spare you the details of my very first wedding shoot. But just know that it was a complete disaster. I had no clue what I was doing, and most of the photos were out of focus because I did not realize that a person could change the camera's ISO to compensate for poor lighting conditions. I just wanted to survive the wedding. I was sweating so much from nerves that it looked as if I had fallen into a pool. It was far more than I could handle, and the photos on the camera's LCD were a total mess. I shot everything in JPEG, which meant I could not recover the photos that were three stops underexposed. I copied the work of every photographer I could remember just to survive, and I did a poor job at it. All that beautiful storytelling and flattering light I dreamed of when I was choosing a wedding photographer went right out the window. I just had to get through the day. Weddings proved to be a lot more difficult than I had imagined! My respect for and perspective on what it takes to be a great wedding photographer immediately and totally changed.

I was exhausted after the wedding, and I still had to prepare for the bridal fair the next day. To address the issue of having no work to show at my booth, I drove to Target before it closed and purchased 10 pre-cut matted frames with an 8x10 cutout. When I got home, instead of falling onto my bed from pure exhaustion, I used my little $99 basic inkjet printer to print 10 photos that looked as if they had come from different weddings. Now I had

work to show for tomorrow. Since I did not want people asking me about my experience, I used my knowledge of marketing and consumer behavior to price myself high enough such that my experience would not come into question at the bridal fair. It worked. Most people never asked me how many weddings I had shot. For the couples who did ask, I told them the truth; but if they didn't ask, I was not about to volunteer that information.

My charm during the bridal fair was fully on. During that bridal fair that day, I managed to book 10 weddings. I still couldn't afford my own gear, so I used the deposits from those 10 weddings to buy my own camera equipment. I know, I know...crazy! I was young, eager, and naïve. So much so, that I used to think, "If you are oblivious to the consequences, sometimes it makes it a little easier to take on the risk." Although at times this can be true, in hindsight it is often not wise to think this way. On the other hand, this is the reason why I believe youngsters make great entrepreneurs, because they don't overthink and micro-analyze everything on an Excel spreadsheet as adults tend to do. They just do it! That is a good lesson to keep in mind.

As the months went by, the wedding dates I booked at the bridal fair began to arrive. I would be obsessed at every wedding, trying to learn from my mistakes at the previous ones. I began trying to control everything in an attempt to be as perfect as possible. This was, and still is, one of the biggest mistakes I have made in my career. When photographing weddings, you have to let the nature of the day take its course. Mistakes will be made. Posing, lighting, and composition will not be perfect in every photo. Most importantly, photographers don't always get what they want. It's not your day to monopolize and turn into a perfect photo shoot for your ego or your portfolio. Weddings are very personal events. We photographers are privileged to be invited into our clients' lives to document that day, so that they can relive those memories every time they open their wedding book.

It was during this time when I was trying to be perfect that I began receiving my first complaints from clients after their weddings. I had lost sight of the fact that it was my clients' day, not mine. Although my clients did not say anything during their weddings, they were not thrilled with how much I tried to make the weddings revolve around me. It was a lesson well learned.

The point came when I had to decide whether I should continue with this wedding photography endeavor. I had my excitement, and I could have just put the camera down and moved on with a very happy life of teaching high school marketing and economics. But in my heart, I just couldn't bear the fact that I had gotten my butt kicked by wedding photography. My photographs left much to be desired, and they looked nothing like the photos of the great wedding photographers who had inspired me so much. It was apparent that I wasn't blessed with a photography strand of DNA.

But what I did have was a burning desire to not let my failures get the best of me; instead, I would use them as a springboard to continue fighting for what I wanted. My solution was to approach photography like training for a classical guitar performance. I had years of experience following a practice regimen for guitar, so why not use that same regimen for practicing photography? This regimen consists of deliberate practice of a very specific element, with small goals, setting parameters, and slowing way down. You do this until the concept is not only understood, but feels completely natural and effortless to achieve.

Although I was still trying to grow my wings as an artist, my work began improving to the point that it became noticeable. I was making fewer technical errors, and I began to really focus upon the storytelling aspect of wedding photography. With the little money I had made, I signed up for another bridal fair, and I began to book more and more weddings.

DECISION TIME

It was now March 2006. I had been married for a little over a year, and I decided to take some time off teaching to attend the annual Wedding and Portrait Photographers International (WPPI) convention held in Las Vegas, Nevada. This convention was the yearly gathering of over 15,000 wedding and portrait photographers from every corner of the world. The most exciting part was that some of the world's top wedding photographers would be there, including the famous Canon Explorer of Light photographers, who are a very carefully chosen group of elite photographers vetted by Canon USA as the top tier of the best photographers in the world in their respective field. I was in heaven!

During WPPI, I realized that my passion for photography was just too strong to ignore or abandon. I felt an inexplicable calling to photography. A very scary thought crossed my mind for the first time: the thought that I might want to follow my heart and perhaps leave my high school teaching career that I loved and worked so hard to get in order to dedicate myself to photography full time. Oh boy! I was in trouble. How do I bring this up with my wife? The woman I had just married and who relied on my humble income as a teacher to live and provide health insurance? The thought of leaving a job I adored and that provided me with a steady paycheck scared the heck out of me.

The trip to WPPI changed my life yet again. It was an overload of brain stimuli. I loved everything about photography—the cameras, the lenses, the lighting, the software, the technical side, the artistic side, and my favorite, the business side. Photography had it all! I knew my wife Kim would be receiving her Master's degree in engineering in May, and she had already landed a great engineering job upon graduation. Kim having her own income definitely helped to solidify my decision to leave my teaching career and pursue becoming a full-time professional photographer. That was probably the hardest decision I have ever made. It felt as if I was jumping into a dark hole without knowing how deep the fall would be. The following week, I made an appointment with the principal of the school to tell her that I would not be continuing after that year. I hugged her and thanked her for the amazing opportunity she had given me. But I had to pursue this new profession, or I would regret it for the rest of my life. Before I left her office she asked me if I was sure, and with a heavy heart I said, "Yes, yes I am."

The most difficult aspect of this decision for me was not even financial; it was the fact that I loved every part of my high school teaching career. The three years I spent teaching at Rincon and University High School were some of the best years of my life. In fact, I still keep in touch with some of my students today. But if I was going to leave a career I loved to pursue my aspirations of becoming a photographer, I would take it all the way! Otherwise it wouldn't be worth it. I told myself that I would put in the work, and regardless of how

difficult the journey ahead would be, I would stop at nothing to become one of the best photographers in the world.

The following photos were all taken during the last day of school, and thus my last day as a high school teacher. Although these photos are difficult for me to see again, they remind me of the sacrifice I made to pursue photography.

Figure 1.1: This a photo of some of my students in our favorite room, the Ping-Pong–photography room. Every day during lunch and after school, we would all work together to try to understand the photography lights and how all the gear you see worked. We would also have a daily after-school Ping-Pong tournament. That Ping-Pong table became very popular, and we had the best times competing with each other. The young man with the black hat and black shirt in the front was the Arizona Table Tennis state champion several years in a row. So the competition was tough!

Figure 1.2: The school principal asked me to take the annual senior class group photo during lunch. Even on simple assignments, such as this one, I remember becoming quite nervous.

Figure 1.3: Once I said a lengthy goodbye to all my students, I took some time for myself to think and just process my decision. I put the camera on a tripod to take a selfie in order to remember my classroom and all the great memories that were made in that room.

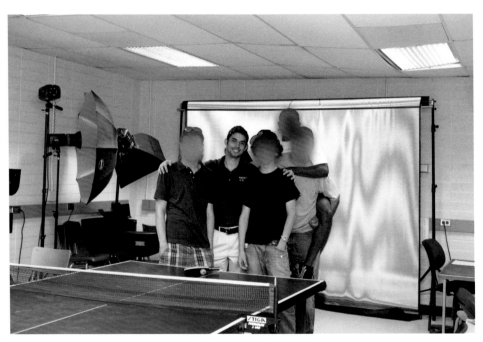

FIGURE 1.1

FIGURE 1.2

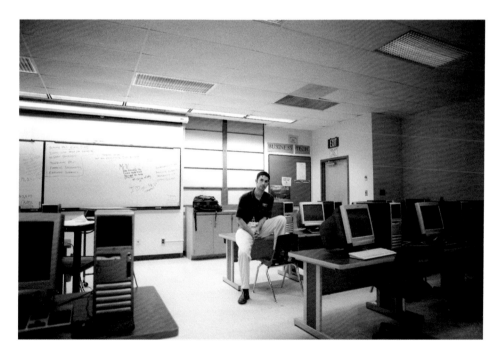

FIGURE 1.3

Figure 1.4: After the selfie, I took a photo of the whiteboard where students left some beautiful messages, wishing me good luck in my new adventure. Taking this photo was very emotional; I cried as I pushed the shutter button. I liked how a student made a drawing of the Canon 1D flagship camera. Every section of this whiteboard has a story, and I remember it as if it were yesterday. I thank my students very much for leaving these messages behind.

Figure 1.5: The time had come to leave my dear classroom. So I did as I was asked, and hung my keys and staff ID over my computer monitor before leaving.

Figure 1.6: This photo is symbolic for me because I'm walking away from my teaching career, but I'm doing so carrying my camera bag over my shoulder. Looking back at this photo as I write this today, I am so thankful for the wonderful years I spent teaching the best high school students I have had the privilege to teach. But by taking these last steps out that door, I changed my life forever. Never did I predict that my career as a photographer would be as blessed as it has proven to be.

Figure 1.7: My wife Kim took this photo of me upon returning from the WPPI convention that changed the course of my life. I am holding an issue of WPPI's *Rangefinder* magazine. I remember reading every article to absorb as much information and knowledge as possible. I love looking at this photo because I can see the intense determination in my eyes. That determination hasn't changed today. In fact, it has grown in intensity.

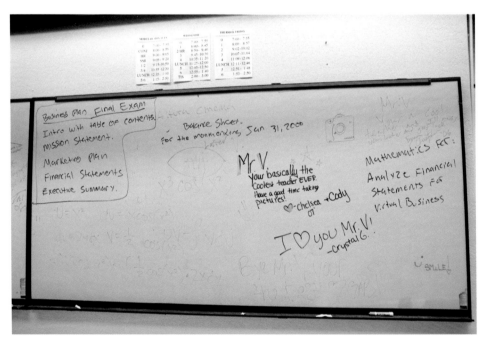

FIGURE 1.4

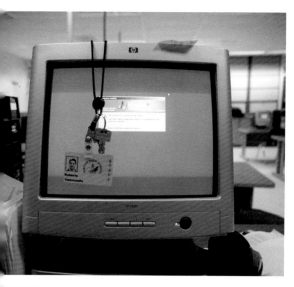

GURE 1.5

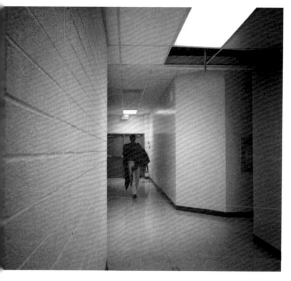

URE 1.6

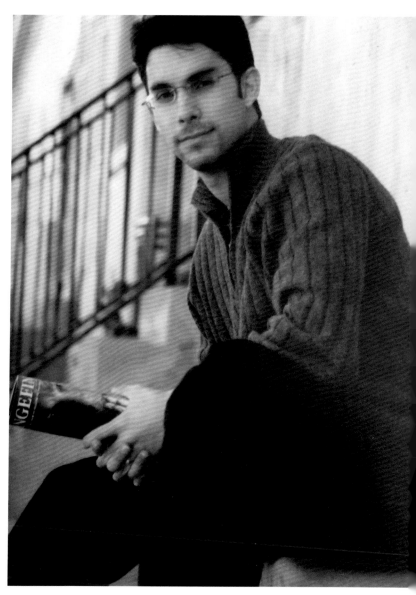

FIGURE 1.7

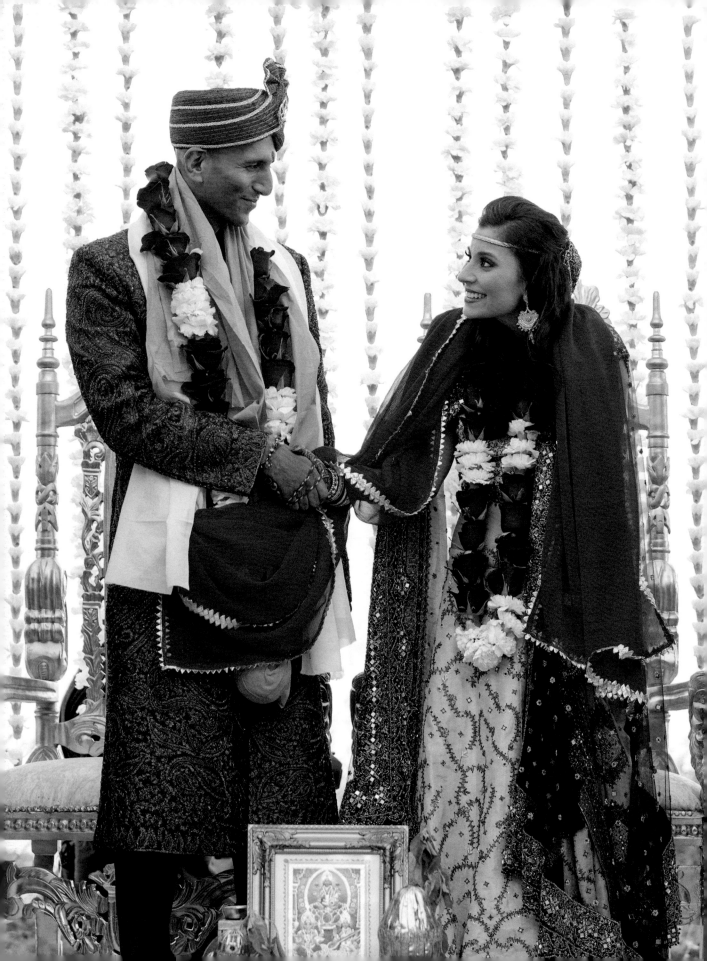

chapter 2
OVERVIEW OF THE WEDDING STORYTELLER SKILL COMPONENTS

Let me begin by saying this: *Wedding photos are not always meant to be perfect.* If you are afraid that you won't create perfect wedding photos, you may not ever take that first photo. Weddings are fast-paced events, and wedding photographers do their best to deal with the never-ending list of variables and challenges that are a part of the job. But with skill, dedication, and commitment, we can thrive in this chaotic environment and create photographs worthy of the term *art*. Skilled wedding photographers are able to make split-second decisions on site, which makes wedding photography such an exciting discipline.

There are few, if any, obstacles or requirements for entry into the profession. However, very few people can completely master this demanding discipline. Since I used to be a musician before becoming a photographer, I like to make an analogy that being a wedding photographer is similar to being an orchestra conductor performing for an exacting audience. An orchestra conductor eventually commands skilled, attentive musicians. Due to severe time constraints, a wedding photographer conducts a wedding party and guests who are not required to listen or cooperate. Yet, both artists are expected to produce a beautiful result—a concert where all the musical instruments seem to be in perfect unison, and a photo album depicting a near-perfect wedding day. I love photographing weddings more than you can imagine, but it has been a long and hard journey to arrive at where I am today. Just finding my personal style proved to be quite a challenge. It may seem like a simple task, but it is not.

This brings me to a very important point. My goal is that this book greatly helps disciplined readers elevate their work, and that you approach or achieve consistently high-level results, regardless of the weather, type of ceremony, budget, or wedding location. My goal is not to teach you how to replicate my style. I believe that photographers should shoot weddings in a way that satisfies themselves and their clients. There is no "best" or "correct" style.

This book has been designed to help you perfect whatever photographic style you wish to use. So, keep that in mind while reading this book, because I wrote every chapter with that goal in mind. I understand very well that there are photographers who choose to photograph weddings utilizing a photojournalistic approach, and others who take an entirely different approach and use techniques that increase their chances of photographing their clients in a flattering way. In my personal experience, there are times when a photojournalistic style works well at a wedding, and other times when the bride and groom would appreciate your helping them look their best yet keep them looking very natural. Regardless of what style you employ, having more knowledge and skill in all areas of photography, such as photojournalism, posing, lighting, or visual storytelling, can only help you and improve your work.

PHOTO-MAKER AND PHOTO-TAKER

Whether or not you consider yourself to be a wedding photojournalist, there will be times when the job requires you to shoot a wedding using two different styles. The photojournalist, or *photo-taker*, shoots the occasion as is, without any modifications, whereas the *photo-maker* takes partial control of the situation and influences the images via techniques such as posing, lighting, and arranging people. Whenever you interact with the people in front of your camera or alter the light in any way, you are shooting as a photo-maker. Although there are passionate feelings about both of these styles—and some argue for being a purist at one of them—I believe that being experienced in both approaches will give you a greater chance of satisfying both your clients and their families.

For example, the couple might hire you because of your photojournalistic skills, but the couple's family may not really care what your style is or who you are. They simply want flattering portraits with their loved ones, and many of them might have traveled long distances to be included in those portraits. If you were to tell these respected guests that you won't take modified portraits because you are a pure photojournalist, I don't think that would go over very well. Therefore, you tell them to stand or sit together, you make adjustments, you place the group in flattering light, and then you take their photographs. You have become a photo-maker for that portion of the wedding. It's very difficult, if not impossible, to never speak or interact with your clients in some way during an entire wedding. Therefore, being open-minded about both styles will serve you well, even if you lean much more toward one style than the other.

After all is said and done, weddings require a photographer to photograph certain parts as a photo-maker and other parts as a photo-taker. I switch between these two styles constantly throughout a wedding. As you read about the Skill Components Program below, keep in mind that every part of this program requires you to approach a wedding as a photo-maker *and* as a photo-taker. You need both.

EXPLANATION OF THE THREE-PART SKILL COMPONENTS PROGRAM

Although it is impossible to address every exception to this program (religious or secular ceremonies, cultural customs and traditions, photography style, and every available piece of photographic equipment), I worked hard to create a program that, if studied and followed correctly, will elevate your skills and make you a more confident wedding storyteller. To develop this program, I needed to recall all of my experiences from more than a decade of photographing weddings. I have also asked many of my colleagues to send me their own wedding photos for me to examine with a fine-tooth comb. Additionally, I have interviewed countless photographers, and analyzed probably well over a million photos from a variety of wedding photographers working from around the globe, as well as by being a judge at the most prominent wedding photography competitions.

The result is the following program based on three main parts:

- Foundation Components
- Storyteller Approach Components
- Expert Components

Foundation Components

The first part, foundation components, addresses the most critical issues and challenges regarding locations and people. As you can see from the lists that follow, each of these categories is made up of five key elements that have the highest impact on your photography. Naturally, there are many more than five elements that are important in each category, but for the sake of simplicity and practicality, I narrowed it down to the five most important elements.

Remember that a great wedding photograph is a result of a combination of many different elements, all well executed at the same time. I realize there is a lot to keep track of, but unfortunately becoming a great wedding photographer is not easy, and it does require your brain to be fully engaged and able to keep track of many photographic techniques while under pressure and time constraints.

Storyteller Approach Components

The second part of the program is storyteller approach components. This section will deal with how you choose to tell the story. This portion of the program is what makes you a director of the "wedding movie," if you will. Many people realize that a movie is a story that has been shot from many different perspectives, which are seamlessly stitched together. When done correctly, viewers hardly notice the angles and perspectives, but they become completely and emotionally enthralled by the story. That is precisely the goal of the storyteller approach components section of this program.

Expert Components

The final section is the expert components. This section consists of 10 elements that, when skillfully executed, will elevate your work to a world-class level. Keep in mind that even if you apply two or three expert components on the list, it does *not* mean that your photo will automatically become a world-class image. These 10 expert components can be accomplished with varying levels of skill. The greater your skill when executing these elements, the more beautiful and top-notch your photographs will be. For this reason, this book will grow with you as your skills improve.

What separates a normal wedding photographer from a renowned wedding photographer is how skilled he or she is when executing many of the elements in this three-part program, particularly the expert components. When I am photographing a wedding, I am constantly thinking about how I can add a combination of expert components to my photographs. Most likely, time will not be on your side, so being able to quickly implement the expert components is the key. To keep things lighthearted and fun, I actually consider using the expert components as earning bonus points in a game. They are not completely necessary to photograph a wedding, but if you want to be a great wedding photographer, then these expert components will certainly help you.

My advice is to be patient with this program that I have developed. Absorb it little by little; otherwise, you will quickly feel overwhelmed. But, if you begin to skillfully incorporate the three components of this program into your work, the emotional impact, visual beauty, and technical execution of your photography will propel you into a league of your own. It worked very well for me.

FOUNDATION COMPONENTS

Location Techniques

- Circumstantial Light (Chapter 3)
- Showing or Removing Context and Clutter (Chapter 4)
- Depth and Walls (Chapter 5)
- Compositional Elements (Chapter 6)
- Luminosity Levels and Contrasts (Chapter 7)

People Techniques

- Breaking Down Defensive Barriers (Chapter 8)
- Expert Confidence and Trust (Chapter 9)
- Being Flexible, Likable, and Professional (Chapter 10)
- The Situational Approach to Posing (Chapter 11)
- The Mechanics of Group Posing (Chapter 12)

STORYTELLER APPROACH COMPONENTS

Approach Techniques

- Photojournalism (Chapter 13)
- Interactive Photojournalism (Chapter 13)
- Stylized Aware Posing (Chapter 13)
- Stylized Unaware Posing (Chapter 13)
- Story Development (Chapter 13)

EXPERT COMPONENTS

Expert Techniques

"Photographing stories as a *photo-maker* and a *photo-taker* where the subject's mind is authentically engaged with a task, a reaction, or a thought."

- Emotionally Valuable People (EVP) (Chapter 14)
- Isolation and Priorities Through Lens Choices (Chapter 15)
- Helper Light: A Wedding Run-and-Gun Approach (Chapter 15)
- Creating and Capturing Movement to Achieve a Sense of Spontaneity (Chapter 16)
- Capturing Peak Action and Achieving Naturally Engaged Expressions (Chapter 16)
- Increasing Affection Through Touch and Energy (Chapter 16)
- Unique Perspective and Higher-Skilled Composition (Chapter 17)
- Creative Cropping (Chapter 17)
- Story Framing and Meaningful Object Placement (Chapter 17)
- Multiple Stories Captured Within a Single Photograph (Chapter 17)

part two
FOUNDATION COMPONENTS: LOCATION TECHNIQUES

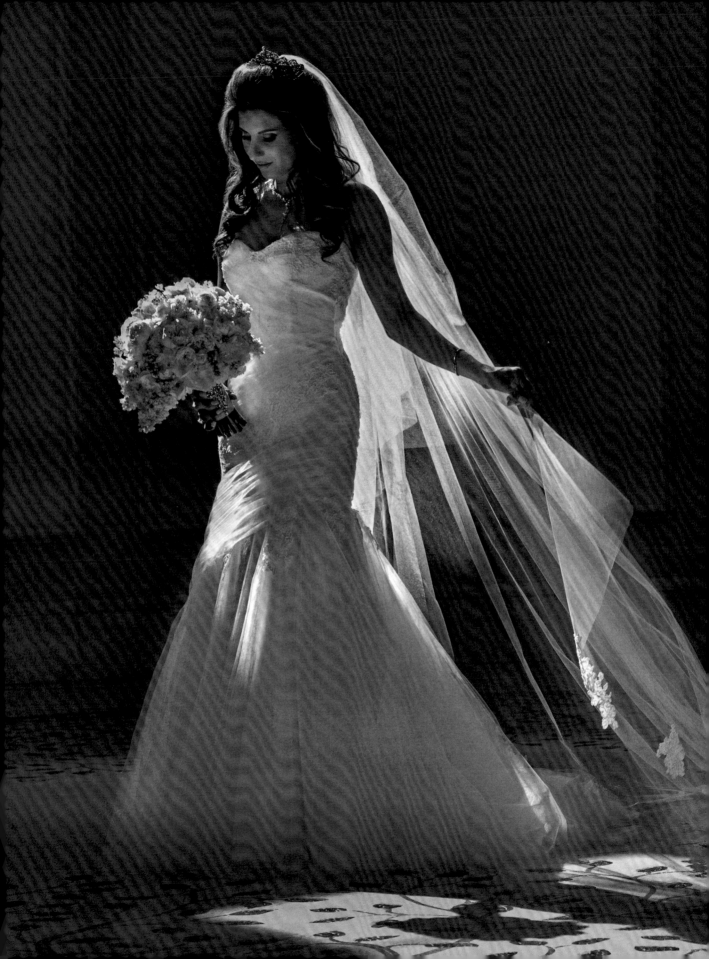

chapter 3
CIRCUMSTANTIAL LIGHT

As wedding photographers, we do not have the luxury of choosing the location where we will be working. The bride and groom choose their wedding venue and, of course, where they will be getting ready. Ideally, the bridal couple would choose a dressing area that is spacious, clean, and full of light, but that is usually not the case. If only we could be so lucky.

But one of the most gratifying aspects of photographing weddings is being able to create beautiful photographs in chaotic settings. That's part of the enjoyment. Throughout my career, I have walked into many hotel rooms and private homes that have had every challenging scenario that could be thrown at a photographer. Many rooms have been relatively dark, and full of decor hanging on the walls, furnishings that take up most of the space, and, worse yet, junk everywhere. Last but not least, the rooms are usually cramped, and the couple's families and the wedding party are often there getting ready and leaving plates of food and drinks wherever you look. However, by rearranging objects, removing context, and using clever composition, smart camera settings, and skillful use of light, you can eliminate most of those challenging distractions that are a part of shooting on location.

Before we continue, I would like to give you a definition for circumstantial light and how it differs from natural light. Natural light (or sunlight) refers to the properties of light, such as its wavelength or intensity. Circumstantial light forces you to pay careful attention to the exact direction natural light is coming from, the objects around your subject, and how those objects are influencing the natural light in your location. This is so important, especially for wedding photography, because you have to work quickly. A photographer needs to recognize that an object, such as a light-colored wall in close proximity to a major light source (like a large window), can provide great opportunities to create photographs with superb lighting. If that light-colored wall did not exist, then the window light would travel into the room and just fall off into darkness. There would be no object to bounce or reflect that light back onto your subject.

The same principle applies when photographing outdoors. Objects such as sidewalks, cars, buildings, and large trucks can greatly influence how the incoming sunlight is reflected back and forth at any given area. Having the knowledge of how light behaves when it strikes different objects is the core of circumstantial light. A great wedding photographer is acutely aware of all objects around the subject(s), because these objects are basically "light shapers." Skilled photographers can use these light shapers to control light, to choose an effective shooting angle, to alter a pose based on the light, and to make people appear younger or older.

CIRCUMSTANTIAL LIGHT INDOORS

Every photographer is different, and every photographer approaches locations in his or her own way. However, by trial and error, I have learned from my many mistakes how to prioritize certain elements that give photography an elegant and timeless feel. For example, the first location I am usually faced with on a wedding day is a hotel room or a private home where the bride and groom will be preparing with their families and friends for the long day ahead. I scrutinize all rooms in the same way, whether it's a room at a Motel 6 or a Presidential Suite at the Beverly Hills Hotel. Why? Photographers rely heavily on the beauty of the light illuminating our clients. Light is the primary reason why someone will love or hate the way a photo looks and feels. Clearly an elegant room helps with the overall aesthetics of the photograph, but I have learned not to become seduced by the location, only by the light. The location's elegance and beauty is merely a bonus, not a necessity.

The first two questions I ask myself when I walk into a room where the photo session will take place are:

- Where is the strongest light in the room coming from?
- Is the strongest light direct window light or indirect window light?

The answers to these two questions are at the forefront of any photographic decision I make thereafter. After these two questions have been answered, the next question is:

- Are there any naturally occurring reflectors that can reflect the window light back toward the subject?

These reflectors could be nearby light-colored walls, white bed sheets, etc. The closer these reflectors are to the window, the more effective their reflective capabilities will be. Having strong light coming from a window and a reflector nearby have become crucial components for creating an elegant and artistic style of work.

Figure 3.1: As you can see from this photo of the bride putting on her shoes, the two large windows are clearly not enough help. This photo was taken during my first year as a photographer. At that time, I had no concept of how important the knowledge and application of circumstantial light would be when photographing weddings. My original thought was, "I have two windows over here, so this should be a great place for the bride to be putting on her shoes." As you can see, I couldn't have been more wrong. The light is

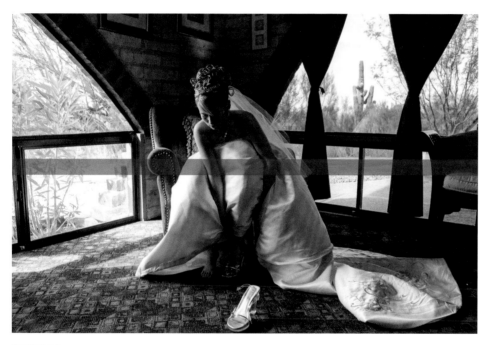

FIGURE 3.1

quite unflattering, even though she is close to the window. Let's answer the three questions to see why this photo is a failure.

Where is the strongest light in the room coming from? The strongest light in this room is coming from the window on the left.

Is the window light direct window light or indirect window light? Both windows are receiving indirect sunlight. If you can see the sun when standing directly in front of a window, that is direct window light. If the sun is elsewhere and you cannot see it from the window, that is indirect window light. In this situation, the left window is receiving better light, but the sun is too high up to be considered direct window light. Therefore, the light entering the

room through that window is just okay, not great. The window to the right is virtually useless. It is not providing much light at all, because the sun is on the opposite side of the building.

Are there any naturally occurring reflectors that can reflect the window light back toward the subject? Absolutely not! Circumstantial light asks us to pay attention to the objects around our subjects and how these objects are influencing the light. In this room, we have a textured red brick wall surrounding the bride, dark curtains, and worst of all, dark carpet, all of which absorb most of the light coming in from the windows. Once we combine the effects these objects have on the light with the fact that we are only working with indirect window light, there is a very good chance of failure. Not only does it appear that there is a red color cast on the bride due to the red bricks, but also the left side of her body (camera right) is completely underexposed. There is nothing in that room that is acting as a great reflector.

Figure 3.2: This photograph of Jessica replicates the previous photo of the bride putting on her shoes; however, this time it was done correctly. The crucial decision that contributed to the beauty of this photo was to ignore other parts of the hotel room that did not have the proper elements. This photo was taken in one of the largest suites at the Hotel Bel-Air in Los Angeles. However, I chose to place the bride in the narrow closet hallway. Why? Referring back to the three key questions, the main light is coming from the window on the right and the intensity of the light is strong. If you were to stand in front of that window, you would be able to see the sun above you. This signifies that the light coming in was almost direct window light. Finally, the closet doors on the left side of the photo are large, smooth, and white. These three attributes created a very effective reflector. The close proximity of the closet doors to the window actually increased the intensity of the reflected light. That hallway had all the criteria I needed to take elegant, quality photos. The rest of the large hotel room was beautiful, but it did not have the circumstantial light qualities that this little hallway possessed.

Figure 3.3: Being able to determine the direction of light and whether it is direct or indirect light will have a major impact on the way your photos look. This ability also separates a novice photographer from an experienced one. This photograph, like Figure 3.1, was also taken during my first year as a photographer. My intention was to take a photo that would feature the bride's dress. Since I had no clue about how to read light properly indoors, I placed the bride in front of a clean background without giving a second thought to the circumstantial light at that location. The incoming window light was so weak that I had to crank up my camera's ISO to 1600 to achieve a proper exposure on the dress. Regarding direction of light, the light was coming in from a poor angle that flattened the dress. This lack of directional light gives the photo a very flat and unflattering appearance.

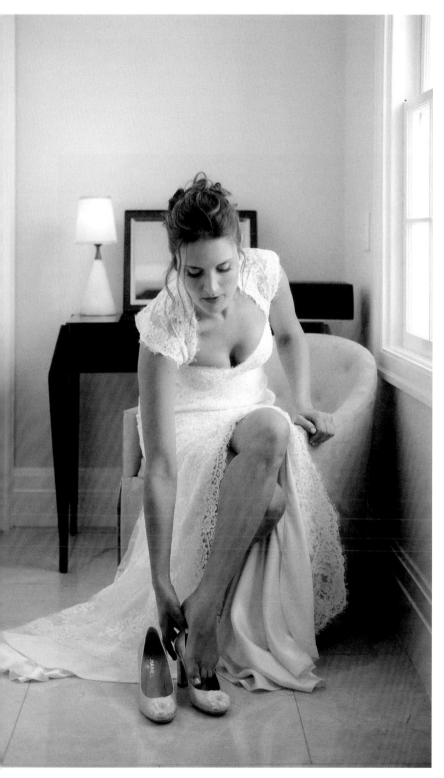

FIGURE 3.2

FIGURE 3.3

Figure 3.4: Again, my goal for this photograph was to feature the dress. The difference was that I took a minute to look around the venue to see if I could find a place with a window facing the sun. Better yet, this location also had a white wall opposite the window reflecting all that intense window light right back. Isn't it amazing that these two photos have almost everything in common—similar pose, similar goal, similar camera angle—but clearly they are not the same. The significant difference is in how I used my knowledge of circumstantial light and knew what to look for.

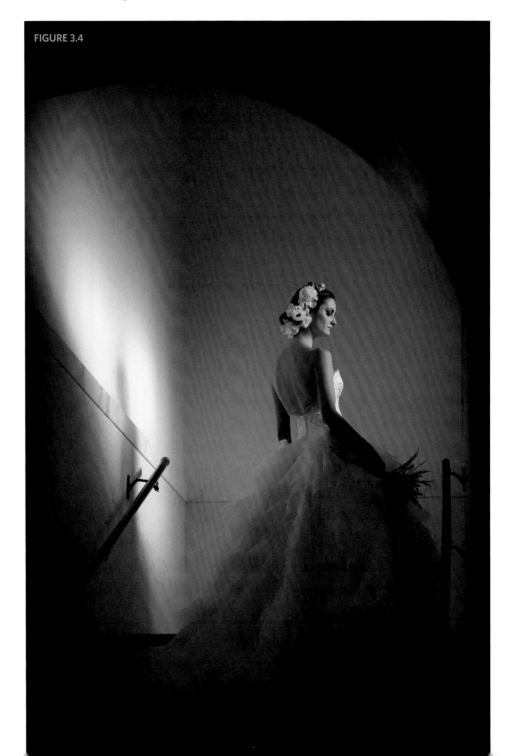

FIGURE 3.4

Working Around the Light

The next three photos are examples of a bride interacting with her wedding dress before putting it on. I took the first two as is. I did not think about the light during that time, nor did I think of the pose with respect to the light. Let me clarify that when I refer to a pose, it often means only making a quick adjustment to what the bride is already naturally doing, something as simple as turning her face toward the light. In wedding photography, the light is usually fixed, and we must learn to work around and with that light. The position of our subjects, the direction they are facing, how close/far away they stand from the light source: these are all decisions that are made with respect to the light we are working with.

FIGURE 3.5

Figure 3.5: In this photo, the bride is standing fairly far away from the window light. The result is a completely flat light that does very little to flatter her. Also, the light on the bride is the same as the light on the wall, the dress, and the door, so the photo lacks dimension and depth. By simply placing the bride closer to the window and strategically positioning her, as well as changing my shooting angle, the photo would have been much more flattering. As you will notice in the next photo, simply positioning the bride near the window is not enough. The angle from which you shoot and how she is posed make a tremendous difference. Keep in mind that the pose could have happened either naturally or with the photographer's help.

Figure 3.6: Looking back at this photograph makes me laugh at my lack of knowledge. I had just invested $8,000 for the newest, state-of-the art camera at that time, and I imagined myself taking such wonderful photos with it. Those were the good old days of innocence. For this photo, I positioned the bride near the window. In theory, that should make this photo amazing, right? Not at all. Her pose and my shooting angle are totally wrong for this window light. First, the bride is facing the dark side of the room rather than the light side. Second, it's difficult to enjoy the moment when more than 50% of the photo is completely blown out by the large window. Third, the camera tilt created distracting shapes from the curtain, the window, and the carpet. All of these shapes compete with the bride interacting with her dress.

FIGURE 3.6

Figure 3.7: This photo was taken recently at a wedding in Pasadena, California. We have very similar elements here as in the previous example. We have a curtain, a large window, and the bride interacting with her dress. Therefore, from an indoor circumstantial light perspective, we have similar elements as in Figure 3.6. However, in this example, the image was handled more skillfully. What makes this photo so elegant and beautiful is how the light graces the bride's face because of her close proximity to the light source and the way she is positioned. If the bride had turned more toward the window, her face would have been completely hidden from the camera. If she had turned her face away from the window, her face would have been much darker.

Next, I positioned her on the left side of the window, because there is a nearby white wall on the left side reflecting light back. Had I not paid attention to the objects around the bride, I might have placed her on the right side of the window. This would have given this photo a much less flattering look and feel. Last but not least, all the vertical and horizontal lights in the scene are aligned with and parallel to the camera frame. This keeps everything looking very attractive and straight. These may be minor nuances, but the differences among these three photos are significant.

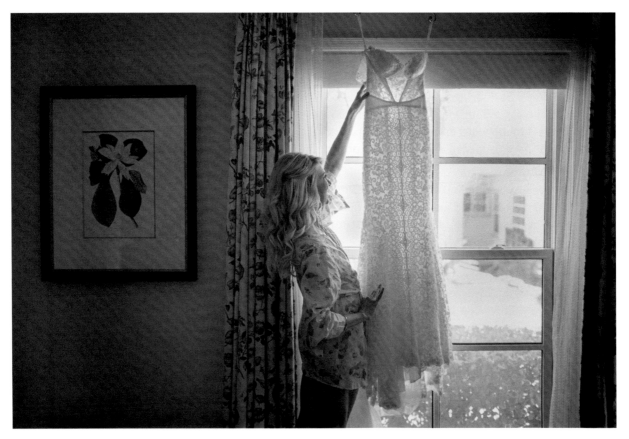

FIGURE 3.7

Proximity to the Light Source

Figure 3.8: One of the most visually impacting circumstantial lighting techniques you can use is to keep your subject close to the light source to achieve a beautiful light falloff as the light travels across your subject's face. Posing the subject close to the main light source is what gives photos a glowing quality and dimensionality. Therefore, I never try to take a wedding photo as a photo-taker when the lighting looks flat. For example, let's examine this photo of the groom, Andre. In this photo, the lighting on his face looks good but not great, because the groom is just a bit too far away from the light source (the window). Also, his face is turned away from the light.

One of the unique aspects of being a wedding photographer is that we must develop a keen attention to detail in a fast-paced environment. As you'll see in the following image, when I posed the groom facing the window light and asked him to move just inches closer to the light, it completely transformed the look of the photo, making it much more dynamic.

FIGURE 3.8

FIGURE 3.9

Figure 3.9: When I asked the groom to stand up, face the light, and lean his upper body toward it, the lighting was much more vibrant. Notice that the light on his face is strong and bold, but then it quickly falls off to a much darker shade just past his eyes. It's incredible that such a short distance from the light source can make such a big difference in giving this photograph a high-end look.

Figure 3.10: It is imperative for me to take portraits of the bride as close to the strongest light source available. In this photo, the bride is approximately three meters, or 10 feet, away from the window light. When this photo was taken, I was unaware that I should look for the brightest window. I assumed that all windows were alike, but they definitely are not. As a result, the intensity of light illuminating the bright side of the bride's face is not nearly intense enough. The distance between the window and the bride is also why the lighting on her face appears to be relatively flat. There are many more problems with this photo (location, distracting background, and forced pose, to name three), but for now, let's just worry about the light.

FIGURE 3.10

Figure 3.11: When I am photographing a bride, my lighting goal is to shower her with as much light as I can and then make sure to turn her head in such a way as to fill every possible wrinkle with light. In this situation, I only had indirect window light to work with. Therefore, I told the bride that I needed her to be as close to the window as possible. She was only inches away from the window in order to take advantage of every ray of light coming into the room. There were no walls behind the bride to act as reflectors, so I cropped tight and positioned her as close to the light as I could. The light on her face is now brighter than the light illuminating the rest of the room. That's the goal! You always want the bride to shine with beautiful, flattering light.

FIGURE 3.11

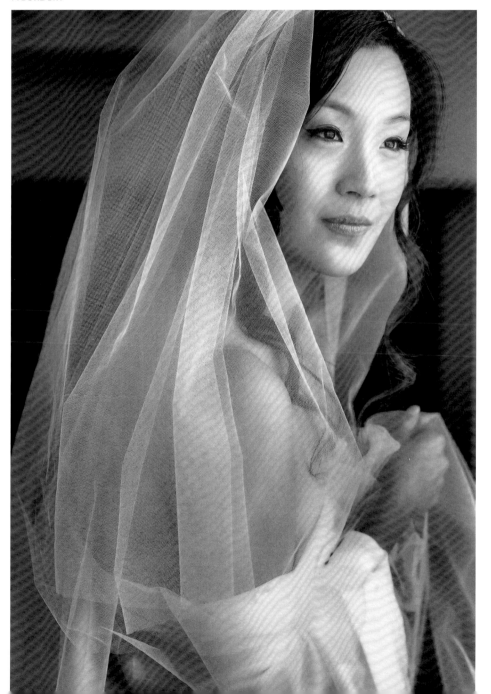

Strategic People Placement with Circumstantial Light Indoors

It took me a while to learn from experience that I must be very strategic about where people stand during certain parts of the wedding when I have a bit more control—for example, when the bride and groom are getting ready. When working with window circumstantial light, making a mistake could emphasize unwanted facial wrinkles and might also block light from reaching one person due to another person.

Figure 3.12: I have learned the hard way how to make sure that people are standing in flattering light. This photo is an early example from when I did not want to say anything and just shot away. The bride is standing and facing away from the light, and the brides-maid helping her has beautiful light on her back but not on her face. The result is that they both have terrible lighting on their faces and a red color cast from the circumstantial light in that room.

Figure 3.13: This is definitely an improvement from Figure 3.12, but it is still far from flattering. From a circumstantial light point of view, the bride has two windows illuminating her: one behind her and another to camera right. From my shooting angle, the bride is facing away from the window, and the bridesmaid's dark blue dress is actually absorbing light. The result is that the bride has very poor lighting on her face, and you cannot see the bridesmaid's face.

FIGURE 3.12

FIGURE 3.13

Figure 3.14: This is a recent photo taken at a wedding in Pasadena, California. Now, I can make sure that the wedding proceeds normally while also being sure to photograph with great light. The bride will always need help zipping up her dress, so this might as well happen where the light is flattering to both people. One oversight that a photographer often makes is to ask the person assisting the bride to stand directly behind her as she makes adjustments to the dress. This is a bad idea, because the bride will block most of the light from the other person's face. To ensure that this does not happen, I ask whoever is helping the bride to simply stand slightly off to the side so that he/she will also receive great window light. Clearly, the bride should be positioned closer to the light source to give her greater importance by making her the brightest focal point.

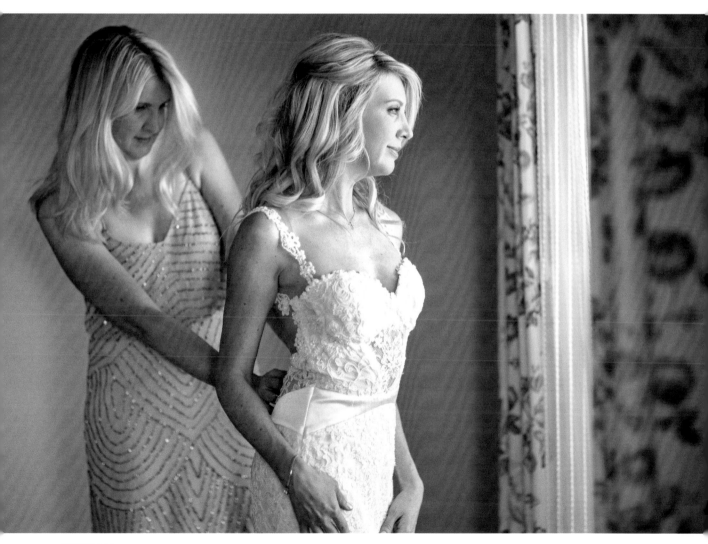

FIGURE 3.14

Reducing Wrinkles with Circumstantial Light

Figure 3.15: Posing your subjects close to a window does not necessarily mean that they will receive flattering light. You must also consider the angle from which the light is striking your subject. For example, when photographing portraits involving the mother or the grandmother of the bride, be sure to position the older person directly in front of the light to fill in every shadow created by facial wrinkles. My mistake in this photo was that I never paid attention to this detail, and I accidentally placed the mother of the bride in such a way that the light illuminated her from the side. This kind of directional light actually *emphasizes* texture. This is not a good technique if you want the mother of the bride to love the photos. Not to mention, the "prom" pose with the mother of the bride isn't exactly suitable, either.

FIGURE 3.15

Figure 3.16: This is the correct way to pose the mother of the bride in circumstantial window light. In this case, both the bride and her mother are positioned more directly toward and as close as possible to the light source. Notice how much more flattering their faces appear by reducing the appearance of texture on their skin. These days, I simply ask them to directly face the window light to take their photo. Even if the background is distracting, I still believe that this is the best option; looking younger and more flattering is far more important to members of the family than a distracting piece of wall decor in the background.

A major exception to this would be if the distracting element in the background is a light, as in **Figure 3.17**. Simply moving the group more to the left and cropping that wall light out of camera would have solved the problem. These kinds of oversights occur, because in the heat of the moment and with everything going on, we photographers often forget to take a few seconds to breathe and observe our surroundings.

Also, here's a helpful tip: If someone in the photo is wearing white, such as the bride, be sure to turn her body to the side and her face toward the light. If the groom is wearing a white shirt, either turn him to the side as well or have him put his jacket on. The reason is that having something large and white in front of a window calls far too much attention to the width of that part of the body, and it's incredibly distracting due to its brightness.

FIGURE 3.16

FIGURE 3.17

CIRCUMSTANTIAL LIGHT OUTDOORS

I know that weddings are fast-paced events, and finding time to do a good job or to take advantage of the location is a constant struggle. For these reasons, I have learned to pay more attention to the surrounding objects around my couple in order to use these objects as natural reflectors of sunlight.

During the day, the sun is always above you. This means that people will always have dark eye sockets caused by the supraorbital ridge bone beneath the eyebrow. Being skilled at recognizing and utilizing circumstantial light will be one of the major talents that set you apart from other photographers. Not all wedding photographers, of course, but a great majority of wedding photographers don't give circumstantial light much thought. They simply place their couples in front of an attractive location and start shooting. They will continually shoot until, hopefully, one or two photos look decent. However, the light illuminating their clients will most likely leave a shadow on the eyes due to the direction

of light. This is very unfortunate, because there is nothing more beautiful than a photo of the bride with gorgeous, glowing eyes.

Look at wedding photographers' websites from around the world. You will rarely find a photographer who intentionally illuminates his or her clients with horizontal light, not just the vertical light traveling down from the sun. In order to find horizontal light, we must seek objects that can reflect the sun toward our subjects. Those objects could be a large tree trunk, the walls of a nearby building, a large white delivery truck, or a light-colored smooth sidewalk reflecting light back up. My personal favorite is an outside, open structure that provides shade but also allows strong sunlight to enter it. A good example of this would be a garage with the door open to let light in.

All of these objects, and many more, help reflected light from the sun to travel horizontally, casting beautiful light onto our subjects' eyes. As soon as I step outside of a hotel room to photograph any portraits required by the couple, I have four extremely important goals with regard to how these portraits will be lit. Keep in mind that in wedding photography, we don't always get everything we want. In fact, it's rare that we ever do. Therefore, these goals are at the forefront of my thought process as I shoot, but there are many instances when I cannot accomplish these goals for a variety of reasons. During tough times, you just do your best and move on. The four goals are outlined here. Let's take a look at a few examples.

Four Goals for Circumstantial Light Outdoors

- First, achieve clean light across the subject's face. Then, utilize circumstantial light to reflect light horizontally toward the subject's face. If there is nothing in close proximity reflecting light back toward the subject, use a reflector, diffuser, flashes, or video lights (LED) to ensure that horizontal light illuminates them.

- Maintain even or consistent light levels throughout the frame. For backlit portraits, you can only minimize hotspots around the scene.

- Make sure that the subject is, at the very least, as bright as the background with the exception of the sky.

- If working with direct sun on your subject, carefully adjust the pose to fit the light and flatter the subject.

Figure 3.18: It's very clear why the first goal is so important. Without paying attention to even, clean light across the couple's faces, the result is splotchy lighting, such as in this example. This photo was taken during my first year as a photographer, when I did not know how to look for clean light across my subjects' faces. The easiest way to achieve clean light during strong sunny conditions is to simply photograph with the sun directly behind their faces. The quickest way to make sure that the sun is directly behind your subjects is to find their shadows and have them stand in the same direction as the apex of their shadows. Note that they do *not* have to stand on the tip of their shadow, just stand in the same direction as the tip of the shadow.

Figures 3.19 and 3.20 demonstrate how circumstantial light techniques were used to reflect light back toward the subjects' faces. In both cases, the light-colored ground functioned as a very effective reflector. For this reason, in Figure 3.19, I had the bride tilt her head slightly downward in order to pick up more reflected light on her face. Notice that in Figure 3.20 I should have asked her to tilt her head down slightly more. Because I did not think about that during the shoot, the result is that her chin is illuminated much more than her eyes. This is a strong testament to how strong the reflected light is coming up from the ground.

FIGURE 3.18

FIGURE 3.19

FIGURE 3.20

Figure 3.21: In this example, I managed to keep the light on their faces consistent. However, while there may not be splotchy lighting in this photo, the couple's faces are completely dark. The second goal was basically ignored. There are multiple hotspots all over the frame. This is very distracting when you are trying to visually emphasize the bride and groom. With a photo such as this, your eyes travel everywhere, from hotspot to hotspot. Even the bouquet has a heavy hotspot. I was such an inexperienced photographer when I took this photo. The sad part is, there was wonderful light at that time of day, and it's unfortunate that I did not think about the hotspots surrounding the couple.

Figure 3.22: We have a similar oversight in this example. It's very difficult to photograph a scene with depth, such as this one, without having any hotspots from the sun striking the ground or a tree. However, try to avoid having a hotspot near your subjects' faces. A hotspot there is much more damaging to the photograph than if the hotspot is near the ground away from their faces. In this case, there is a heavy hotspot right behind the bride's upper back, close to her face. You can see from looking at this photo how distracting that hotspot is. If I had changed my camera angle slightly to the left, I could have avoided this hotspot or I could have cropped it out in camera. The lesson to take away is to avoid heavy hotspots near your clients' faces. On a more positive note, the first goal was achieved by having clean and consistent light across her face.

FIGURE 3.21

FIGURE 3.22

Figure 3.23: As I said in the previous example, it is very difficult to take a photo with depth without the sun directly striking different objects, such as the ground or plants. This photo achieves all of my four goals. It falls just a bit short on my second goal. The light levels are fairly even and consistent throughout the frame, with the exception of the ground. But the reason this works is because the ground is far away from their faces, which greatly diminishes the distraction. After I cropped out the ground from this photo, I finished with **Figure 3.24**. Now, you can see that all four of my outdoor circumstantial light goals were well executed.

FIGURE 3.23

FIGURE 3.24

Figure 3.25: This is a recent bridal portrait that I took during a wedding in Orange County, California. I successfully achieved all four of my circumstantial light goals for this portrait. From corner to corner, the beautiful lighting looks almost surreal. At weddings, you cannot always make all four circumstantial light goals work together; however, there are times when the stars align and the opportunity is there. You just have to know what to look for and to take advantage of these opportunities. In this instance, the sun was illuminating a light-colored building in front of the bride. That building then reflected a great deal of soft light back toward her, and the results speak for themselves.

FIGURE 3.25

Figure 3.26: There are times when we must work with direct sunlight illuminating our bride and/or groom. For this reason, the fourth goal states that when working in direct sun, we must adjust the pose carefully to keep the light and shadows under control. In this case, I chose to have the bride receive the direct light rays from the sun. To control the shadows that this pose would create, I adjusted the pose by tilting her head upward until most of the shadows disappeared from her face. Then, I simply had the groom kiss her upper cheekbone to ensure that he would also have his face tilted slightly up. The result is a dynamic photo with strong light that is still flattering to the couple.

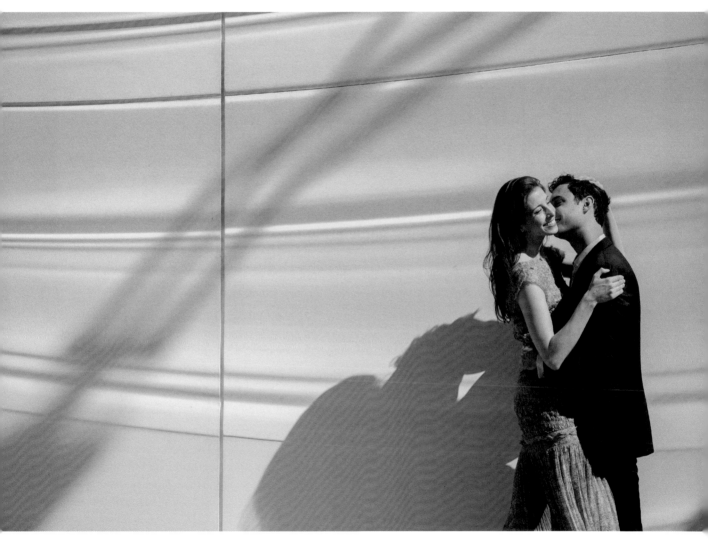

FIGURE 3.26

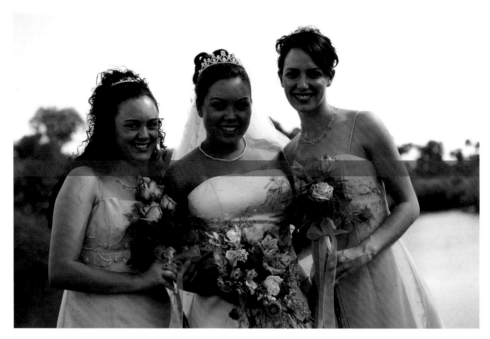

FIGURE 3.27

Comparing a Photo with Proper Outdoor Circumstantial Light with a Photo that Completely Ignores It

I cannot emphasize enough the importance of the objects surrounding your subjects and the effects they will have on the lighting quality of your photographs. Through experience, I have become more acutely aware of all objects and how they influence the scene.

Compare the lighting quality in **Figures 3.27** and **3.28**. Both of these outdoor photos are of bridesmaids holding their bouquets. Although the two photos are similar in some ways, they could not be more different with respect to the quality of light illuminating the subjects.

Figure 3.27 practically disregards all of the circumstantial light goals listed above. The bridesmaids are standing over green grass, which not only leaves an unflattering green color cast, but also absorbs most of the light coming from the sun. There is no light traveling horizontally to illuminate the subjects' eye sockets, and there is splotchy lighting on their faces.

Now, compare that lighting to Figure 3.28. In this photo, I positioned the bridesmaids under the cover of an arch. This arch blocked the sunlight from directly striking their heads. Although the arch provided some shade, I strategically positioned the bridesmaids as close to the sunlit ground as possible. I wanted them to receive as much reflected light from the ground and walls as possible. You can see how effective horizontal light can be by looking at each of the bridesmaids' eye sockets. They are perfectly illuminated, giving each and every one of them a beautiful sparkle in their eyes.

The subject of circumstantial light can go much deeper. However, because there is so much more to being a great storyteller than just good lighting, I kept this topic to the point with emphasis on the most crucial aspects that a wedding photographer will deal with. If you wish to dig deeper into this subject, you can read my lighting book titled *Picture Perfect Lighting*. A great deal of that book is dedicated to mastering circumstantial light.

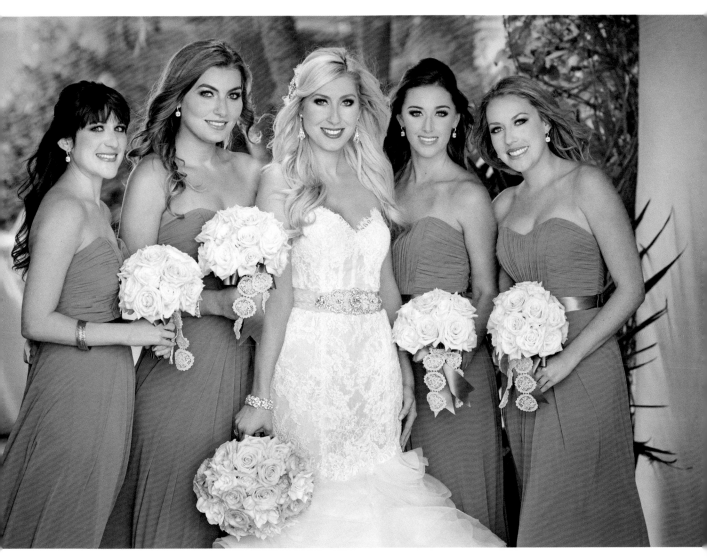

FIGURE 3.28

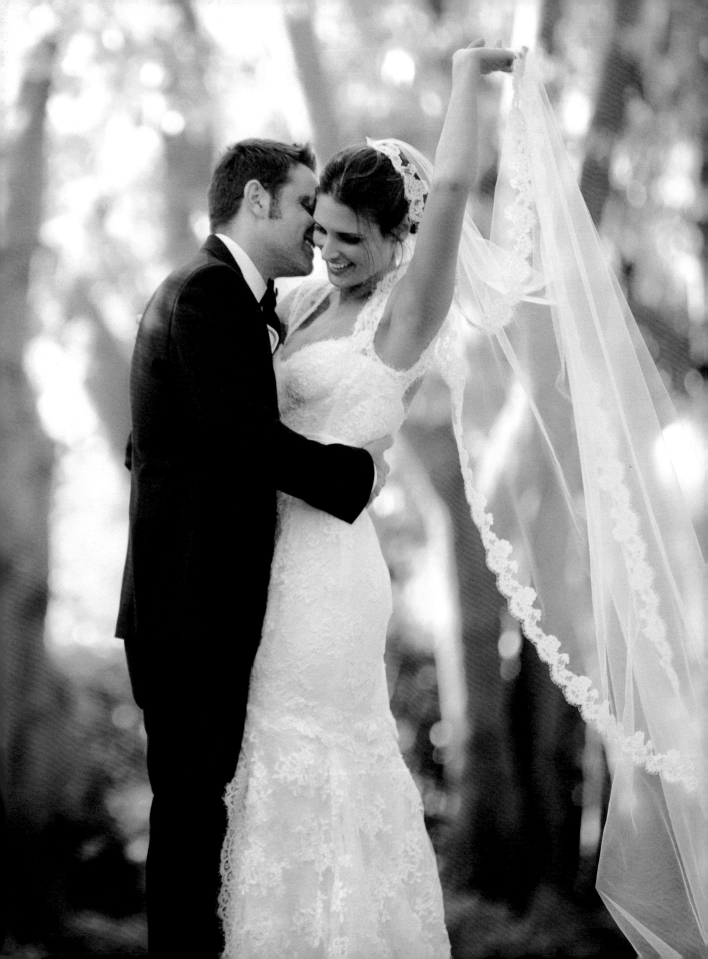

chapter 4
SHOWING OR REMOVING CONTEXT AND CLUTTER

I can guess what many of you are thinking: "Clean out the clutter? That's obvious!" Evidently, it's not. If clearing clutter from photos were common sense, why do I discover clutter in most professional photographers' wedding photos? It is a significant issue, but it can be resolved quickly. Clutter-free images focus all the visual attention on the intended subject(s). After finding a room with the best circumstantial light, the next step is to determine what kind of situation we are confronting with respect to how clean or messy that location is. Ideally, the bridal couple should be getting ready in the cleanest part of the room with the best lighting. But most times, there will be a serious mess in every corner of the room.

Wedding photo sessions of the bride or groom getting ready usually occur at their private home or in a hotel room. These rooms can accommodate three or four people comfortably. However, during a wedding, the photographer will be dealing with the bride and groom, their entire wedding party, and family members. There will be food and drinks everywhere, as well as items of clothing, garment bags, make-up, flowers, televisions, beds, lamps, bedside tables, etc. For the sake of your photography, this mess must always be dealt with.

In my experience, if you ask politely, you will always receive permission to move things around a bit and to clear the clutter from the area where you will be photographing the most. If you don't ask and just assume that you can meddle, it is likely that you will appear unprofessional and rude. On the other hand, if you don't wish to interfere with the current state of the room, your photos will show the entire distracting mess.

"Showing or removing context" refers to the artistic decisions a photographer makes about how much or how little of a room or location he or she wants to show in the photographs. As you gain experience in wedding photography, your decisions regarding how much of the scene you show will become one of the most important decisions you make.

PROPERLY DEALING WITH CLUTTER

Take a look at **Figures 4.1–4.3**. They show the reality of what wedding photographers encounter when they first see the bride or groom getting ready, and these are not even the worst situations I've worked in. I have entered rooms where there is so much clutter that I cannot even see the carpet. Yet, it is in rooms such as these that we must produce beautiful and elegant work. I believe that part of the thrill of being a wedding photographer is overcoming these challenges and somehow taking great photographs.

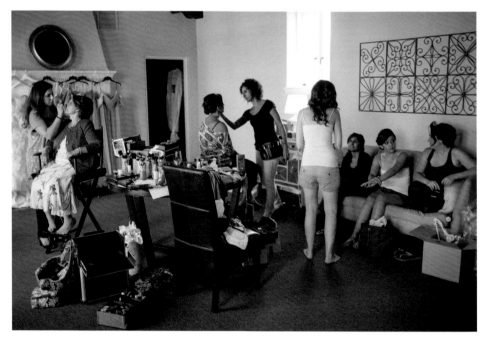

FIGURE 4.1

FIGURE 4.2

FIGURE 4.3

Photographers are obviously aware of the negative impact that distracting clutter has on photographs. But I still see clutter as a major problem when I look at photographers' work from around the world. Below are the steps I take to manage clutter in wedding dressing rooms. Please note that only my assistants and I clear out unwanted clutter and furniture. Never ask the wedding party or the couple's family to help you move furniture, etc.

Steps to Deal with Clutter

1. **Food and drinks:** Find the area of the room with the very best circumstantial light. Once this area has been found, ask if you can move all food items to another part of the room where you are sure those items will be completely out of the way.

2. **Furniture and accessories:** If the best light is near a window, which is usually the case, try to remove all distracting furniture and accessories such as phones, some lamps, and cables. You want the area to be as clean as possible. If you move furniture around, make sure you put everything back the same way you found it. Your clients will perceive you as being very professional and considerate.

3. **Placing emotional objects:** Once the area of the room where you will be taking photos is clean, sometimes add items that could be part of the story or that add emotional value to the photographs. Those items could be a gift from the groom, the bride's wedding dress, shoes, or a bouquet. When placing these items in the scene, make sure they are attractively balanced with respect to where the bride or groom will be posed.

4. **Moving:** If the room is too messy to clean, and there are no areas with great lighting, simply find another room, or ask the bride to get ready outside, if it's convenient to do so. You have to use your judgment on this, of course. But if, for example, there is a large balcony available or the bride's parents have another room somewhere in the hotel, ask if you can use those areas instead.

 I have even asked the front desk if they have an available room that faces the sun that I could borrow for a few minutes. Not only does that give me a clean room in which to photograph, but it provides me with direct window light to work with. Depending on how flexible the hotel staff is and how you ask, they usually give you a room for 30 minutes or so. Naturally, moving to a different location to photograph the bride or groom getting ready is a last-resort solution. The point is, I personally believe that it is very important to go to great lengths to photograph with beautiful light. To make an analogy, I consider great lighting to be as important to wedding photography as a surgeon would consider scrubbing up to be important before surgery. I know it sounds extreme, but it was this kind of thinking that propelled my photography to higher levels, year after year.

Figures **4.4** and **4.5**: During a wedding in Orange County, California, we walked into the groom's dressing room. If you take a minute to analyze the room, you will quickly see that from a circumstantial light point of view, this room is quite challenging. As I mentioned in the previous chapter, a large window provides the best light coming into the room. With that established, look at the area around the window. The dark brown wall will absorb light, not reflect it, and the carpet will also absorb light. There is a distracting white lamp near the corner of the room, and the lounge chair is taking up too much valuable space. That whole area needed to be cleared so that we could convert it into a cleaner canvas to work with. Remember, everything needs to be done respectfully and after receiving permission.

If we move personal items, we must tell the subjects exactly where we are moving their items. Furthermore, do not let the wedding party help you. It's not their job to move furniture for the photographer. The last thing you need is for someone from the wedding party to pull a muscle or become injured on your behalf. Trust me, it is not worth the risk.

FIGURE 4.4

FIGURE 4.5

Figure 4.6: The results of clearing out that area of the room really paid off. This attractive photo of the groom has nothing in the background that distracts from the story. It's all him. Just imagine what the photograph would have looked like with that white lamp close to his head and the large brown couch blocking most of the space.

FIGURE 4.6

Figure 4.7: This photograph illustrates how I cleared a portion of the bride's room of distracting objects and replaced those objects with items that have emotional value to the bride. The Indian jewelry that she is pulling out of the jewelry box has cultural meaning to the bride and her family and will adorn her sari for the Indian ceremony. You can also see the sari itself hanging on the right side of the curtain rod. To the left, you see the traditional wedding dress giving you (the viewer) a visual cue that she will have two ceremonies, an Indian ceremony and a traditional Christian ceremony. In the foreground, there are hints of the rest of the wedding dress and the shoes she will be wearing. Most importantly, you do not see anything else, just treasured items and the bride herself. Any clutter would have completely ruined the elegant and symbolic mood of the photo. The next time you walk into a room, you should not just think about clearing out the clutter from your well-chosen area based upon the light, but you should also think about items you can place in the scene that may have symbolic meaning for the bride and/or the groom.

FIGURE 4.7

Figure 4.8: The wedding coordinator asked me to allow the bride to get ready in this particular room. She informed me that the wedding dress was already hanging there for me to photograph. When I arrived at that room, this is what I saw. First, the light in the room was flat and not intense enough, and second, the room left much to be desired from an aesthetic point of view. My immediate reaction was to move to a different place. That particular building had several rooms adjacent to the main room where the dress was hanging. I took a few minutes to walk around and explore the other rooms in the house, and I found a small room with a bed. Although small, the room had more light coming in from two large windows. I politely asked the bride and the coordinator if we could move to the room I had just found. The other bedroom was in the same house, so it was quite convenient to just walk to the other room.

FIGURE 4.8

Figure 4.9: This is the room I asked the bride to move to. How much cleaner does this look? There is no doubt that it was well worth the short time it took to walk to another room in the house. I respect the philosophy of not intervening too much with the scene, but I also know that the bride or groom will be very thankful that their wedding photographer took the initiative to find a room that yielded much cleaner and more elegant results.

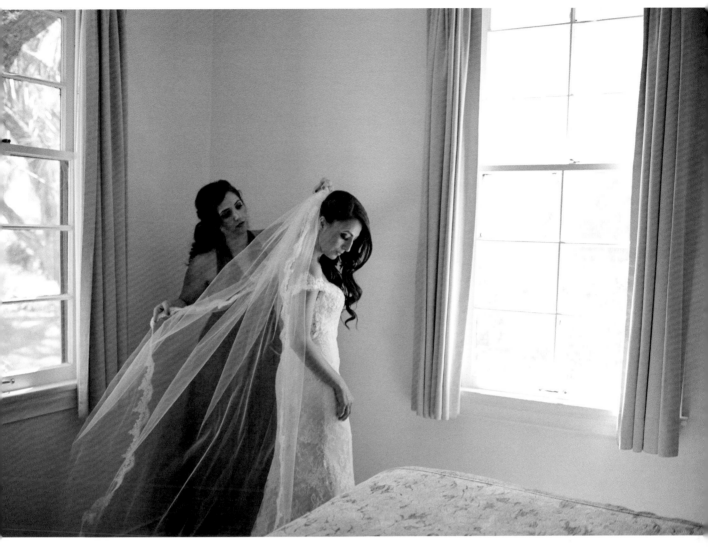

FIGURE 4.9

Figure 4.10: In the previous situation, the room did not look great, and there was very little light coming in. In this example, the light was much better, but it was far too crowded. The make-up artists had occupied the room and the wedding party was comfortably seated on the couch. It would take a long time to clear out a room such as this, and it's not worth it. After assessing the situation, I decided it would be better to move the bride to a different room completely free of clutter and people. The move was made to photograph the important moments of getting ready for the wedding, such as putting on the dress, veil, and shoes.

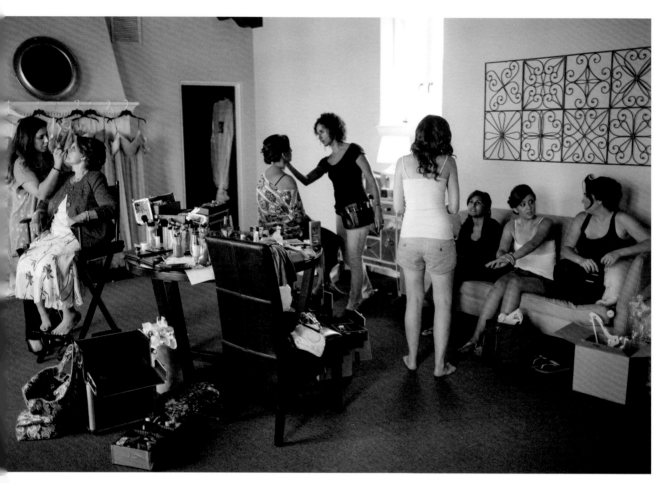

FIGURE 4.10

Figure 4.11: The building where the bride's family was preparing for the wedding was quite large and had multiple rooms. It was not difficult for me to search for a room containing the most amount of light. In less than a minute, I located this perfectly clean, beautifully lit room. I asked the bride if she would mind putting on her dress and accessories in this room, and I explained to her why it would be worthwhile to move. I wanted to keep the photos as clean and elegant as possible. Without hesitation, the bride agreed to move rooms. This touching photo captures the mother of the bride helping her daughter to put on her dress. Nothing in that room distracts from that special moment between mother and daughter.

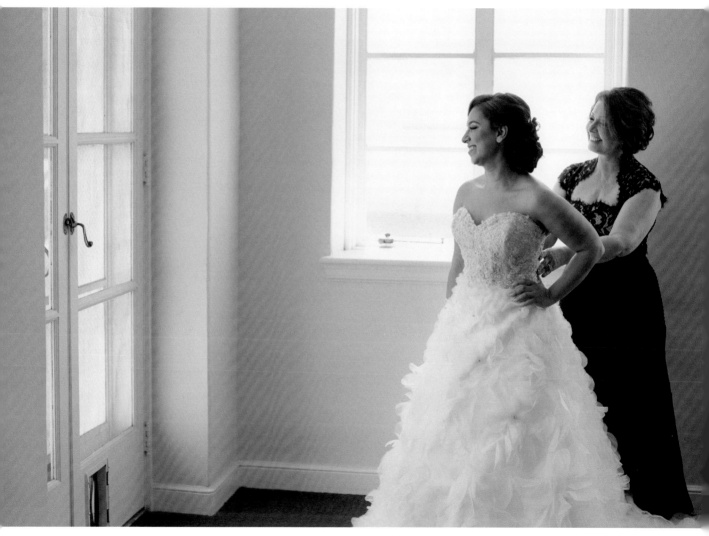

FIGURE 4.11

Figure 4.12: During a recent wedding, I was given a tour by the venue manager. As we walked together, she showed me this particular room and mentioned that this is where the brides get ready. The room was narrow, completely filled with wall decor, and worst of all, it had practically no natural light coming in. I immediately began to look for another room, as I did for Figure 4.11. In this case, there were no other rooms available. I began photographing the bride with her family and bridesmaids in this room, and this is one of the photo results. As you can see, there is clutter everywhere and the room was far too distracting for my taste. Luckily for me, this was a one-story building, and as soon as we walked out of that room, we were outdoors.

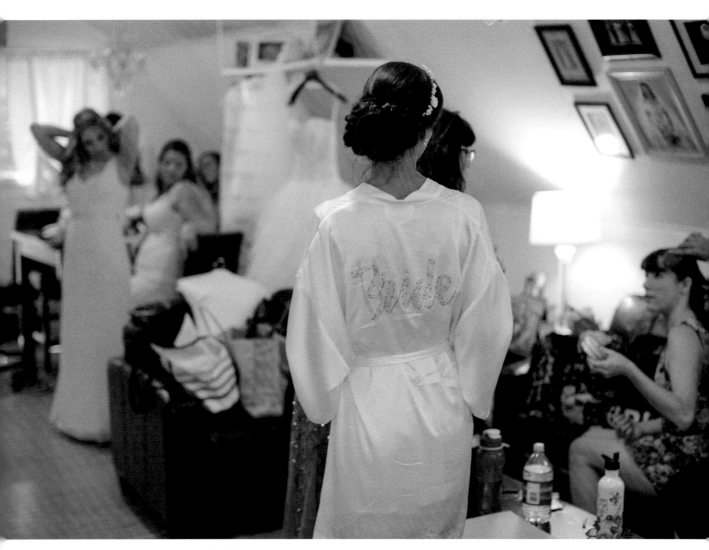

FIGURE 4.12

Figure 4.13: If you look to the right, you can see the door to the room in Figure 4.12. By taking a few steps outside, I was able to get rid of all that clutter and take advantage of the natural light. It's worth noting that this portion of the walkway just outside the room was in open shade. Most open shade situations leave darkness in people's eyes, so for this photo I used a flash bounced against an umbrella to fill the eyes with much needed light. (Using flash to boost natural light is a topic for another chapter.) I absolutely love the way it appears as if the bride was getting ready by the garden. This photograph would have looked much different had we remained in that dark, crowded, cramped room. But I was lucky. If that room had been on an upper floor of a high-rise building, we would not have been able to go outside.

In wedding photography, time is of the essence. These decisions are all based on balancing the beauty of the photographs for your clients with the convenience of going somewhere else or the time needed to clear the room. Common sense and good judgment help you make these decisions from wedding to wedding.

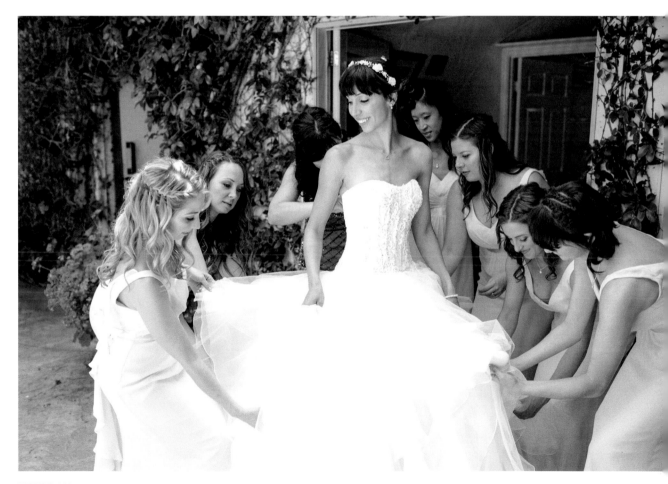

FIGURE 4.13

WHEN, HOW, AND HOW MUCH CONTEXT TO SHOW IN A SCENE

How much of a scene you should show or not show are decisions that will always change and evolve as your artistic maturity and experience increases. At first, most photographers are not very selective about how much to show. They don't feel confident about cropping parts of a scene out of the frame. Instead, they show everything and everyone from head to toe.

To me, context is about three things: clarity, storytelling, and composition. If the scene adds to the story and the clarity of the message I'm trying to tell, then I add as much context as necessary. However, if the scene is simply a scene that doesn't add to the visual story, then it becomes a distraction. The third element to consider when deciding about context is composition. Here is a clear list of the three most important elements.

> **Decision Points to Consider Regarding How Much or How Little Context to Show in a Scene**
>
> - **Clarity:** Does the scene or context shown in camera add or remove clarity from the main subject?
>
> - **Storytelling:** Does the scene or context add to the visual story or setting in the photograph, or does it distract the viewer from the story?
>
> - **Composition:** Can the elements in the scene be used for compositional techniques, such as (but not limited to) creating balance or contrast in the scene?

Creating photographs in very strange places can look bizarre to an untrained eye, but to a skilled photographer the scene will look very different in the final photograph. I am often questioned by the wedding party as to why I am taking the photos where I decided to take them. You can't blame the wedding party for being skeptical. To them, a photo in an alley surrounded by trash bins doesn't exactly fit the stereotype of beauty. However, a skilled photographer does not see the alley for what it is, but sees it for its quality of circumstantial light, colors, textures, contrasts, and depth. The human eye sees everything within view, but a photographer can use equipment to crop out unwanted parts of the scene and only show the very best of that environment.

Figure 4.14: How does this scene look to you? Imagine that you are part of the wedding party and witness this photo being taken in front of an ordinary elevator in a corporate hotel. It doesn't exactly look appealing, right? Now, try to imagine the scene without the pink walls, the elevator call buttons, and the emergency exit map posted on the wall; just visualize the metal portion of the elevator doors. How would the photo look? This is an exercise I practice all the time. I visually crop things in my head and imagine photographs taken with what's left over. Doing this will highly elevate your ability to visualize how scenes would look cropped in camera.

FIGURE 4.14

Figure 4.15: This is the result of cropping out the unwanted elevator features. By answering the context questions I have repeated below, you can see why I was drawn to this scene and why I made the decision to crop out what I did.

Does the scene or context shown in camera add or remove clarity from the main subject? By cropping out the walls, elevator call buttons, the map on the wall, and the elevator door frame, I isolated a clean, polished surface that focuses attention and clarity on the bride.

Does the scene or context add to the visual story or setting in the photograph, or does it distract the viewer from the story? The story is about the stunning beauty of the bride. Everything that shows in this photograph directs the viewer's attention to her. There is not a single element shown in the photo that would take away or distract from the story.

Can the elements in the scene be used for compositional techniques such as (but not limited to) creating balance or contrast to the scene? The color of the elevator doors and the bride's skin tone create a monochromatic feel to the photograph, which contrasts with her hair, eyes, and dress. In this case, there are no other elements in the background, and it would not be applicable to place new elements in the scene for balance.

FIGURE 4.15

Removing Context with Light

One very important technique every wedding photographer should have readily available is the ability to use high intensity light to darken distracting objects in a scene. Simply stated, when the light illuminating your subject is much brighter than the light falling on the rest of the scene, the photographer will most likely expose for the brightest point on the subject. Therefore, the exposure on the brightly lit subject will be correct, which leaves everything else that's not lit by the same high intensity light falling into darkness. I use this technique quite often at weddings.

Figure 4.16: This room is full of distracting objects, including supporting columns, tables, and window frames. However, this location is lit by direct sunlight coming in through the windows. You can stand in front of the window, look out, and see the sun.

FIGURE 4.16

Figure 4.17: I posed the groom in the direct sunlight coming through the window and exposed for the brightest part of his face. Everything else in that room that was not lit by the same intensity of light would fall to almost complete darkness. Therefore, all the distracting objects were no longer an issue. They were far too underexposed to compete with the groom. In this case, I also took advantage of the mirror to the groom's left to add his reflection to the image and create a more balanced composition.

FIGURE 4.17

Compressing the Scene to Remove Context

Another helpful technique to reduce context in a busy scene is to compress the scene with longer lenses. The key is to use a lens that allows you to photograph at 200mm or close to it. Lenses with high compression capabilities, such as telephoto lenses, can greatly reduce the appearance of distance in a scene. This proves to be incredibly handy when trying to reduce the amount of distracting elements in a scene. For example, a series of trees in the background can appear as wallpaper, creating a perfect backdrop for a portrait.

Figure 4.18: This photo was taken at New York's famous High Line Park. The couple requested unique photos here, since they live in the city, and they wanted my artistic interpretation of High Line Park. Unfortunately, about 30,000 other people also had the same idea to enjoy the park on that beautiful, sunny Saturday afternoon. As I walked around frantically trying to find a peaceful area among the chaos and confined spaces, I spied this billboard of a woman located far away across the street. Her eyes intrigued me enough to give me the idea to use compression to make the billboard appear as if it were directly behind the groom.

FIGURE 4.18

Figure 4.19: This is a behind-the-scenes photo of me shooting this scene using a Canon 200mm f/2 lens to obtain as much compression as possible. I wanted to remove all context except for the woman's eyes. You can see how far I had to backtrack from the billboard in order to get just the right amount of the scene within my frame.

FIGURE 4.19

FIGURE 4.20

Figure 4.20: This is the result of using compression to remove context in a scene. If you refer back to Figure 4.18, you can see how far away that billboard is from the groom. However, all context has been removed and the billboard now appears to be right behind him. It is times like these when I really truly enjoy the challenges of wedding photography. This was a completely unexpected result right out of camera.

Figure 4.21: This photograph shows a typical street in the city of Bel-Air, California. There are rows of trees on both sides of the road. Photographically, it doesn't matter how far the distance is from the camera to the long row of trees because a 200mm lens will completely compress that distance. The only consideration that matters is to make sure that the trees are lit at the same light levels, because once the trees are compressed, an evenly lit background is still necessary to avoid any single hotspot distractions.

Figure 4.22: By using a 70–200mm lens at 200mm, I was able to compress the row of trees into a completely different scene. I had to lie on the ground and shoot upward to avoid showing the street or the sidewalk in the photo. I wanted the viewer to feel lost while viewing this photograph and to keep wondering where the couple could possibly be? By removing all unwanted context, I achieved this goal.

FIGURE 4.21

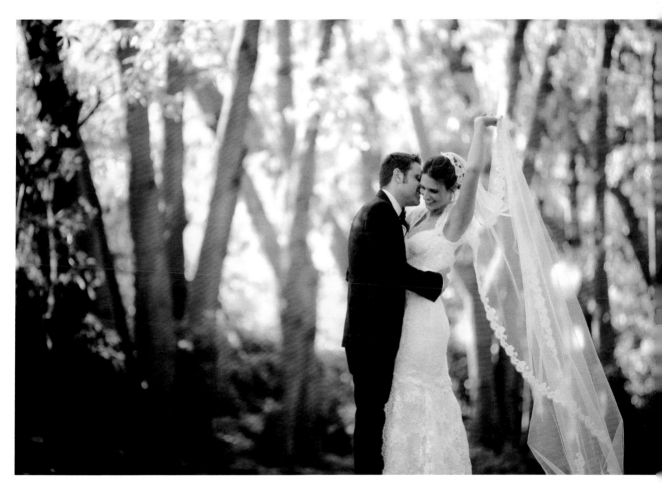

FIGURE 4.22

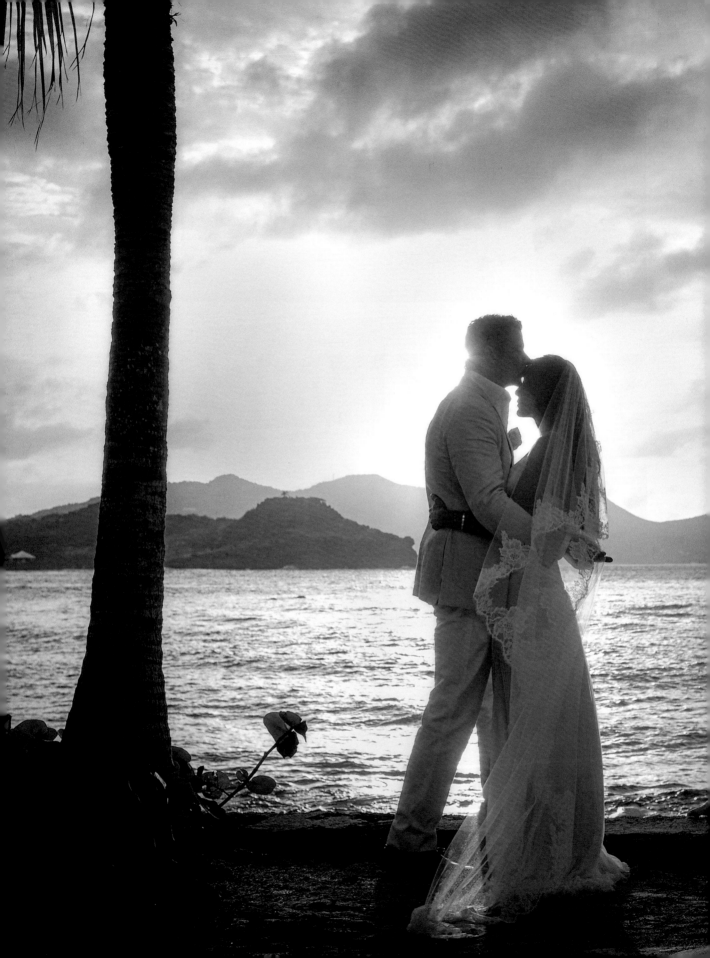

chapter 5
DEPTH AND WALLS

As my experience in wedding photography has grown, I have learned to regard buildings and the space around me as photographic tools. When I arrive at a place where I will be taking photos, I immediately take a short walk to become familiar with all of my surroundings. I also take notice of the location of the sun, because this directional light will highly impact my decisions regarding where I will shoot. Indoors, an action as simple as walking into a room becomes a quick but very detailed inspection of the walls and the space within that room. Most people cannot imagine how many ways walls can be used to achieve spectacular photo results.

Depth is another critical component of wedding photography. Without depth, photos run the risk of looking flat, lifeless, and unimaginative. Depth can also be used to capture stories happening in the background as well as in the foreground. For example, a bride could be in the foreground talking with guests, while her parents are captured in the background looking tenderly at her. The photographic opportunities using depth and walls are endless. But if you wish to become a master wedding photographer, you must be fully aware of the many benefits and challenges these two artistic techniques can provide and how to balance each of them to tell a visual story.

THE PROS AND CONS OF USING DEPTH

During a wedding, if you decide that you do not want to place your couple directly in front of a wall, but instead you wish to add depth to your photograph, then you should know the following characteristics that will help you choose opportunities and recognize the challenges that depth provides. Then you can make a much more informed decision, especially if you are pressed for time.

> The principal beneficial characteristics depth provides to a photo are the following:
> - The context of space and surroundings
> - A feeling of openness
> - A sense of romance
> - Foreground/background storytelling

Now that you know the benefits of having depth behind your subjects, you must keep in mind that these benefits mean nothing if you don't include the two location skill components we discussed in Chapters 3 and 4: circumstantial light, and showing and removing context and clutter. Think about it. What is the point of having depth in your photo if the lighting on your subjects is terrible or if you are showing too many distracting objects in the photo? It is a top priority to keep in mind that you must use all the skill components to create a spectacular photo. These are your building blocks.

FIGURE 5.1

Figure 5.1: This photograph has depth, so why does it look so terrible? Quite simply, this photo clearly illustrates the consequences of not implementing the previously discussed skill components for this photograph. To begin, the circumstantial light is not complementary to the couple at all. The bride is illuminated by direct sunlight and the groom's face is partially in shade. The strips of light illuminating the road are distracting because they are inconsistent, and they do not create a light/shadow pattern. The road is black, therefore not much sunlight is being reflected upward toward the couple's faces. When considering lighting, this photo is a complete mess.

Camera Tilt Tip

When photographing with context, as in **Figure 5.1**, you should really be cautious about camera tilt. Any tilt with context can be extremely distracting. When photographing in front of a wall with no context, you can get away with some camera tilt, but not much.

Now let's discuss the context and clutter. First, there is far too much negative context in the area. The cars, trees, buildings, and telephone wires are all just clutter, and they provide nothing but distractions in this photograph.

Simply adding depth to your photos does not automatically yield the benefits of depth. You must consider circumstantial light, context, and clutter to even begin to take a successful photo with depth.

Figure 5.2: While casing my surroundings during a wedding, I searched for an open area that had relatively the same color palette, as well as similar luminosity levels. This means that everything at the scene would be lit by similar lighting intensity. The tree above the groom's head is the brightest part of the image, but it is still within the range of the rest of the scene. For these reasons, I chose that location as the place to pose my couple and incorporate depth as my artistic decision. It is clear to see that the first three major benefits of depth listed above are present in this photograph.

As a side note, the roses on the left side of the frame made the composition left-heavy. Therefore, I compensated by placing the couple on the right side of the frame. As a result, the photograph feels well balanced.

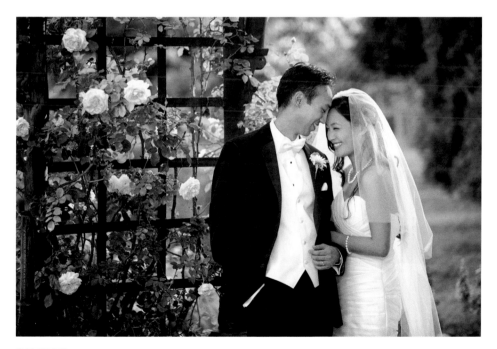

FIGURE 5.2

I began this book by saying that you do not have to take perfect photos at weddings. Do your best to minimize issues, but don't worry about it if one or two issues exist. For example, in this photo you can see a small hotspot on the groom's forehead. I could have asked my assistant to move the diffuser above their heads a bit more to cover his whole head, but it would have been at the cost of this beautiful expression. I will always prioritize the couple's expressions or a beautiful moment over a slight technical issue. I recommend that you do so, as well.

Figure 5.3: When I think of using depth for an artistic decision on location, this photo always comes to mind. I took this photo of my wonderful friends Angie and Darin a few years ago during their wedding in beautiful Savannah, Georgia. To me, this photo exemplifies the romance and impact that depth can have on your wedding photos. Keep in mind that everything in this gorgeous scene at the Wormsloe Historic Site adds to the overall impact of the photo. Having plenty of context contributes to the breathtaking scenery.

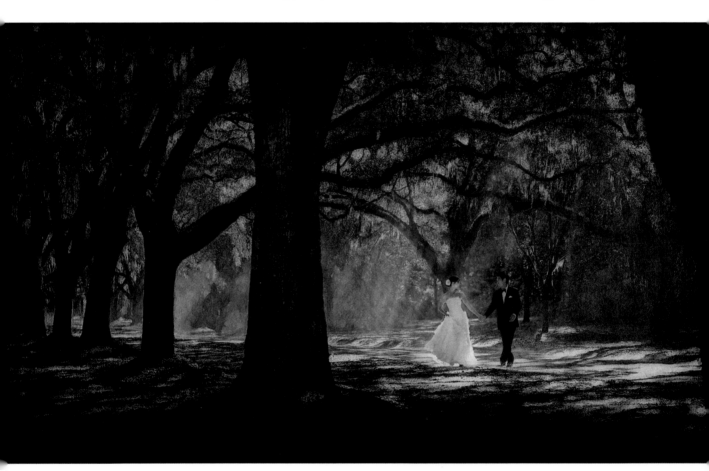

FIGURE 5.3

Figure 5.4: During a wedding in Kauai, Hawaii, we drove up to the north side of the island and encountered this stunning pier with the most incredible mountains in the background. I actually remember asking more than 30 people if they would move away from the pier for just a few minutes so I could take this photo without anyone else in the scene. To my surprise, they all gladly moved and became animated spectators throughout the whole process.

I thought about context and lighting before deciding upon how to take this photo. The scene was too beautiful to use walls. It was a no-brainer to use depth, but I wanted the entire pier in the image. I had to walk quite a distance away from the pier to be able to use a telephoto lens to compress the scene. The greatest challenge at the site was that the circumstantial light was not good enough to separate the couple from the rest of the scene. To solve this problem, I placed a flash on the pier pointing up at them and triggered it from my camera. Now the couple is a little brighter than the rest of the scene.

FIGURE 5.4

It's so important to take the extra effort to correct the lighting in your photographs. Without it here, the choice of using depth would have been wasted. This scene has impact because it has many elements coming together, and it was properly executed.

Figure 5.5: Here we see foreground and background storytelling. This is one of many examples I have taken using depth to create two separate stories within the frame. In this photo, the bride is in the foreground interacting with something to her left (camera right). The bridesmaids are in the background reacting to the bride's reaction. The bride is in focus while the bridesmaids are far back enough to be gently out of focus.

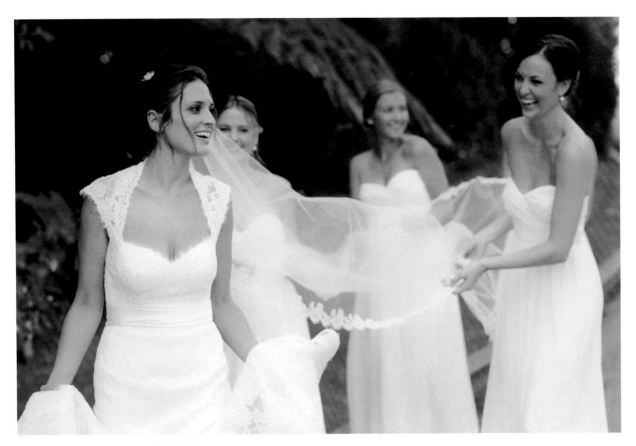

FIGURE 5.5

Figure 5.6: In this example, too, I used depth to create two separate stories. Not every story has to be from a person's point of view. In this situation, the bride and groom are out of focus in the background, and the grass is in focus in the foreground. It is as if this view of the bride and groom comes from the perspective or point of view of something in the grass.

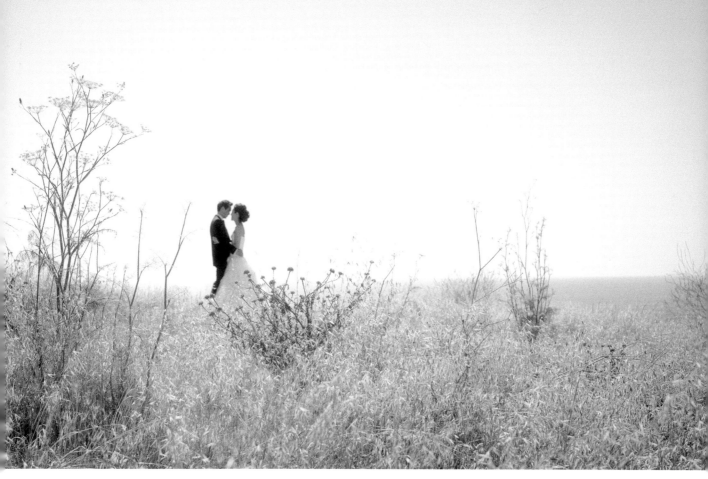

FIGURE 5.6

As I said, the photographic opportunities that depth provides are endless. It all depends upon your creativity and how much you want to push yourself to utilize depth in different ways. For example, you could put two wine glasses in the foreground very close to the camera's lens and out of focus, and frame the couple in the background. The list goes on and on.

THE PROS AND CONS OF USING WALLS

Walls are a rather simple subject, but it is important to know their impact on your images whether you choose to take portraits in front of walls or with depth (space) behind your clients. Believe it or not, there are a great number of techniques you can employ for both choices. Naturally, during portions of the wedding, a photographer should take photos with a photojournalistic approach and should quickly react to moments happening around him or her, regardless of the location.

In either case, walls are everywhere. To an unobservant person, a wall is just that: a wall. To a skilled wedding photographer, walls are much more than structural elements. Walls are photographic tools that should be used in the best possible way. In order to do so, you should be aware of the photographic benefits both walls and depth can bring to your photography.

One unique aspect to wedding photography is that you don't always know where you will be working. A wedding is on-location photography. This means that all the elements in your surroundings become your light modifiers and studio backdrops.

The principal characteristics walls provide to a photo are the following:

- Simplicity
- Light modifiers
- Monochromatic color palette
- Contrast through colors or size
- Graphic elements through either decor or shadows

Simplicity

Figure 5.7: This is a photo taken during my early years as a wedding photographer. Like most beginners, I did not pay attention to how distracting the context was in this photo. There was no need for this background at all, because it added nothing to the photo. In hindsight, I could have used the cream-colored wall by the doors on the right side of the frame. Then, the wall would have kept the scene simple and free from distractions. However, additional light would have been needed, since that wall was in open shade.

Figure 5.8: Here we have a similar situation as in Figure 5.7. This photograph was taken at the Parker Hotel in Palm Springs. The back courtyard of the hotel is full of distracting elements. I deliberately kept the photo simple because I wanted

FIGURE 5.7

the viewer's attention to be on the intricate flower arrangement. Notice that the focal point is on the flowers, and the bride is slightly out of focus. Also, since there is a wall of bushes in the background, there is nothing distracting you from the desired message. This is key. When I want to communicate a simple message, I usually choose to use a wall, which removes all context and provides me with a simple, clean background. Compare this photo with Figure 5.7.

FIGURE 5.8

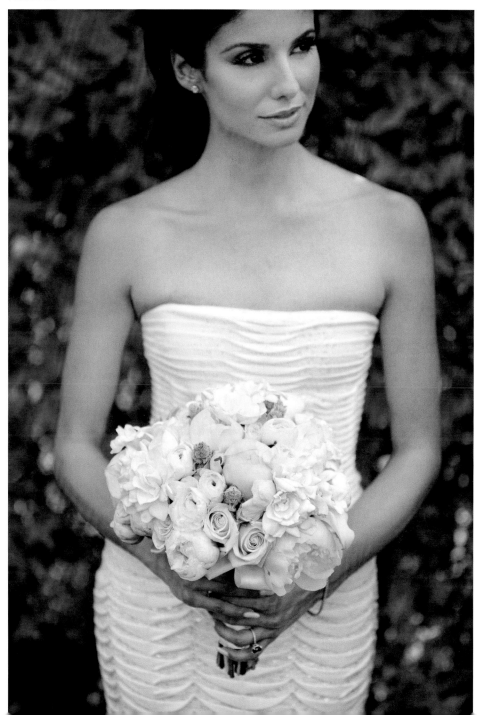

Figure 5.9: You don't always need to remove all context if you wish to use a wall to keep a photo simple. This wedding took place in Oaxaca, Mexico. I wanted to maintain the Mexican flavor of the locale, so I kept some of the context while still harnessing the simplicity of the wall for this portrait of the groom.

FIGURE 5.9

Walls as Light Modifiers

Figure 5.10: I realize that this is not a wedding photo. But this is a perfect behind-the-scenes example of how I use walls to create soft light during weddings. I usually carry multiple flashes and a portable Profoto strobe with me. The light where the model was sitting was adequate but not great. The lighting was quickly remedied by using a strobe and aiming it toward the wall, rather than at the subject. The wall is much larger than the light modifier, so it will create much softer light. This is a great technique for beauty lighting, and brides love the way they look with high intensity soft light such as this. Now you can see how walls don't have to be used just as backdrops; they can also be used as great light modifiers.

Figure 5.11: This is the result of using a wall in front of the bride as a light modifier. I used a flash and bounced it against the wall in front of the bride. I used the other wall as a clean and simple backdrop. It is very important to remember that great lighting is crucial to create a great photo. A nice wall is useless if it's in terrible light. In this case, the lighting on the bride was fine, but it wasn't great. I enhanced it significantly by adding a flash and bouncing it against the opposing wall.

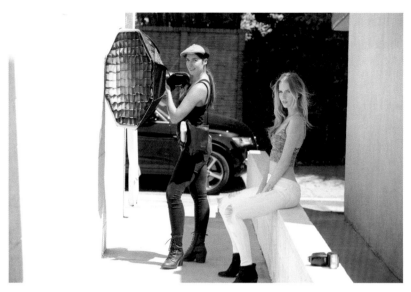

FIGURE 5.10

FIGURE 5.11

Monochromatic Color Palette

Figure 5.12: I absolutely love finding walls that have a gentle color palette. Brides look ravishing in front of such walls. It gives the photo a fine-art feel because it takes on a monochromatic color palette. Quite a bit of consideration was taken with respect to the lighting for this portrait.

FIGURE 5.12

Contrast Through Colors or Size

Figure 5.13: Walls can be of all sizes and colors. If you have a large wall and you place a couple in front of it, it can make an interesting contrast in size. In this photo, the wall was a beautiful sky blue color, and the bride was wearing a white dress. The contrasting colors really give the photograph a lovely feel.

FIGURE 5.13

Graphic Elements Through Either Decor or Shadows

Figure 5.14: There are many instances when walls can provide interesting graphics to enhance the visual interest of a photograph. For this reason, we must keep our eyes open for any graphics that are printed on walls. At this engagement photo shoot, I noticed this wall depicting a little girl holding a teddy bear. The painting reminded me of innocence. For this reason, I posed the couple against a cheerful, pure backdrop.

FIGURE 5.14

Figure 5.15: This location at the Ritz Carlton in Orange County had a few paintings decorating its walls. Next to me, my friend Collin is enhancing the light with a reflector; I refuse to be complacent about lighting the moment I take a photo. I wanted to make the background look like a wall instead of a painting on the wall, so I removed all context from the scene.

Figure 5.16: By removing all context from the scene in Figure 5.15, the viewer no longer has any idea where the photo shoot was held or how large that wall is. The roses symbolize romance, so I tried to make the photo romantic. Furthermore, the roses seem to be directing the viewer's eyes to the bottom of the frame toward the couple. For this reason, I chose this particular painting over the other two on the wall.

FIGURE 5.15

FIGURE 5.16

Figure 5.17: This wall was a perfectly clean background. When I come across a large, clean, and clear wall such as this one, I think about adding a graphic element to the wall by creating light and shadow designs. All a photographer needs is any kind of object with a cutout design. With a flash, the light passes through the cutout and replicates the pattern on the wall in the form of light and shadow.

FIGURE 5.17

Figure 5.18: Now, the simple wall with no visual interest becomes quite interesting. I purposely had my helper move the chair up or down until the light strip illuminated the bride's eyes perfectly.

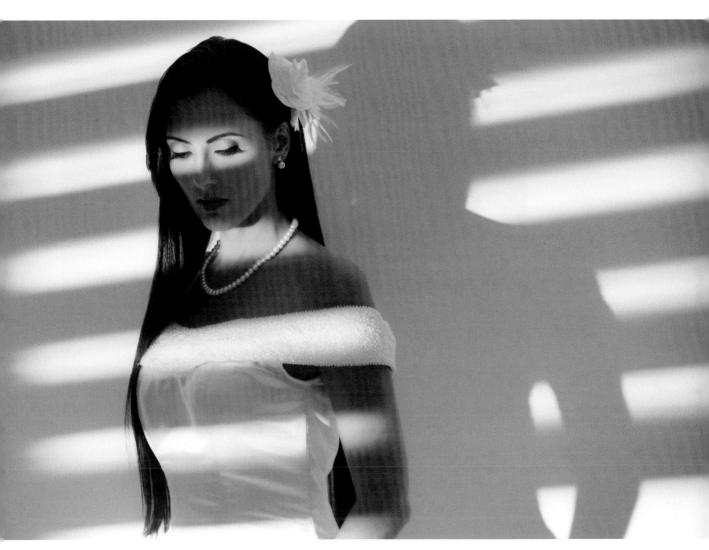

FIGURE 5.18

Figure 5.19: After wrapping up a wedding in New York City, I was about to return to my hotel when I noticed this wall outside of the reception area. As I said before, I am always on the alert for walls that could be clean canvases for graphic designs. In this case, I did not have a chair or anything else that I could use to add the graphic, so I asked the couple to pose in such a way that I could see their silhouettes on the wall when a strong light illuminated them. This time, I used a Profoto strobe to illuminate the couple and create their shadows on the wall.

Figure 5.20: It is this kind of photo that can give you an edge over other photographers, not because the photo is out of this world but because it shows creativity within your surroundings. Couples want to hire a photographer who is going to "make magic" at their wedding. Photos like this one give them confidence about your skill set, and they would be more than willing to pay for it.

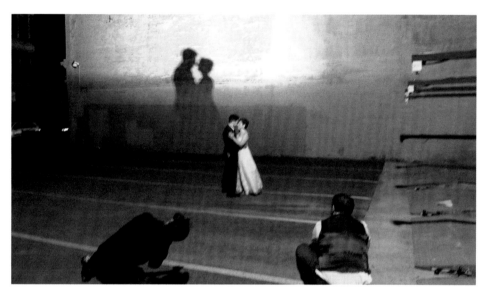

FIGURE 5.19

FIGURE 5.20

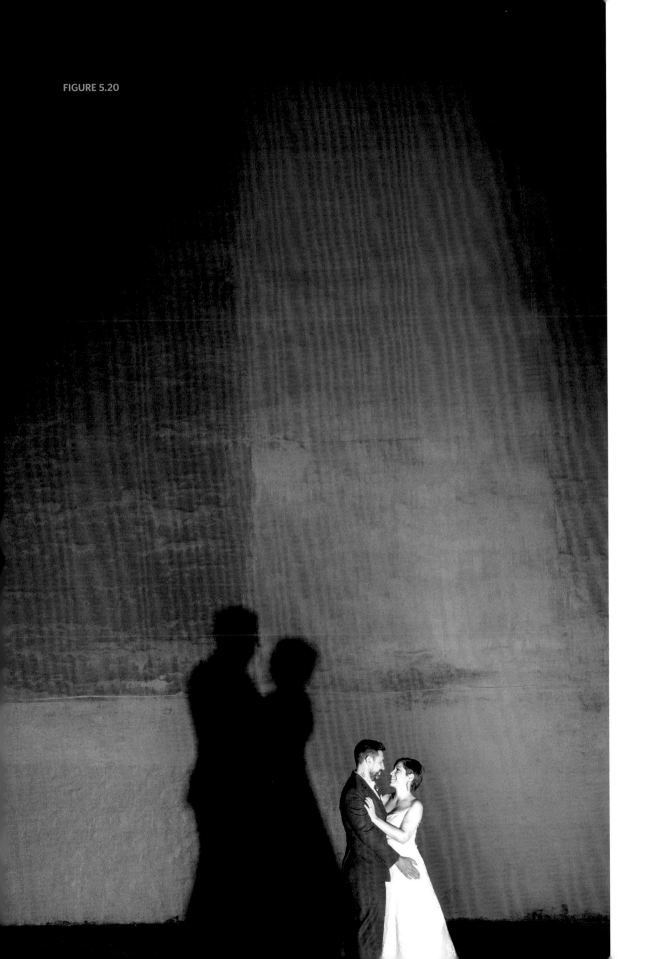

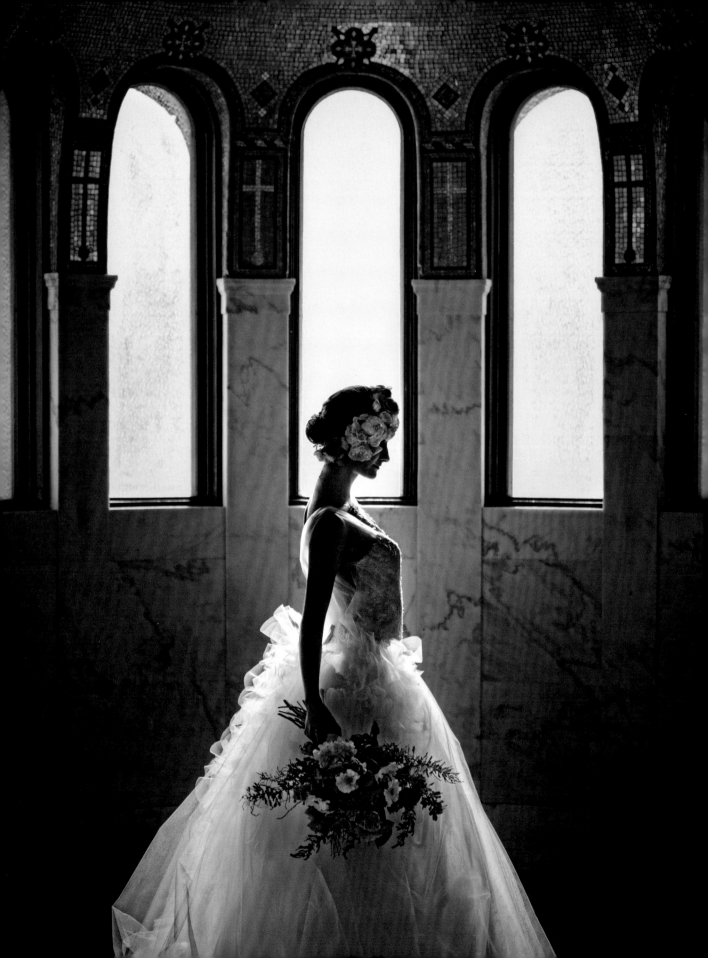

chapter 6
COMPOSITIONAL ELEMENTS

The primary goal of compositional elements is to guide the viewers' eyes toward the intended story in a photograph. The photographer has the option of conveying the story in a very straightforward manner, or he/she can tell the story subtly and imaginatively. For instance, when a photographer points the camera toward an urban scene, there will be cars, trees, sidewalks, people walking, buildings, windows, doors, and shops. These objects are the tools you use to create an out of the ordinary composition that draws the viewers' eyes to precisely where you want them. By carefully posing your subjects with various elements in the scene, you can accomplish this goal.

KEY COMPOSITIONAL ELEMENTS

Some of the most popular techniques for creating an interesting composition include: framing, pointing, reflections, repetition, and balance. As your skills grow and mature, you will eventually be able to create impressive compositions almost instinctively.

Framing with Objects

Figure 6.1: For example, in this photo, I am clearly trying to showcase the bride's dress. However, instead of just taking a photo of the dress by itself, I took an extra minute to look around and see how I could use the elements in the room to frame the dress. It did not take long before I noticed that the chairs had a square cut out of the backrest. I hung the dress in the middle of the room, and I placed the chair as a foreground element to frame the dress.

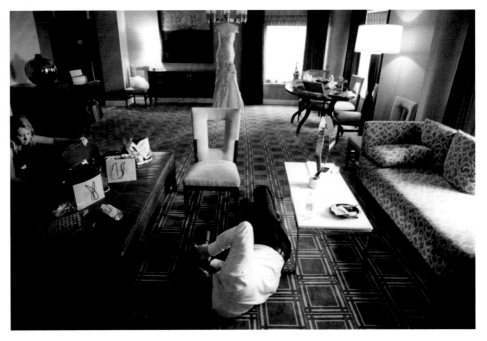

FIGURE 6.1

Figure 6.2: Because I used the chair's backrest as a compositional element, the viewer would look straight at the dress. Due to time constraints, I left the paper hanger on the dress. I looked for a better option for a while but decided not to invest any more time and just took the photo. The next time you are at a wedding, take a minute to look around and see if you can find an item in the scene that can be used to frame or to effectively compose a photo.

Figure 6.3: Just before the bride was about to be driven to the ceremony, I asked the driver if he would wait a few seconds for me to take a quick photo. I noticed that the vintage car's back window made a perfect frame, so why not use it? I asked the bride to sit in the right rear seat of the car and to look elsewhere. Now, the car's window perfectly framed the bride's smiling face, making this photo much more interesting. Had I not noticed this frame, I would have said nothing, the bride would have gotten into the car, and the driver would have sped away. There are so many ways this scenario could have played out, but remember that if you develop a keen eye for details in your surroundings, you will surely achieve much better photographs.

FIGURE 6.2

FIGURE 6.3

Framing Through Structures

Figure 6.4: It was drizzling at the time this photo was taken in Sarasota, Florida, and the bride and groom were understandably seeking shelter from the rain. Not only did this building provide shelter, it also had decorative arches that could be used as frames. I asked the couple to go inside that building on the right side, so I could frame them beneath the arches.

FIGURE 6.4

Figure 6.5: I chose the far right arch to frame the couple. To make the scene more dramatic, I used a flash with a color temperature orange (CTO) gel attached to it to mimic the orange light above them. Finally, I changed the exposure on the camera until the arches were no more than silhouettes. In a photo like this, it is very important to be aware of the hori-zon-tal line references. These horizontal lines at the bottom of the arches must be parallel to the bottom of the frame to keep the photo perfectly straight. Tilting the camera when there are strong horizontal or vertical references in the architecture would make it appear as if the whole building were falling down, which would be very distracting.

FIGURE 6.5

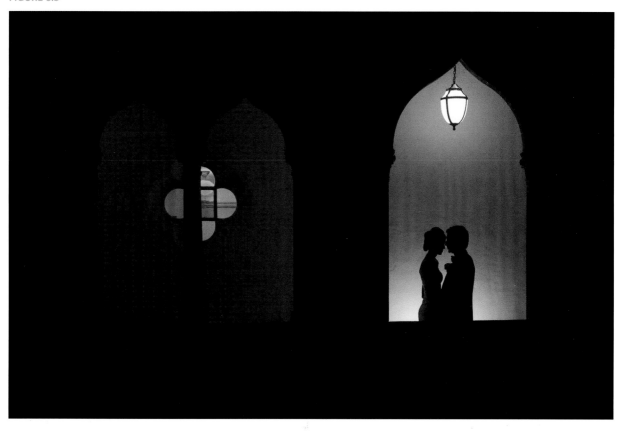

FIGURE 6.6

Figure 6.6: This is a bad photograph that shows what happens when the frame is chosen poorly and the horizontal or vertical lines are not parallel to the camera frame. When I took this photo, I thought I was being clever by framing the bride between the bar and the ceiling, but obviously that did not work. Also, the large, blurry ceiling light in the foreground is also extremely annoying.

Figure 6.7: Inside hotel rooms or private homes, a photographer can close the window curtains a little to change the width of the window's rectangular shape. In this case, I closed the sheers just enough to create a nice frame for the bride putting on her veil. To avoid the typical composition, I chose not to pose her perfectly in the center of the frame. Having the bride stand just a bit off-center can add a sense of realism to the photo.

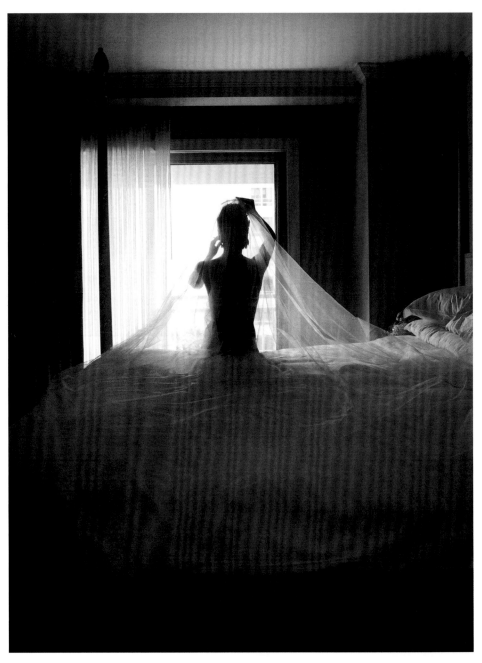

FIGURE 6.7

Figure 6.8: This is the same concept as Figure 6.7, but instead of using window sheers or curtains, I partially closed the door to the room to create a smaller rectangular frame. Sandwiching the story between the bedroom door and the wall created a sense of seeing the moment through voyeuristic eyes.

Double Frames

Figure 6.9: Early in my photography career, I tried to do something special with composition, but as you can see here, I clearly did not pay much attention to the fact that many elements must come together for a wedding photograph to look good. This photograph shows my failed attempt to achieve a double frame technique. The first frame is the open door under which the couple is standing. The second "frame" is a small hole through the thick foliage. The result is a total disaster. The viewer cannot see either the frames or the couple. Referencing back to Chapter 4, "Showing or Removing Context and Clutter," the principal steps in that chapter would have shown me that a great photo in this location was not feasible.

FIGURE 6.8

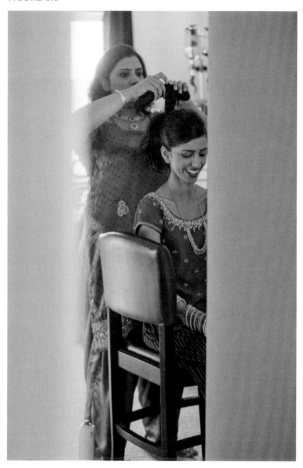

FIGURE 6.9

Figure 6.10: This photo also has two frames in the scene, but this composition was executed correctly. The first frame is the two doors behind and in front of the bride and her mother. The second frame is the arch in the background. Double frames are more difficult to find, but they are always there.

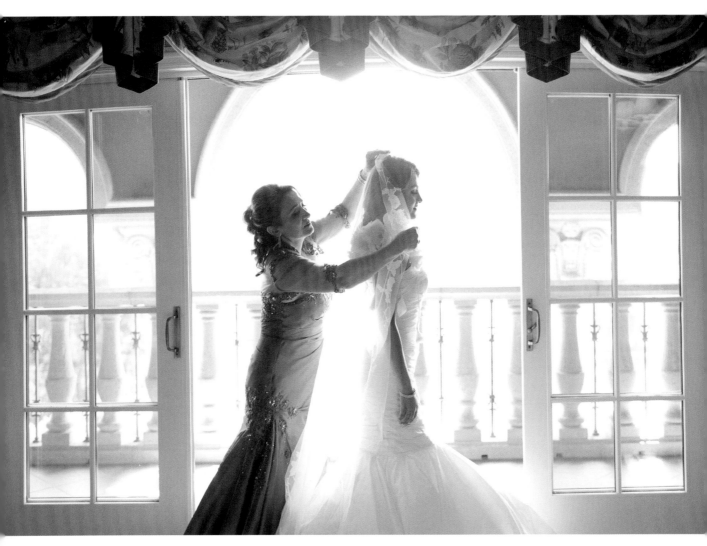

FIGURE 6.10

Figure 6.11: In this example, I used two door frames to two different rooms to frame two separate stories happening simultaneously. This is one of my favorite composition techniques for weddings. There are always so many stories happening at the same time that having structural shapes to frame these moments in one single exposure is a great way to take wedding photography to a high, artistic level.

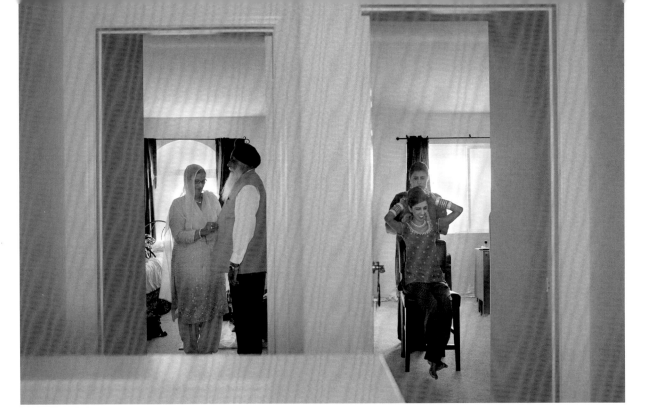

FIGURE 6.11

Pointing

There will be times when objects or graphics can be used to point the viewer to the intended story. For example, traffic arrows painted on the ground could be pointing toward a couple; if a photo was shot from a bird's eye view, it would look very interesting. There are countless ways to use subliminal pointing techniques to force the viewer to look in a certain direction.

Figure 6.12: For this example, I did not see a painted arrow, but I did notice a framed sketch of a woman mounted on the wall. The woman is looking toward the left side of the camera frame. This gave me the idea to place the wedding dress alongside the sketch. In the resulting photo, it appears as if the woman in the sketch is looking at the dress, which also causes the viewer to look at the dress. Imagine this photo without the sketch. It would be boring.

FIGURE 6.12

Reflections

Figure 6.13: This photograph of the bride adjusting her earrings combines two main compositional techniques: reflections and framing. Not only are you seeing a reflection of the bride, but the design of the mirror is also framing her. This is a more advanced technique, when a photographer begins to recognize a combination of compositional techniques and applies them in a single exposure.

FIGURE 6.13

Figure 6.14: In this example, there was a mirror mounted on the wall. I placed my camera parallel to the mirror as close as possible to show the bride's reflection and to achieve compositional balance on both sides of the frame.

FIGURE 6.14

Repetition

Using repetitive elements or shapes can be very effective for creating interesting compositions. But the technique must have a definite purpose. As you will see in the next example, just showing repeating objects is not enough to produce a successful photo.

Figure 6.15: There are many factors that contributed to the failure of this photograph. The repeating row of chairs was a good start to create composition through repetition, but it did not work. There is simply too much context and clutter in this photo. The groom is far away from the camera, which makes him appear small and unimportant. The palm tree on the top left of the frame is a vertical line reference, and it is tilted. For all of these reasons, the photo failed.

Figure 6.16: Inside the lobby of this hotel in San Diego, I noticed the rectangular wall with a repetitive design element. There were so many vertical and horizontal

FIGURE 6.15

lines that it was crucial that I keep these lines parallel to the edges of the camera frame. I used a flash to illuminate the wall and give this photo a dynamic feel. Without the flash, this location wouldn't have worked because it was too dark. If you see a special location or feature, such as this wall, remember that you can create the light if natural light is not working well enough on its own.

Figure 6.17: It was late afternoon, and the sun's low position created this repetitive row of arches of light and shadow on the wall. Because I learned my lesson from Figure 6.15, I decided to place the groom in the foreground to make him appear more important from a compositional standpoint. The repeating arches direct your eyes to the groom, and they also create visual interest throughout the entire frame.

I must admit, it's not easy to keep track of all of these different compositional techniques when photographing a wedding under pressure and time constraints. For this reason, we must practice our craft. The best way to work on your composition is to do some street photography. Take your camera and go for a long walk. Pay close attention to colors, light, shapes, frames, multiple frames, repeating patterns, and reflections. I find that practicing street photography is one of the most effective ways of fine-tuning your composition skills. These skills must be instinctive by the time you arrive at a wedding. Otherwise, you will miss many opportunities because you did not see them. If you do not train your brain to notice these things quickly, it will not.

FIGURE 6.16

FIGURE 6.17

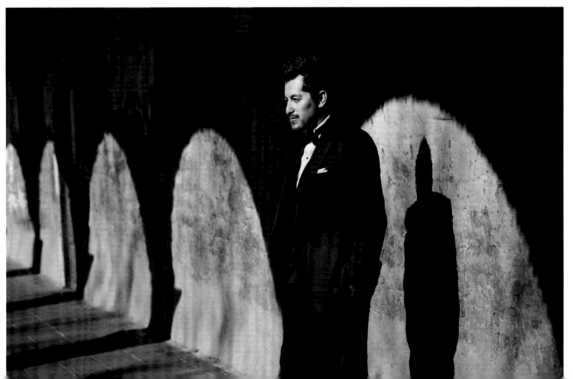

chapter 7
LUMINOSITY LEVELS AND CONTRASTS

Getting inside the head of any great wedding photographer is very much like understanding the thinking process of a gourmet chef. They both combine what is available to them with a deep knowledge of their craft, producing exquisite results that evoke enduring, sensual memories. Sometimes the product is simply made. Other times, it is more complex. More complexity is not necessarily better, but more knowledge definitely is.

The photojournalist (photo-taker) captures beautiful and emotional moments among people who are important to the bride or groom. In those moments, your primary job is to photograph quickly, regardless of the light or pose. If a crucial moment happens to occur in great light, then you are lucky. I believe that it is very important that all wedding photographers prioritize a touching moment over any technical, lighting, or posing technique. As I said at the beginning of this book, wedding photos do not need to be perfect.

However, when you are asked to take portraits of the family, wedding party, or the couple, it is advantageous for you to be knowledgeable about the impact that luminosity levels, contrasts, and colors have on your photography. For this kind of work, you are primarily a photo-maker. The focus of this chapter is for you to become comfortable and familiar with these concepts. All the chapters that cover the Wedding Storyteller Skill Components are building blocks that will help you produce higher-caliber wedding photos through knowledge, practice, and experience. That said, it is also possible that misunderstanding this chapter could have undesirable consequences.

The human eye is instinctively drawn to the brightest area in a scene. Think of the brightest point as a bullseye that forces your eyes to stare right at it. If you position that bright spot in a scene in the wrong place, the photo will suffer greatly. However, if you strategically place the brightest point in a scene, you may have enriched the photo in a way that will really set you apart from other photographers. In my experience, I seldom find photographers who naturally use the brightest point in a photo to guide the viewers' eyes to precisely the right location in the frame. Why? In digital photography, many, if not most, photographers create the brightest point in the photograph in post-production, instead of while shooting. The most common post-production techniques to bring visual emphasis after the fact are dodging, burning, and of course, the vignette. These are all fine techniques, and they do the job. However, through careful analysis of the location, composition, and lighting, you can more naturally and skillfully place the brightest point in the scene, the intended story, or the location. There are four main characteristics of luminosity levels to keep in mind when doing this.

DISTRACTING LUMINOSITY LEVELS

It's very important to be watchful of not only your subject(s) but also of everything else happening within the frame. When shooting with depth, it is especially imperative to watch for random spikes of luminosity levels around the frame. I say "especially imperative" because it is more difficult to notice hotspots in the background when you're shooting with depth rather than, for example, shooting your subject in front of a wall, where your eyes will have an easier time identifying distracting hotspots on that wall. Let's take a look at some examples of how these random hotspots in the scene can have damaging consequences in our photography.

Figure 7.1: In this photo, taken at the beginning of my career, I failed to notice the hotspot on the left side of the frame. This random, blown-out area by their heads makes it very difficult to notice the bride and groom without your eyes wandering toward the bright area behind them.

Figure 7.2: This is similar to the previous example. This time, though, the distracting highlight is on the grass on the left side of the frame, created by the sun directly illuminating that patch of ground. Highlights on the ground are incredibly common, and we have to be extremely diligent about making sure that we take a second to look for them and recompose accordingly.

Figure 7.3: Highlights on the ground can still occur on an overcast day. The light-colored sidewalk behind the bride's torso is much brighter than the bride. It's difficult to enjoy the photo when your eyes keep noticing that unpleasant, distracting, rectangular bar crossing the entire frame. I could have changed my shooting angle until that line was no longer visible in my frame. But due to my lack of experience, I did nothing about it.

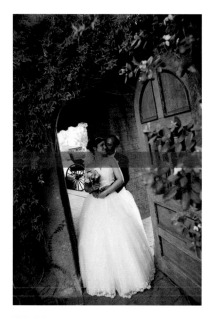

FIGURE 7.1

FIGURE 7.2

FIGURE 7.3

FIGURE 7.4

Figure 7.4: At the time I shot this, it appeared to be a novel idea to frame the couple with tree branches to create depth in the background. That idea did not exactly pan out, did it? It is important to notice anything light colored in the background, because if the sun illuminates it, the object will become an automatic hotspot. There are multiple problem areas in this photograph. First, the sun is partially illuminating the bride's right arm but not the rest of her body. That mishap puts visual emphasis on just her arm. Secondly, there is the bright spot on the ground to the right of the frame near the heads of the bride and groom. Next, the white gazebo is directly illuminated by the sun. Lastly, the white lamp near the groom's head is also a luminosity level spike.

Figure 7.5: While covering the groom at a wedding in Hawaii, I was happily photographing him touching up the last details of his tuxedo. When reviewing the shots later, I noticed that the lamp to the right of the frame had been on the entire time I was photographing the groom getting ready. Worse yet, a person can't even tell that it is a lamp. It just appears to be a random hotspot near the edge of the frame. Unfortunately, most of the photos of the groom in this scene had this distracting highlight. Since I did not notice it, I just kept on shooting. It is my hope that this chapter makes you more aware of these devious luminosity level spikes that only distract from the main subject and seem to sneak up on the photographer.

FIGURE 7.5

HIGH-CONTRAST LUMINOSITY LEVELS

"High-contrast luminosity levels" simply means that the main subject should be more than a stop of light brighter than the background. Placing someone near a doorway that faces outside is a quick way to accomplish this technique. The subject receives a great deal of ambient light from the sun, but he/she is still shielded by the ceiling from direct sunlight. Obviously, the inside of the room will be much darker due to the light illuminating the main subject. Any time the subject is in open shade and is still receiving light from the environment, reflectors, or flashes, you will achieve high-contrast luminosity levels. It is up to you to turn this higher-contrast situation into a flattering photograph.

Figure 7.6: This photo was taken under the shade of an open garage. I had the twins face outside, so that they would receive a great deal of light from the sunlight bouncing around at the scene. In this particular case, I was not satisfied with the intensity of light the twins were receiving from the sun, so I used a flash with a large umbrella to enhance the light intensity illuminating them.

FIGURE 7.6

Figure 7.7: In this photo, I used the window light coming into the room to strongly illuminate the wedding dress against a much darker background in the room. The closer the dress is to the window, the higher the contrast between the dress and the room will be. Because I used a high-contrast luminosity level technique, your eyes are immediately drawn to the dress, which was my intention.

FIGURE 7.7

Figure 7.8: This high-contrast situation was achieved by finding a location outside that was still partially under the cover of the building's overhang. I placed the couple in the shade of the overhang but as closely as possible to the outside areas lit by direct sun. This created a beautiful high-contrast effect with soft and flattering light.

FIGURE 7.8

Figure 7.9: In this indoor scene, I loved the composition utilizing the repetitive arches, but there was not enough contrast in the scene to draw the viewers' eyes to the bride. To remedy this situation, I had my assistant hold a flash behind the column to illuminate it and thus achieve a higher contrast between that column and the rest of the room.

FIGURE 7.9

EVEN LUMINOSITY LEVELS

Properly implementing even luminosity levels in wedding photography can have a very pleasing effect on the overall feel of the photograph. The human eye does not have to adjust for bright highlights and dark shadows. The entire scene is more or less lit by the same luminosity levels. This could be achieved in open shade or in direct sun. In most cases, you want to avoid having your subject darker than the background. I bring a reflector or flashes to improve the light on my subjects, if necessary, in order to balance it out with the background.

Figure 7.10: When looking at this photo, you can immediately appreciate how easy this image is on your eyes. The entire scene is close to the same range of luminosity levels. In situations such as these, I still try to put slightly more light on the main subject to give him/her greater importance than the rest of the scene. Otherwise, having even luminosity levels in open shade can appear flat.

FIGURE 7.10

Figure 7.11: This photograph presented a tricky situation, but there was an easy solution. The scene was lit by similar luminosity levels with the exception of a few scattered highlights on the ground and on the walls behind the group. If I had simply posed the bridal party in an area of open shade from one of the trees, the lighting on them would have be too low compared to the scattered highlights. Furthermore, the group is standing over grass, which further absorbs the light. To solve this dilemma, I knew I had to use flash to increase the light on the group, so that the light on the group and the light on the scattered highlights were more even. In situations like this, I always prefer to have both my camera and my flash in manual mode so that I can quickly make decisions and adjustments regarding how to achieve balance in the luminosity levels between the subjects and the background.

FIGURE 7.11

Figure 7.12: This recent photo was taken just minutes before the ceremony was to begin, so we were in a rush to finish the portraits with the bride and groom. Since we were shooting under direct sunlight outside, I had to find a background that did not have anything white; otherwise, it would have become a hotspot. I found a row of green bushes, which was good enough for me. I turned their heads away from the sun and noticed that the light on their faces was too dark compared to the bushes in the background. To even out the luminosity levels, I asked my assistant to use a white reflector to bounce light onto the couple's faces. That increased the light levels on the couple, and it evened out the scene. If I had more time, I would have placed a diffuser over them to avoid direct sunlight from illuminating her back and the front of his jacket. But, as I say, during weddings, you have to problem-solve as best you can, even though the results may not always be perfect.

FIGURE 7.12

REFERENCE POINT LUMINOSITY LEVELS

This technique is about the highlight in the scene having a natural place in the viewer's mind. The highlight needs to make logical sense for the viewer. For example, a random highlight coming from nowhere is far more distracting than if that highlight came from a window. If you can give the highlight a sense of place, then the viewer of the photograph deems it normal, and it won't cause a distraction. Mastering how to give targeted luminosity levels a natural sense of place is an advanced technique. Correctly implementing this technique says a lot about the skill of the photographer.

Figure 7.13: In this room, clearly the windows are much brighter than the main subjects inside the room, but your brain sees that highlight as a window, and windows are normal in a room. Therefore, it is much less of a distraction.

FIGURE 7.13

Figure 7.14: In this example, the arch in the background is definitely a distracting element, but because it appears to be part of the same architectural elements of the building, it has a sense of place. Ideally, that arch on the right side of the frame would not be there, but it's good to know that the photo doesn't suffer too much because that highlight occurs within the natural context of the scene.

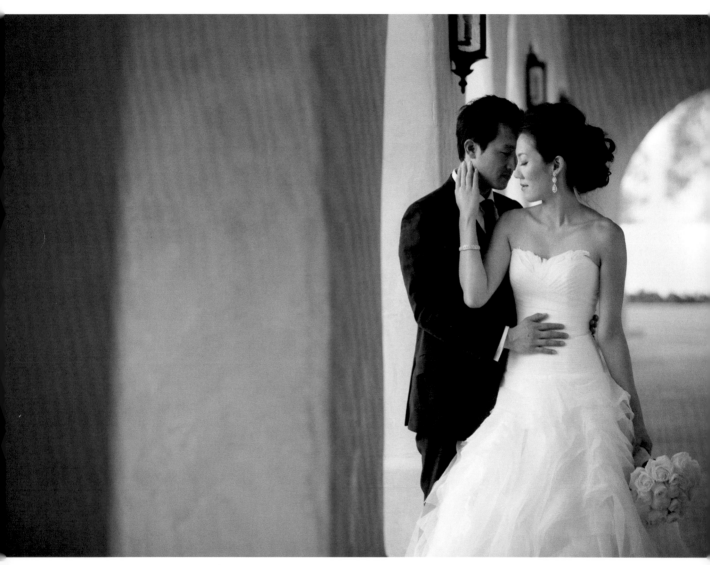

FIGURE 7.14

Figures **7.15** and **7.16**: In some cases, you have to use your judgment about how much of a highlight you want to show in your composition. Remember, the human eye is always drawn to the brightest point in the frame. Therefore, any highlight could potentially take away visual attention from your subject(s), even if the highlight has a reference point. As you can see in these examples, Figure 7.15 shows a bride illuminated by beautiful natural light coming in from the large doorway in front of her. However, I thought that there was too much doorway in my composition. Although this doorway is very much within the context of the hotel lobby in Hawaii, I decided that it was too much of a distraction. Therefore, I recomposed to remove much of the doorway in the photo. The result is Figure 7.16. I find this composition less distracting and easier on the eyes.

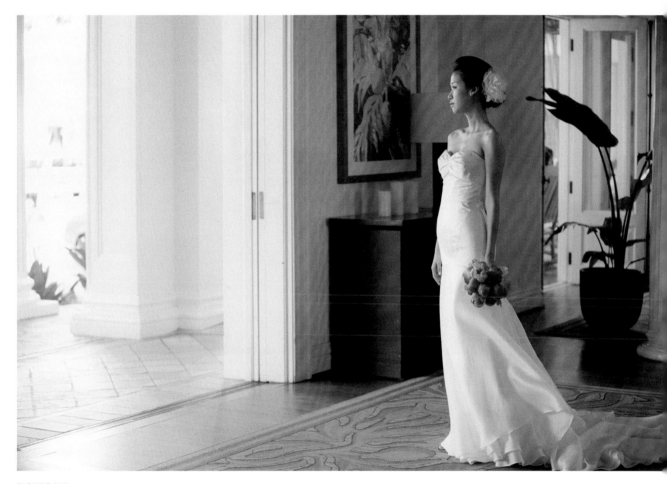

FIGURE 7.15

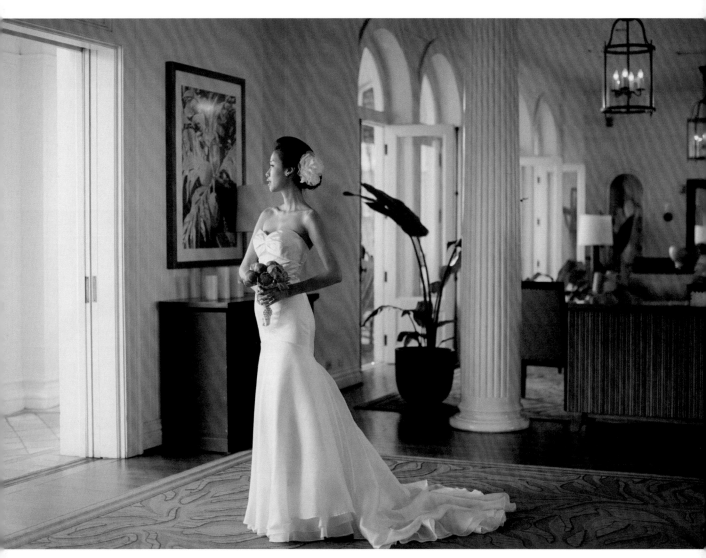

FIGURE 7.16

part three
FOUNDATION COMPONENTS: PEOPLE TECHNIQUES

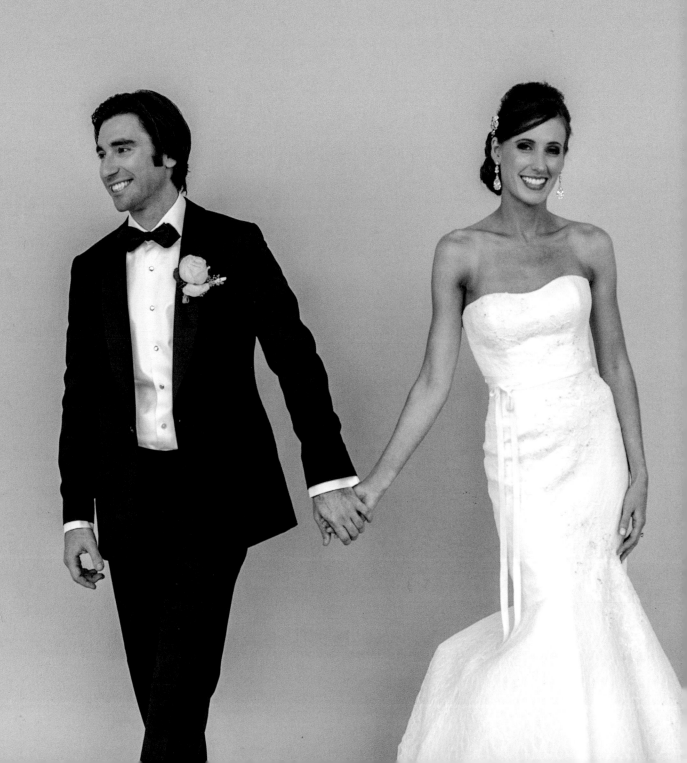

chapter 8
BREAKING DOWN DEFENSIVE BARRIERS

Obviously, the photographic techniques laid out in this book—or anywhere else, for that matter—are completely useless if your client's family and friends cannot relate to you or if they don't want to work with you. As the wedding photographer, you probably spend more time with the bride and groom on their wedding day than their own families. You are invited to witness one of the most personal and intimate events in this couple's lives, and you are not even part of the family or, in most cases, even a friend.

One of the things I learned the hard way is that for the couple and their family, this is a rare and highly emotional event. But busy wedding photographers can view a wedding as just one job of many. This is entirely the wrong attitude to take. To my surprise, psychology is one of the most vital elements that separate an average wedding photographer from a reputable one. To understand why, let's put ourselves in the shoes of a client's family and friends.

They are attending a wedding of their loved ones to witness with love and support one of the most important rites of passage of a couple's lives, to spend time with them, and to laugh, toast, and dance in celebration. And, now, here comes the wedding photographer. The moment the photographer arrives, the energy in the room changes completely. The bridesmaids or groomsmen don't know you, nor do they care to know you. To make matters worse, from the moment we arrive, we begin to bark orders at people, telling them what to do, where to stand, how to dress themselves, where to look, and to smile on command. I mean…really? This is how they think of us. It is our job to change their low opinion of us, and quickly.

The job of a wedding photographer is challenging enough as it is. Without the cooperation of the people we were hired to photograph, we are completely doomed. Ultimately, it is your responsibility to deliver superb photographs to the couple. Excuses such as, "People didn't want to be photographed!" or, "I tried but nobody would listen!" are not going to work. You must deliver, regardless of the situation. Wedding photography requires the photographer to deal with the personalities and requests of over a hundred people. The best way to begin your wedding coverage is to break down the families' defensive barriers toward you. This chapter, and the two that follow, are short, but they explain behavior far too important not to mention.

JOINING THE FESTIVITIES

In addition to the engagement session, where you become better acquainted with the couple and build a rapport with them, you should strive to join any social opportunity you can to meet as many wedding family members and guests as possible in a social setting, not a photographic setting. Clearly you must be invited to these festivities, but if you are, take advantage of them and go.

I recently photographed a wedding on the island of St. Barths. The bride had left a beautiful welcome letter in my hotel room, and inside the envelope was an invitation to the welcome dinner for all her guests. My wife and I were quite tired from a long trip. However, I knew that this was my only chance to get to know the wedding party and some of the family members before the next day's wedding. Attending this dinner was a great decision. I chatted with several members of the wedding party, and we laughed and talked business, world travel, and food. I kept all conversation away from controversial topics, such as religion or politics. We had drinks together and just enjoyed ourselves. It was imperative that the family see me as a friend of the couple, not as the hired photographer. When I headed back to my hotel room with my wife, I felt as if I was going to photograph a friend's

wedding. On the day of the wedding, I felt as if everyone was my friend. Any reservations people had about being photographed were gone. When I asked for something, they all cooperated. It was fantastic!

The welcome dinner was a wonderful way to break down defensive barriers. Had I not gone, I would have had to photograph the wedding alone and clueless. This matters, because breaking down defensive barriers will directly affect the mood and guest behavior for the entire wedding day. The best photos are taken when people don't see you as a photographer or as an intruder. When people are caught off guard, they become resentful and uncooperative. When people don't believe that the wedding photographer is intruding in their personal space, they relax.

MEETING THE WEDDING PARTY FOR THE FIRST TIME

In most cases, there will be no opportunity for you to attend any festivities before the wedding. Therefore, you must dive straight into cold water. It is very important to remember the influence that the wedding party has on the bride and groom. If the wedding guests don't like or care for you, you are in serious trouble. When I walk into a room, I immediately introduce myself with a firm handshake to everyone in the getting-ready room. I repeat their names, look straight in the eye, and follow with an "It's really nice to meet you!" If the wedding party is young and male and I feel comfortable, I keep my salutation more informal, such as, "Jeremy, what's going on?" or some other casual comment. I want to keep the energy light and fun. I need them to think of me as one of them. When I'm with women, my behavior is different, since I'm a man. I make sure to be respectful and polite, but I still keep the energy light and fun. If I photograph the groomsmen before the bride, I usually use the groom's getting-ready coverage with the guys as an icebreaker when I'm trying to get to know the bridesmaids. For example, I make light of their nervous energy or what they are doing. I make brief, general, fun comments to the ladies about the groomsmen's personalities or quirks to help build a bond based on having something in common. Any effort to build a bond helps get them comfortable with you around. Remember that the photographer is the only stranger among friends in a room. It is important to do this initial introduction without your camera. You want people to see you as a person first, not "the photographer."

I also have a terrible memory for names, but I do my best to remember as many bridesmaids' and groomsmen's names as possible. If you can somehow remember a few of them, it will greatly reduce the tension, if not actually break down some barriers. Since most wedding parties are young, they usually play along with a little memory game. When I ask for their names, I also ask them to help me come up with a way to remember their names. At a recent wedding I photographed, I met a nice woman named Lauren. She told me her first name, and then, we tried to come up with a fun way for me to remember it. She came up with "Lanky Lauren." I laughed at how wonderfully that nickname fit her, since she was tall and, well, lanky. We laughed about it, and then I moved on to the next bridesmaid.

This little memory game does wonders for breaking down defensive barriers, because the guests feel as if they have already collaborated with you as a team. They also realize that this game is your way of making a great effort to refer to wedding guests by their names. They will be more than impressed by your professionalism and sensitivity, because to photograph a wedding, you really don't have to make that extra effort. They will feel extra-special and will be on your side throughout the day. Just imagine if you were part of a wedding party, and the photographer pointed at you and said, "Could you move over here?" or worse, "I need you to move next to the couch for me." Talking to people you don't know in such an inconsiderate way makes them feel as if you are treating them like cattle. But if you say, "Excuse me, Peter, could I have you move to this area to place you in better light?" Now you are not only using their names, but you are also telling them why they should listen to you.

PROTECTING THE SPACE

I use the phrase "protecting the space" because the photographer will be in the same space as the wedding party, but it really should be "protecting the energy in the room." It is so important that the wedding photographer does not interfere too much with the energy in the room. It is inevitable that you will intrude a little since most people don't know you, but people will be far less defensive toward you if you don't make the energy in the room all about you, the photographer.

I talk when I must. Otherwise, I stay quiet and become an avid observer. Additionally, you should carefully place your gear out of the way. I have seen video crews leave their giant tripods and cameras literally everywhere. It's not a Hollywood set, it's a wedding. Remember that you are being invited by your clients to photograph a very personal event, not to seize the event and make it about yourself.

There will be times when protecting the space will be more important than at other times, such as when family members or people in the wedding party are having an argument. In the event that something like this should happen, quietly leave the room and wait outside. When tensions are high, you really want to minimize your footprint in the room. In my early years, I brought an assistant to a wedding whom I had never worked with before. It was quickly apparent that he did not understand what it meant to protect the space when the bride was getting ready with her family and friends. He was chatting away about football, and worse, about how many weddings he had shot. The straw that broke the camel's back occurred when he saw the bride's wedding dress hanging by the window, and with an excessively excited tone of voice he said to the bride "Wow, what a dress! Is it a Monique Lhuillier or just a look-alike?" My jaw dropped in disbelief! The bride's expression said it all, but she said, "No, sorry. I can't afford those dresses." The whole energy in the room changed.

So, regardless of the various personalities, styles, and approaches of wedding photographers, I have repeatedly given the following advice to everyone: Ask the bride and groom themselves what kind of behavior they prefer from their wedding photographer. Their answers to me have been unanimous. They prefer the photographer to capture events with minimal disturbance to the energy in the room.

Therefore, I talk only when it is necessary. If I'm posing the bride or the wedding party, that's obviously a time to talk and direct, but my normal demeanor is to be quiet, respectful, and attentive.

MAKING JOKES TO BREAK DOWN DEFENSIVE BARRIERS

It is a common practice to banter with people to break the ice. However, making jokes at a wedding requires serious common sense and a fine-tuned awareness of the kinds of clients you are working with. Making a joke that offends someone will not go well for you. Moreover, at weddings, remember that emotions are high and it is very easy to offend someone.

Let me give you an example. I was with a great group of groomsmen photographing them getting ready. They were laughing and making fun of each other, as guys do. The energy in the room was playful, fun, and relaxed. When I was photographing the groom's portraits, one of the groomsmen asked me if I Photoshop my images. I said, as a joke, "Well, I don't think the current version of Photoshop is powerful enough to help this groom!" The room exploded with laughter. The groom almost fell off his chair and was laughing hysterically with his groomsmen. It was a risky joke, but I felt it was the right kind of group, and I said it. After that, the guys became instant buddies and gave me 110% of their efforts posing for the photos.

Now imagine if I had read the group wrong. I could have seriously offended the groom. Clearly, the groom I chose to make this joke about was very good looking. Part of the banter in the room was about how he is always looking at himself in the mirror and admiring his appearance. Listening to these comments, I figured that it would be alright to jokingly make fun of the groom's looks. But if there had been any indication that the groom had self-esteem issues, that joke could have gone terribly wrong. Instead of breaking down barriers, I would have created a wall of steel with my joke.

With bridesmaids, I never joke about physical appearance with anyone. I just mention how beautiful the bride looks. In this case, a joke can be too polarizing to risk it.

A joke can be humorous, or it can go horribly wrong. If there is any doubt, it's best not to make jokes. If you do joke, be very careful about what you say. Remember, although some people might laugh, they may still feel very offended.

MANAGING BARRIERS WITH SEVERAL CULTURES AND GENERATIONS

I am fortunate to be sought after by clients from many cultures and religious affiliations to preserve their wedding memories. I find that photographing diverse cultural weddings keeps my profession very interesting. Many people consider different portions of the wedding to be much more important than others.

For example, I currently live in Beverly Hills, California, which means that many of my weddings are Persian, Jewish, and Asian weddings. In the Persian culture, the bride and groom photos are less important than the family group photos. At a "normal" American wedding, photographers schedule a substantial amount of time for bride and groom photos. The couple usually wants to have the family photos finished as quickly as possible and at a time that won't interfere with their couple photos. But for Persian weddings, we schedule over two hours for family portraits. Within the Persian culture, you can quickly break down defensive barriers by showing much respect and attention to detail regarding the family photos. If, for any reason, you make the family members feel as if these group photos are interfering with your artistic style, they will put up barriers so high against you that they will not come down. Trust me on that. In fact, when I'm photographing the bride or groom getting ready at a Persian wedding, I mention how lovely the mother of the bride looks, and how beautiful she will look in the family photos. This behavior lets families know that I'm knowledgeable about their culture and very much interested in doing the best job I can to express what that particular culture cares about the most.

With regard to Asian weddings, showing great respect and giving priority to the older generations—such as the grandmother or great grandmother—is absolutely crucial. The older generations should always be featured and positioned in the most prominent place. The same goes for Indian weddings. They have a very highly structured and respected generational hierarchy. If these families notice that you are taking great care of the older generations, you will be well on their side. It is an understatement to say that a successful wedding photographer does more than take great photos; they do their research. You need to know who you are photographing. Not being culturally prepared will eventually lead you to offend someone, and the word about you will spread quicker than wildfire.

The most important lesson to be learned from this chapter is to be aware that the environment in which you must produce beautiful work is, initially, not favorable to the photographer. You are the stranger in the room among family and best friends. A great wedding photographer finds a way to have the wedding party see you as one of their own, and quickly! As in most businesses, people skills are more valuable than technical skills.

chapter 9
EXPERT CONFIDENCE AND TRUST

Psychology plays a much larger role than one might expect in successfully photographing weddings. By behaving in a way that puts people at ease around you, they will think of you as a leader, and they will respect you and collaborate with you from the beginning to the end of the wedding. Having the collaboration of the wedding party and the couple's family members is of the utmost importance in determining whether you succeed or fail. For this reason, I have written this short chapter about how to gain your clients' confidence and trust. Once you have broken down or minimized the natural defensive barriers people put up when being photographed by a total stranger with a professional camera and an oversized lens, then the next phase of the psychological journey begins.

EVERYONE IS A PROFESSIONAL

Perception is reality, correct? Unfortunately, these days many people believe that they are professionals. If they have a basic SLR kit, they are a pro. If they have ever attended another wedding, they are a pro. If someone has ever told them they take great photos, they are a pro. The list goes on and on. Why do I say this? Now more than ever, we must stand out as the true experts in the field of wedding photography.

A few years ago, we competed with anyone who owned a basic point-and-shoot camera. Now, we compete with every wedding attendee who has a camera built into their smart phone. What does this mean? It means that people used to attend weddings to enjoy the event. Now, people feel the need to feed their social media outlets and take photos of everything and everyone. In fact, at least in the United States, the first photos the couple sees of their wedding are most likely the photos taken by family and friends with their smart phones. Those folks have been snapping away the entire day, and they capture every moment from a variety of angles. And there is power in those numbers. With one hundred guests taking photos, putting them through filters to give them an arty look, posting them online immediately, and tagging everyone in the photo, we have a tough battle to win.

YOUR ATTITUDE IS AS IMPORTANT AS YOUR PHOTOGRAPHS

For the reasons mentioned above, the professional photographer *must* be perceived as a master of his or her craft. The people attending a wedding should feel as if you have a firm control over the proceedings so they can relax and enjoy the day. The photographer must photograph the wedding with a modest attitude, but at the same time, the photographer must be a leader who quickly earns people's respect. If the guests believe you are a pushover when you try to arrange photos, they probably will not listen to you. Additionally, if you have not established a relationship with the wedding party and your behavior is too confident, or cocky, people will not only begin to ignore you, but most likely they won't like the photographs you deliver later, regardless of how beautiful they may be. Nobody wants to like a photograph from a cocky, arrogant photographer.

It's also difficult to be an experienced photographer and have your clients doubt your location choices during the coverage. But I try, at all costs, to make sure my clients are happy with their experience with me. If the bride or groom doesn't like the location you chose for their photos, listen to them and take their concerns seriously. In such a case, finish your set quickly, and then move to the location requested by the bride and groom. Do not show any signs of being annoyed or irritated. Just go with the flow and keep your clients happy.

Just remember this: It is human nature for the wedding couple and guests to associate the experience they had with you with the photos you deliver. Even if the photos are beautiful, you can ruin the overall experience by being difficult to work with. The same association is true for surgeons. Arrogant surgeons—though they may be at the top of

their field—are sued for malpractice at a much steeper rate than their less experienced but caring counterparts. I repeat: The experience you provide to your clients during their wedding has a direct correlation to how they feel about your photography.

HAVE A PLAN

One of the most effective methods to gain the respect of the wedding party, family, and friends is to have a basic plan before beginning to arrange people for a portrait photo. For example, if you are about to arrange a photo of the groomsmen, at least have a location chosen and an exact number of how many people will be in the shot. With this information, you can begin to visualize the shot and the arrangement of each of the groomsmen. You can always make small changes once people are in place, but at least you have a plan. Also, when taking any kind of portraits, you should remember that most guests don't want you to take photos of them. They accept that it is part of the wedding process, but I'm sure they would rather be elsewhere enjoying the wedding. Therefore, being quick, effective, and confident is the key to obtaining their trust and cooperation.

During a wedding in Pasadena, I learned the value of having a plan, or at least pretending to have one, in the presence of the wedding party. I only had a few minutes to take photos of the bridesmaids. I asked them to stand together for a portrait. In the heat of the moment, my mind was thinking about how to get this photo finished quickly and move on to another variation of the group photo. Well, three of the bridesmaids began to look at the bride, wondering why I was not telling her where and how to pose. They were probably thinking that I didn't know what I was doing. The energy changed against me, and I could feel them losing respect. In an effort to save face, I told the ladies to hold tight because I needed to change my lens and get a flash out of my bag. Basically, I was trying to convey that the reason I had not told them where to stand was because I was not yet ready to take the photo, not because I did not know what I was doing. Once I changed my lens and fired up my flash, I began to rearrange the group. The amusing thing about this situation was that my arrangement of the bridal party did not really improve the photo much at all. But because I was taking charge, they all felt good about me being the photographer. It was all in their heads. Remember, perception is reality.

FAMILIARIZE YOURSELF WITH THE TIMELINE

Despite the best efforts of the wedding coordinator, more often than not the wedding begins to run late from the very start. It is almost a guarantee that the make-up and hair stylists will be running behind. Way behind! At least, that has been my experience for over a decade. When this happens, people will turn to you and the wedding coordinator and expect that things will still get done to make it to the ceremony on time. That doesn't change, but the time allotted to you to photograph them usually is compromised. I realize that not all weddings have a wedding coordinator, but it doesn't matter. What matters is that you have an idea of the key parts of a wedding and when they will occur.

For example, when the bride and groom are getting ready, I let the bride know that we only have 15 minutes before we are supposed to meet the groom for the first look. A simple statement like this gives the bride the impression that, despite the chaos going on around the room, you are still keeping track of time and are trying to keep to the schedule. The bride's perception of the photographer being in control improves matters considerably.

During my first years as a wedding photographer, I was under the impression that my only job was to take the wedding photos. But I learned quickly that taking the photographs is just one of the many jobs the wedding photographer is expected to perform. Early in my career, I remember telling many couples that the reason why I didn't have a chance to photograph this or that was because the wedding was running so late that we simply ran out of time. That did not go well for me, believe me.

As I said before, you are expected to photograph all the sets the couple requests, whether you have time or not. It's a good idea to carry the timeline in your pocket so you can reference it and demonstrate that you are on top of things.

BE DECISIVE

Because of your proximity to the couple, the wedding party, and the couple's families, you will become their go-to person for anything related to the wedding. Many times, different people will ask you the same questions regarding photography. When asked a question about how or when you will photograph something, answer the questions in a decisive manner. Answers that include the phrases, "I'm not sure," "Maybe," or "I don't know" do not instill confidence in anyone.

A few years ago, during a wedding in Orange County, California, I was asked by the wedding coordinator where I was going to do the first look of the bride and groom. At that time, I was busy photographing the last of the wedding party photos in the bride's getting-ready room. Without thinking, I told the coordinator that I had no idea where I was going to take the couple to do the first look. The mother of the bride also heard me make that statement. A couple of minutes later, my second shooter told me that he overheard a conversation between the mother of the bride and the wedding coordinator. The mother asked her if I knew what I was doing. I couldn't believe my ears! I was doing my job perfectly, and suddenly I had lost the respect of two very important people in the wedding. It took me half a day to gain their confidence back.

Now, having learned that lesson, even if I don't yet know the location of the first look, I answer the question in such a way that people never doubt me. I'll say, "In a couple of minutes, I'm going to go downstairs and choose a great location," or "I noticed a beautiful private place by the lobby. I'm going to go check out how the light looks there at this time of day." You don't have to answer this way. These are just examples of how you could answer the question in a way that instills confidence in you and, again, shows that you have everything under control.

Be aware that I am sharing just a few stories that deal with important lessons learned. For every example I have written in this book, there are more than a hundred stories I have not included that involve similar problems and challenges. I am telling you my experiences because I wish someone had told me or warned me about how quickly things can get out of hand during a wedding.

In summary, people need to see you as a leader at the wedding, regardless of your style. You need to be perceived as someone who has complete command of his or her duties. As photographers, we don't just take photos as we wish. To properly do our jobs, we must deal with so many personalities that it can make our heads spin. Psychology actually plays a more important role in wedding photography than the photographs themselves. Once you understand this, everything else will fall into place and make your job a great deal easier.

chapter 10

BEING FLEXIBLE, LIKABLE, AND PROFESSIONAL

Although this is a short chapter, I think it contains some of the most important material in the book. The reason is this: no level of skill or mastery will ever save you from the consequences of leaving a bad taste in other people's mouths. During discussions with my colleagues and peers about the writing of this book, everyone agreed unanimously that being a great wedding storyteller means so much more than just what you do with your camera. The artistic and technical skills of your photographs are only 50% of the job of a wedding photographer. The other half depends on psychology and people skills. A well-tuned common sense and a high degree of self-awareness will be critical in determining the success of your career.

EGOS AND HIRED HELP

A smart way to put yourself on the right track with the families at a wedding is to leave your ego at the door. Photographers are artists, and many artists are driven by ego. Ego can help an individual push himself or herself to develop a higher standard of artistry, but that same ego needs to be tamped down the minute you begin interacting with the families.

First impressions are critical to win people over, so be sure that their first impression of you is one of a friendly, polite, and respectable human being. You want to exude a modest confidence. In other words, you want the family and wedding guests to see you as both a respectful person and someone who knows exactly what he or she is doing.

As a wedding photographer, your patience and experience will be tested by people at the wedding. Many times, wedding party members think that they are experts at weddings because they have attended a few, and they will try to show their worth by taking over your job. I'll be honest: The more experienced a wedding photographer you are, the more irritating this behavior becomes. But it is crucial for you to handle these kinds of situations with great care. The last thing you want to do is appear arrogant and belittle them because you don't agree with something they said or asked you to do. These individuals are the most important people in the bridal couple's life. I'll do anything to make sure that they feel respected and important, regardless of the request. Arguing with any of the wedding party about a photo idea they have will only leave a bad impression about you. The resulting tension also makes it very awkward between the couple, their wedding party, and you, the photographer.

Leaving your ego at the door does not mean letting people walk all over you. There is a way to accommodate people's requests and still keep the ball in your court. To do your job well, you need to carry yourself in such a way that people are happy to work with you. If you have earned people's respect, the wedding party or family members will even go out of their way to help you—for example, helping to get people together for a photo. Regardless of how expensive (or inexpensive) the wedding may be, the photographer can never be perceived as hired help. In fact, during the first meeting consultation, I make sure my clients see me as an artist, not someone they just pay to do my job and shut up. In cases where the couple does feel that way, I don't take the job. I go as far as telling each couple that the interview meeting goes both ways; I want to make sure they are a good fit for me as much as they want to see that I am the right fit for them.

HANDLING PEOPLE WHO TELL YOU HOW TO DO YOUR JOB

Let's tackle five challenging scenarios that you will most likely encounter when photographing weddings.

Photo Ideas

Recently, a bridesmaid told me in front of the other bridesmaids, and I quote: "At the last wedding I attended, the photographer did this really cool photo in which the bride contemplates her bouquet, while the rest of the girls closely surround her smelling their own bouquets." I almost wanted to gag just visualizing such a distasteful photo. I controlled myself by the grace of God, and I said, "Oh, great! Let's definitely try that later when everyone is more ready." In most cases, I take the photo the bridal party asks for, and I do it with a smile. If I take the photo quickly, I can leave them feeling that their ideas were amazing, and I can move on with my more elegant style of photography. Everyone wins. And by the time the photos are published on an online gallery, I can omit that photo from the gallery, and the wedding party member who asked that I take it will have most likely forgotten about it.

When clients hire you to photograph one of the most important days of their lives, they have invested a lot of trust in you. They have spoken with you and have most likely met with you, as well. It is very easy for the photographer to feel that he or she has developed a good relationship with the client before they show up at a wedding. But then, it hits you: The bride and groom are only two people out of a hundred or more at a wedding. Neither the family nor the wedding party has ever met you, and whether you like it or not, you inherit them as clients, too. And these people begin to make suggestions about where and how to take photos.

One of the most common and irritating aspects of wedding photography is when members of the wedding party suggest that the photographer replicate photos they have seen online (on sites such as Pinterest). In situations like this, you must be very careful how you handle their suggestions. If you make them feel ignorant or silly for asking, you will never gain their support. Furthermore, the bride will always defend her friends over you.

The solution that has worked well for me is to show the person making the suggestion that I have no problem at all taking the photo they so enthusiastically described. If I can take it quickly, I do, and then I move on. But if I feel that taking the photo will be far too time consuming, I suggest that I take the photo later because we are running out of time. Most of these photo suggestions occur when the bride or groom are getting ready. This is when they have the most time. After the getting-ready portion is over, the wedding day becomes hectic, and most wedding guests focus their efforts more on consuming beverages and appetizers with their friends and family than on giving the photographer photo ideas. Therefore, it is a goal of mine to get through the getting-ready portion of the wedding with both the couple and the wedding party on my side.

Location Disputes

During another recent wedding, the ceremony had just ended and I was gearing up to take the family photos. It was a hot and sunny day, and the couple had been married at a gorgeous venue with an ocean view. When I scout for locations to take the family portraits, I am mainly looking for three criteria: a proximity to everyone, the quality of light, and a clean non-distracting background. I want the family photos to shine, since they are very important to me, and I want my clients to be delighted with the job I did for them. In this case, I found the perfect place that satisfied all three of my requirements, and I quickly began to group people for the photos.

Not 10 seconds later, during the first group photo, the brother of the bride said to me in front of everyone; "Excuse me, really? You are going to take our photo here, when we have the beautiful ocean right over there? Are you kidding me?" Everyone was staring at me, wondering why I had chosen that particular location instead of having the ocean in the background of their family photos. I had only seconds to react before I would begin to lose face. I responded by saying, "Oh, if that's everyone's preference, we could certainly move, but just realize that if we do so, you will have very harsh light and shadows over everyone's faces. Let me show you."

I quickly asked three people to come with me to take a photo of them with the ocean view. Sure enough, the lighting was horrific. I showed the gentleman how the photo looked so that he could see for himself. I did *not* do it with an "I told you so" attitude but in a respectful way. This is very important, because in situations like this, he could have very easily felt humiliated in front of his entire family. On the other hand, had I not shown him the photo at the location he requested, he could have felt that I had not listened to him, and he would never have known how bad the photos would have been. I thought it would be better for me to keep my demeanor respectful and polite. After that, all the family members approved the chosen location, and we finished the photo shoot quickly.

There are times when it is best to give the clients what they ask for, and there is a way to do this without sacrificing quality. At an Armenian/Persian wedding, the bride and her family felt strongly about taking photographs in front of the Sofreh Aghd (which is a traditional Iranian/Persian ceremony decor spread). The Sofreh Aghd was a place that would have yielded splotchy lighting on the family members. To address this sensitive issue, I informed the bride and groom about the problem we would have if we moved to that location. However, I knew that this location was very important to them culturally. To achieve my goals and the clients' wishes, I asked the bride if she would allow me to do the family photos at the location with beautiful lighting, and then we would move to the ceremony site and take a second set of photos with just her immediate family. Naturally, we would not have the time to do another entire set of family photos, but if we just did another quick set of her immediate family, we would all be happy. She agreed, and I got a full set of beautifully lit photos, and she had her set of her immediate family in front of the traditional Sofreh Aghd. This was a win-win situation!

The point of this story is that if people feel that your decisions are made for their happiness and well-being, usually they will not argue about them. Sometimes, the wedding coordinator will tell me where to take the couple for the first look. But if the lighting is bad and will

not flatter the couple, I tell the coordinator that the position of the sun at that moment wouldn't be flattering to the bride. The coordinator cannot argue with that.

Bride Getting Dressed and Privacy

As a male wedding photographer, I often run into the situation when the bride is about to put on her wedding dress, and there is that unspoken vibe in the air about what I'm going to do when she is undressing. During my client meetings, the couple has already seen photographs in my portfolio of the bride getting dressed, or she might be in her undergarments while she elegantly slips on her dress. These photos are usually presented in black and white, and they are taken with the utmost class, elegance, and respect for the bride.

While the photos may be absolutely gorgeous, not all brides feel comfortable with the photographer in the room when she is undressed. My experience has taught me to be extremely cautious during these moments, regardless of what the bride says. Therefore, I ask about these photos and whether she feels completely comfortable with me being in the room and taking some stylized photos of her putting on her dress. This is discussed from the very beginning, long before the wedding day. Regardless of whether the bride says she is comfortable or not, during the day of the event, I give her the options again. However, there are two distinct ways of asking a bride about my presence in the room. One way could make the bride feel guilty. The second approach allows the bride to feel at peace with her decision.

- "Would you like me to leave while you get dressed?"
- "I'm going to step out while you get dressed. Let me know when you are completely comfortable, and I'll come back in."

Notice that the first question makes the bride feel as if she is kicking someone out. Subconsciously, she will feel guilty doing so. Trust me, you don't want to make the bride feel cornered. With the second approach, you are leaving the room of your own accord. If the bride responds, it is to let you back into the room later or to ask you not to leave but photograph her as discussed during the client meetings. Subconsciously, the bride feels much better saying something that invites you in rather than saying something that feels as if she is kicking you out. So be careful how you ask.

Difficult People and Avoiding Drama at All Costs

In 2010, one of my closest friends and industry mentor David Edmonson suffered a terrible stroke. In the middle of the wedding season, I was asked by David's son, Luke Edmonson, to take over a wedding for them in Dallas while Luke photographed another job in a different part of town. In this situation, the couple and I had no rapport whatsoever. My good friend and marvelous wedding photographer Joe Cogliandro was kind enough to offer his help shooting this wedding with me for the Edmondsons.

Everything at the wedding was going relatively well and smoothly until the family photos portion just after the church ceremony. The interior of the church was quite dark, so I had

found an attractive location just outside the church to take the family photos. I approached the family and proposed that we take the photos outside. People from California almost always take family photos outdoors. However, this was Dallas, Texas. I had no idea that people in Dallas are accustomed to taking the family photos inside the church in front of the altar. This is culturally important to them. The father of the groom was in disbelief that I would propose leaving the altar to go outside for the family photos. He quickly lost faith in me as an experienced wedding photographer.

Furthermore, the situation got worse when the father of the groom expected me to know the names of all the family members, including the extended family. I only knew the names of the bride and groom. This did not bode well for me, and the father of the groom expressed his displeasure to the wedding coordinator about the photographers. I felt an incredible burden on my shoulders, because I wanted to represent David and Luke Edmonson in the best way possible. But the father of the groom was not letting go, and his negative energy trickled down to the couple and the wedding party. The situation was not good, to say the least.

The wedding coordinator had to intervene, and she basically asked Joe and me what we had done to make the father of the groom so upset. I thought that if I argued with the coordinator in an attempt to defend ourselves, we would look even more guilty. Instead, I decided to ask her what the family's problem was with us, and that I would fix it immediately. I did not argue, even though it seemed unreasonable to expect me to show up and know every single family member's name. At weddings, tensions can be unnaturally high, and I was completely focused on defusing the situation and showing the father of the groom that we wanted to do things right. Following that unfortunate situation, the bride and groom were not particularly excited about giving us any time to do bride and groom photos.

During that time, the coordinator actually called Luke Edmonson while he was shooting another wedding to make him aware that things were not going well between the photographers and the couple's families. I wanted the ground to just swallow me whole! I was beyond embarrassed and frustrated. I apologized to the couple for what happened and for not knowing everyone's names. I also humbly asked them if they could just give me 10 minutes of their time to turn it around and take some beautiful photos of them. Reluctantly, they accepted.

The couple loved the photos they saw on the back of my camera, and their attitude toward us completely changed for the better. Later, at the beginning of the reception, the wedding coordinator asked me if this was my first wedding. I couldn't believe my ears! Somehow, because there was an issue between the father of the groom and me, her perception of me was so incredibly low that she thought this could very possibly be my first wedding.

What I found most surprising was how quickly emotions can escalate and misjudgments can be passed at a wedding. For these reasons, it is imperative that you keep in mind that a single issue—no matter how small or irrational it may be, and no matter whose fault it is—can create a major problem for you. It is imperative that you do whatever you can to prevent issues from arising between you and the family. Think of it like a blister. As soon as you begin to feel it forming, you must apply dressing and put a Band-Aid on it, because if you don't, it will only get worse.

Uncooperative Groom or Wedding Party

This could be a very sensitive topic, but coping with uncooperative clients or wedding parties is part of the job. In theory, if the client, such as the groom, does not want to cooperate with you, it is simple to brush it off and blame the lack of photos on the groom. However, one thing I learned the hard way is that no matter what happens at a wedding, it is always *you* that people will blame. If there are no photos of the groom, it will be your fault in the eyes of the couple and their families. People will point their fingers at someone for anything that goes wrong, and naturally they will not blame their loved ones or good friends. They will blame you.

For this reason, when I have an uncooperative groom, I always try to meet him halfway and make him feel that his request not to be photographed was heard and respected. However, I still must take at least two or three good photos of him just in case the bride or the groom's family asks for those photos. If a groom doesn't want to take photos or portraits, I always respectfully ask him if he would just give me a couple of minutes of his time, just to cover my bases; in the future, someone such as the bride may ask for photos of him. I also tell the groom that I understand, because I don't like being photographed either. I explain that during my own wedding, I had to pose for a few portraits because I wanted to make sure that my wife wouldn't become upset with me for not having groom photos on our wedding day. Then, I follow with a joke to ease the conversation. Something such as, "I will take these photos so fast, you won't even know what hit you!" or "It will be totally painless, plus you look so good it would be a crime not to photograph you looking like that!"

Approaching the groom this way lets him feel that we have something in common—our mutual dislike of being photographed. But he will know that you are just covering your bases for the bride and the album, and he will cooperate with you for a few minutes. Just make sure that you do not go over the time that you agreed upon. In fact, take less time than you had requested. He will appreciate it, and you will have him more on your side for the rest of the wedding.

chapter 11

THE SITUATIONAL APPROACH TO POSING

A successful situational pose occurs in a photograph when the type and the mood of the location fits the pose, and the location/pose combination creates a situation that is believable and where the action seems to have occurred naturally. The goal of situational posing is to avoid gimmicky poses or ideas that appear completely unnatural and obviously staged by a photographer. Consider this approach a "macro" view of posing. It's about the overall scene and whether or not the photo makes sense when considering the location and lighting. This book is not a posing book; it is a book about how to become a great storyteller. Therefore, I'm not going to discuss "micro" posing points such as how to pose fingers or what to do with the hands. I wrote a book titled *Picture Perfect Posing* that is 100% dedicated to all aspects of posing. But as a storyteller, it is more important to have a good understanding of this situational approach to posing.

LIGHTING CONSIDERATIONS

Lighting reigns supreme in photography. Lighting is, by far, the most influential element that determines the location where I will place my subjects and the pose I will choose. Correctly reading light at the scene requires serious skill, but determination and tenacity will help you succeed. To simplify the complex subject of lighting at quick, run-and-gun situations such as weddings, I have broken down lighting into two major categories: high-contrast light and low-contrast light.

High-Contrast Light (strong directional light). High-contrast light basically means that the light is very directional. The smaller the light source, the higher the contrast will be. When dealing with high-contrast/directional light, I allow the light to determine the pose and whether I will give the bride and groom equal importance or just feature one of them. Many conditions can create high-contrast/directional light, but some of the most common examples are direct sunlight, windows, and doors that lead outside, as well as lamps, etc. Correctly positioning and posing your clients under high-contrast/directional light is more challenging than using low-contrast light, and it requires more refined skill, but it will reward you with much more dynamic photographs that set you apart from your competition. Watching how a photographer handles high-contrast/directional light is also one of the most effective ways to quickly determine a photographer's skill level.

Low-Contrast Light (flat light). Basically, flat light is open shade. Open shade is the easiest and most common type of lighting that photographers seek at weddings. Low-contrast/flat light provides the photographer with the most posing options because the light falls on your subjects almost equally without the danger of harsh, splotchy light on their faces. Although open shade is the easiest type of light to use in order to achieve relatively flattering light on your subjects, it is important to know that not all open shade areas are equal. Depending on the situation—for example, whether there are nearby structures, buildings, walls, etc.—some open shade spots contain a higher intensity of light than others. The higher the intensity of light within an open shade area, the more beautiful the light in the photograph will be.

LOCATION CONTEXT CONSIDERATIONS

Context. Context gives the viewer a sense of place. At any location, whether it is a beautiful garden, a building, or a city alley, you must decide how much of the scene you want to show in your photo. Everything you choose to show in a photograph contributes to the impact that photo has on the viewer. If you choose to show a great deal of the scene, then the photo will give the viewer a lot of context. In contrast, if you choose to tightly crop the photograph, it will remove or limit the context the viewer sees.

My general rule: If I choose to crop tight, I make sure that my subjects' expressions appear completely genuine and that the lighting is strong and flattering on them. When I choose to show much of the context of the scene, I make sure that my subjects' behavior makes

natural sense within that scene. Lighting is still important, but I am much more lenient with the lighting on my subjects when I am composing a high-context scene.

MOOD AND EXPRESSION CONSIDERATIONS

Depth. Locations that offer depth are relatively more romantic because the lens's bokeh creates a painting-like blur in the background, while your subjects are tack sharp. When photographing at locations with depth, I usually attempt a more candid, romantic mood and expression.

Mood, Character, and Charm. Certain locations have such distinctive character and charm that they can automatically transport you to another time. Locations such as the interior of an old library, which has a nostalgic mood and character, inspire me to match the quiet atmosphere of the location with an equally quiet and pensive pose. Another example would be a charming nursery filled with flowers and plants of all colors. In such a lovely location, I try to create a pose with the couple that has a feeling of child-like innocence.

Dynamic (walls, bright colors, high-contrast). Dynamic places are the opposite of romantic environments. Walls with high-contrast scenes and bright colors inspire a more energetic pose—something lively, playful, and fun. I usually make the couple genuinely laugh, or I capture a moment of pure joy and happiness.

If you are familiar with my previous books, you know I have discussed posing in more and more detail. In *Picture Perfect Practice*, my first book, I introduced a variety of couple poses with a quick paragraph explaining some technical issues about each pose. In my second book, *Picture Perfect Posing*, I devoted the entire book to addressing everything regarding posing. In that book, I explained in much greater detail how to successfully achieve and create posing variations for couples. I began each explanation with the foundation of the pose and guided the reader through the process of achieving beautiful interpretations of each of those poses.

Wedding Storyteller, however, focuses on how to become a great storyteller. Here I would like to focus less on the mechanics of posing and more on how posing and facial expressions can be used to create a sense of harmony between the couple and the mood of the location where they are photographed. I consider this posing/location harmony whether a bride and groom are being photographed individually or together.

Very rarely, if ever, do I see this issue being discussed. This is surprising to me because mastering this skill will greatly deepen the quality of your work as a wedding storyteller, and your images will become much more refined and sophisticated. Not to mention, it will free you from having to continually repeat the same poses over and over. This approach allows you to choose your pose and facial expressions based on the mood and lighting of any location. The goal is to make the pose/expression make sense within the context of the location. These decisions should be based on the personalities of the couple, the energy of the day, the timeline, the lighting, and the context of the location.

A Note about Why It Is Important to Master the Craft of Posing

I'll keep this as short as possible because I really want you to remember it. "Posing" has a negative connotation for most people—not just clients, but photographers, as well. In general, people associate posing with fake, awkward, and contrived body positions that do not look natural at all. For example, we have all seen how photographers have their subject strike some dramatic pose in front of a landmark. Photos like this beg the question, *Why?* Why is the bride posed so awkwardly and uncomfortably in front of that building or landscape? What is the possible connection between the pose and the environment? When was the last time you found yourself in front of a landmark and felt possessed to suddenly strike a dramatic pose in front of it? It's just not natural.

These questions come to my mind when I see photos where the pose looks stiff and arranged by the photographer. Often, it seems the photographer was seduced by the location. Our brains try to make sense of the photograph, but just understand the combination of pose and location. There is a tremendous difference between the "posed look" and masterful posing. When you take the time and effort to truly master posing, you will be rewarded with a skill I call "invisible posing."

Invisible posing occurs when the pose is so well done that it flows naturally and effortlessly within the context of the photo. It appears to be simply normal human behavior. The key word here is "normal." I call it invisible posing because when people look at the photo, they will not notice the pose at all. The pose disappears into their subconscious. Instead, they are taken by the emotion and natural, relaxed beauty of the overall photograph. This notion of invisible posing is important, and it's very effective; I always enjoy hearing clients tell me that one of the main reasons why they chose me as their photographer is because they love the vital feel of my photographs. They are shocked to hear that those beautiful, natural photos they love are actually posed. Even when I tell them the truth, they still cannot see it.

When you become skilled at posing, the "posed look" will fade away from your images and be replaced by a feeling of animated and effortless moments. It is a thing of beauty, and I am thankful that I put in the work to learn this skill. If I can do it, you can, too.

THE SITUATIONAL APPROACH TO POSING

One of the biggest breakthroughs I made in my career regarding how to better photograph weddings came when I stopped applying the same poses to every client. At the beginning of my career, I used to have between three and five go-to poses that I repeated over and over, regardless of who was in front of my lens. I paid no heed to my clients' personalities, the location, the lighting, or the amount of time I had to photograph the couple photos. I thought, why should that matter? As it turns out, it matters a lot!

One of the most successful changes I made to my photography was to create a connection between the pose/expression, the scenery around the couple, and the lighting. In other words, this "situational approach" compels you to choose poses based on the conditions at a given time or place. The main purpose for creating this connection is to create a mood or feeling in a photograph that makes sense with the scenery or lighting.

As an example, imagine that you are photographing a couple in a beautiful garden that is backlit by the warm light of the setting sun. Close your eyes and imagine this scenario in your head. You would probably agree that such a scene inspires romance. Therefore, I would select a few poses and expressions that fit a romantic mood. Now let's change gears. Imagine a quiet, antique, and moody room, such as an old library lit by old, rustic tungsten lamps. Ask yourself, what kind of photo/pose would make sense here? You probably wouldn't have the couple jumping and laughing, right? It's fair to say that a high-energy pose is probably not the best match for such a quiet and delicate room. However, if you find yourself outside on a sunny day photographing at a location full of art and vividly colored stucco buildings, the splashes of color at the scene would go well with a high-energy pose. Perhaps you could include a photo where the couple is reacting to a human impulse with a smile or laughter. As a final example, let's imagine a situation where the main light is coming from above—the sun in the afternoon or a building light at night. These are very strong directional light sources. Under such conditions, it would be senseless not to choose a pose that would place the light at the most flattering place on the bride, the groom, or both of them. When photographing with heavy directional light, usually one person will receive the most amount of light, while the other becomes a complement to that. Alternatively, you could photograph just the bride or groom instead of trying to pose both of them. Either way, you are capturing the best light for one person. For this reason, when I find myself in strong directional light situations, such as with windows, I choose poses that feature just one individual. In evenly lit situations such as open shade, I can more easily feature the couple together.

EXAMPLES OF FAILED SITUATIONAL POSES

Though it pains me to put these photographs in the book, I believe that it is crucial for your success to see photos that, at one time, I thought were good. However, now that I have spent a long career photographing all kinds of weddings around the globe, I have learned what I wish someone else had taught me from the beginning: *create poses that make sense*. To remain respectful toward my clients from the beginning of my career, I will only focus my commentary on how these poses failed to make sense with the situation at hand. Believe me, I could write a book on the other things that are wrong with these images. Hopefully, when analyzing these photos, it triggers your brain to ask yourself before shooting, "Does this pose/expression make logical sense in this situation?"

Figure 11.1: This is a perfect example to illustrate the point. For some reason, this particular pose, in which one person is awkwardly staring at the other person from behind, is one of the most popular go-to poses for inexperienced photographers. Now ask yourself, does this make any logical sense? In what situation do people who are newly married do this on their own? Why is she looking at the camera while he is staring at her from behind? To me, the photo appears to be a bit creepy and very unnatural.

Figure 11.2: As previously discussed in this chapter, lighting is one of the most important considerations when posing people at weddings. In this case, the pose is somewhat believable, although the bride should not be staring at the photographer when she is being tenderly kissed by her husband.

FIGURE 11.1

FIGURE 11.2

Her connection with the photographer during an intimate moment makes the bride appear more interested in the photo than in the groom. But the critical issue, even more so than the moment being clearly interrupted by the obvious presence of the photographer, is the lighting. The lighting in this photo simply doesn't make sense. The light is illuminating the couple in all the wrong places. Furthermore, it also leaves splotches of light on their bodies and faces, which are extremely distracting. The lighting is not complementary to either the bride or the groom. The next time you shoot a wedding, I hope this image comes to mind and reminds you that, although you might be in a rush, at least pay attention to the light.

Figure 11.3: For this photo, I was attempting to be fancy and create a foreground/background composition by having my assistant hold the bouquet in front of the lens. For the background, I had the couple pretend that they were at their first dance, even though we were in the middle of an ugly alley. When looking at this photograph, your brain probably hurts. Too many questions come to mind trying to make any sense of this scene.

Looking back, this is an open shade situation. Although the lighting is weak, there is still some light coming from the right side of the photograph. I could have changed my angle and had the couple face the light featuring both of them, giving the couple the best light at the scene. This would also have removed that random blue square from the composition. Remove the bouquet from the foreground, and this photo might have had a fighting chance.

FIGURE 11.3

FIGURE 11.4

Figure 11.4: In an attempt to be clever, I tried to create a foreground/background scenario using reflections to add a level of complexity and creativity to the image. This photo begs the question, "How does this make sense?" It doesn't. First, there is far too much context in this photo. Usually, when reflections are used, you don't want the viewer to know where the reflection is coming from. There is no scenario in which a bride's head would appear to be coming from the piano keys, her eyes staring at the photographer, while her husband is standing on the other side of the piano observing her.

Again, looking back, if I had to create a similar photo now, I would choose a part of the piano surface that is completely clear of any distracting elements. I would lower my angle to be just inches from the piano surface. Next, I would make sure that both individuals have strong yet flattering light to increase the clarity of the reflection. But the most important decision here would be to create a scenario that is believable and that could happen naturally between the couple. Perhaps they would be holding champagne glasses and having a peaceful moment on their own away from the dance floor, and they happen to find a quiet corner by the piano. Finally, I would create a composition that would show the couple, their reflection on the piano surface, and nothing else. I would keep the viewer of the photo guessing how or where this reflection comes from, while they enjoy looking at a beautiful and quiet moment between the couple.

Figure 11.5: Although this could potentially be cute, it's also completely abnormal. One of the best skills I have developed from years of pushing myself to be a better wedding photographer is to keep things simple. Simple and beautiful goes a long way in wedding photography. This photo represents thousands of photos that I have unfortunately taken myself or that I see inexperienced photographers take. The awkward pose is so obvious and the idea so gimmicky that it completely robs the image from what could have been a beautiful and elegant bridal portrait.

FIGURE 11.5

Having different ideas is good, but there is so much context in this scene. For example, you can see quite a bit of the room—the carpet, the large windows, the sofa. You need to create a believable scenario in a room such as this to take a successful bridal portrait. Posing the bride belly down with her legs up on this ottoman is far from natural. Ask yourself, if you were about to be married, would you plop yourself down on an ottoman such as this on your wedding day? You most likely would not.

It is important to remember my purpose for showing you these photographs. It's not the photos themselves that are the problem; it is the fake, gimmicky poses and staged ideas that do not resemble a sense of reality at all. I have continually strived to create new ideas in photography. Now, I always ask myself, "Could this pose or my concept occur naturally, or does it appear staged for that particular situation?" When I'm not sure, I trust my immediate instincts. Often it is the lack of a genuine expression that proves that the photo was staged by the photographer.

Figure 11.6: It is very important for me to see a higher level of wedding photography across the board. When you begin to feel insecure about your creativity or skills during a wedding, when you are drawing a blank, and when you are aware that your clients notice your anxiety, this is when photographers are trapped into devising staged scenarios that make absolutely no sense. It is this insecure feeling that compelled me to come up with this photo. I was quickly losing light, and I had no idea what to do with the bride and groom. So, in an attempt to appear creative, I asked the bride and groom to sit in different rows that were set up for their ceremony, look at each other, and smile.

FIGURE 11.6

If we pause and analyze this photo, we notice that it suffers from far too much context. The context shows a scene of their ceremony setup. By showing the entire scene in the photo, I am making that scene a part of the story. But there is no story to tell. As you read this, take a moment and try to think of a pose that would make sense in this situation. What could the couple be doing in remembrance of their ceremony that would look natural to the viewer? If nothing comes to mind, you could always position yourself behind the bride or groom, and shoot from there to show what they see from their perspective. For example, you could position yourself behind the groom about 20 feet away and use a telephoto lens to crop tight and show the bride's face smiling through the groom's shoulder. By cropping tight, you crop out the entire scene and now the story becomes just about the couple, not about them and their ceremony location. Big difference.

Remember that if you are going to include the context of the scene in the photo, be sure that what the bride and groom are doing within that scene could have happened naturally. Keep it simple, and you will have a higher yield of successful photos.

EXAMPLES OF SUCCESSFUL SITUATIONAL POSES

Figure 11.7: In this example, there are two main factors that contributed to achieving a great situational pose. First, the strong high-contrast directional light tells me exactly where to position the bride. Imagine if I had posed the bride three or four steps further down the staircase. She would have been in complete darkness, and I would have missed the beautiful light coming from the window to the camera's right and bouncing against the wall. Second, I chose to show the context of a stairway inside a building. What do people normally do on stairways? They go up or down the steps. Therefore, I posed the bride in such a way that it appears as if she is simply going down the steps, perhaps making her way to the wedding ceremony. The bride is looking down toward the steps and thus not looking at the photographer. Therefore, you don't really see or feel the presence of a photographer in this photo.

Figure 11.8: The structure's wall directly behind the bride and groom makes this an automatically "dynamic" situation. As soon as I saw the wall, I knew a lively fun pose and expression that would go very well with it. I liked how the various green objects framed the couple: the grass at the bottom, the plants to the left and right of the couple, and finally the trees above them. For this reason, I decided to include quite a bit of context in this scene. I want the viewer to feel as if the couple were on a distant, exotic island. Although the lighting was flat because we were under open shade, I strategically had the bride turn her face to her left and upward to catch as much of the diffused sunlight rays as possible. This improved the lighting on the bride's face significantly, even though we found ourselves in a low-contrast lighting situation.

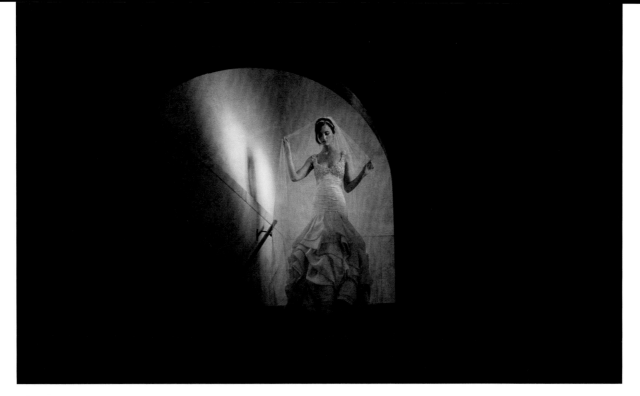

FIGURE 11.7

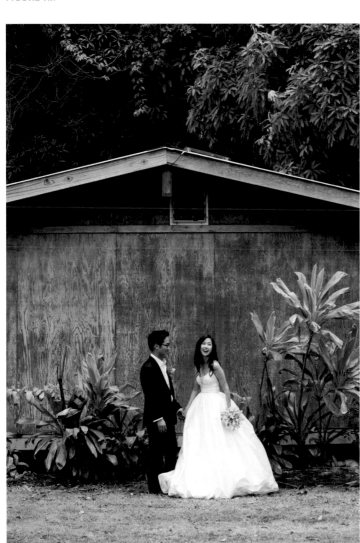

FIGURE 11.8

Figure 11.9: During a wedding in the tiny, remote town of Donegal, Ireland, I noticed this beautiful gate framed by the two cranes. Again, I asked myself, "What do people normally do when facing a gate in a pathway?" They cross the gate. So, instead of trying to have the bride strike some awkward back-breaking pose with her hands on her hips, I kept it simple and had her hold her dress and just walk slowly through the gate, away from me. That's all. This turned out to be one of the bride's favorite photographs.

You might be asking yourself, why did Roberto pose the bride walking away from him rather than walking toward him? Well, look at the direction of light. You can tell by her shadow that the sun is directly in front of her. I wanted to create a moment when the bride would be peacefully walking away, while the sunlight created a beautiful rim of light around her entire body. This photo has a romantic undertone to it because this scene has depth. Clearly, quite a bit of context is necessary to show that the bride is outside and walking through this stunning iron gate. The action of the bride is perfectly natural with the location.

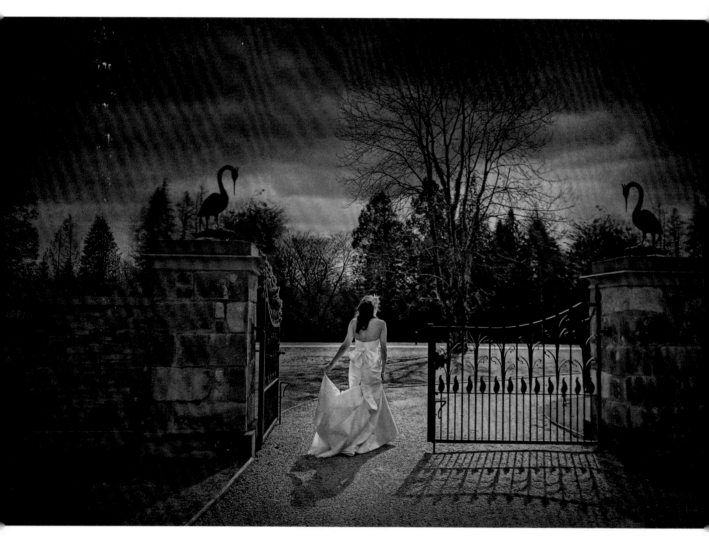

FIGURE 11.9

Figure 11.10: This photo was taken at a public park in Los Angeles and is similar to Figure 11.8, I noticed that the brown of the tree trunk on the left and the brown branches on the right frame the couple, who are positioned in the center of an even patch of green foliage. The direction of the light was coming from in front of them toward me. The fact that there was depth in the scene led me to create a soft romantic pose using the direction of light to achieve a flattering and romantic rim light around them. Because there was nothing else to see that would add to this photo, I cropped tight. By removing most of the context, the viewer remains fixated on the loving moment between the couple. To maintain a natural feel to this pose, I had to make sure that their expressions were legitimate. The bride is looking down, almost closing her eyes, while he tenderly looks at her eyes. It appears as if he paused during their short walk in the park to whisper something that he finds charming about her and she reacted affectionately to his compliment. Most likely, when you see this photograph, you see the moment between the couple, not the photographer staging this pose. Good posing means you don't notice the pose.

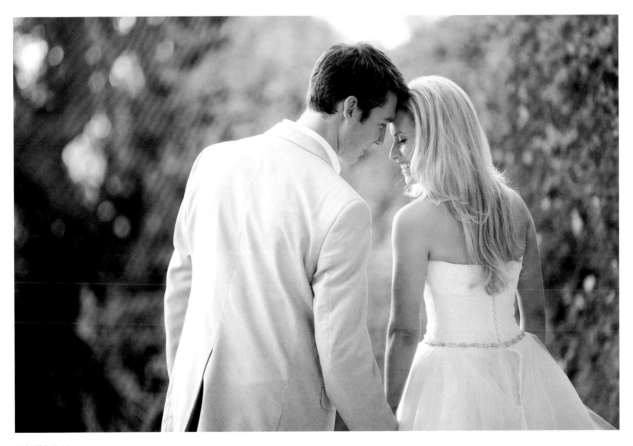

FIGURE 11.10

Figure 11.11: At the beginning of this chapter I discussed location context considerations. This is a great example to review to determine whether or not to show context. This is from the wedding of my great friends Brooke and Alexander in New York City. They asked me to take some of the photos at High Line Park. As it turns out, we were not the only ones who thought to take a stroll down the High Line on a sunny Saturday afternoon (Figure 11.12). The place was crowded beyond belief, and it was also surrounded by buildings, plants, billboards, etc. I felt inspired by one of the billboards, which showed a photo of a woman in black and white. The problem was that it was across the street, and there were overgrown plants and junk all around it.

FIGURE 11.11

FIGURE 11.12

This is when getting rid of context comes in handy. I wanted to create a photo where it appears as if the woman in the billboard is either possessively observing the groom or looking at the viewer of the photo as if she is a protective figure for the groom. I used my Canon 200mm f/2 lens to crop out the entire scene except for the woman's eyes. To keep the pose simple and natural, I posed the groom as if he was reacting to something amusing on the road toward his left. The result is a unique photo where the viewer has zero context of the location or its surroundings. However, you are intrigued by the composition of the groom and "big sister" protectively looking over his shoulder.

FIGURE 11.13

Figure 11.13: I wanted to finish the chapter with this example because I feel it showcases situational posing at its best. During Brooke and Alexander's wedding photo shoot at the High Line Park in New York City, I thought it would be fun to have the couple sit down on the bleachers and enjoy a quick moment in the sun. This time, instead of cropping the public out of the photo, I decided to not fight them, but to include them to create a much higher energy photo. It is New York after all, right? So, I asked myself, if I were sitting on the bleachers minding my own business and suddenly a couple sits close to me on their wedding day, what would happen? Well, a person can't exactly ignore them; I would naturally stare at them, and maybe say something congratulatory to them. Then if one person says something, maybe another will, too, and the next thing you know, people begin to laugh and stare and enjoy the moment they are sharing with the couple on the most important day of their lives.

So that's exactly what I did. I had the bride and groom sit on the right side of the bleachers to isolate them from the crowd, and I asked everyone to look at the couple, knowing that they would soon break into natural laughter. Almost everybody laughed and was having fun! Brooke and Alexander didn't stand a chance, and they also cracked up at the looks and sounds of everyone staring, smiling, and laughing with them.

I absolutely love when the situation, the pose, and the moment work perfectly together! The reason why people have a negative association with posing is because many times photographers place their clients into poses that are awkward, unnatural, staged, and make no sense in a particular situation. When you can imagine poses that go well with the situation, the photo appears believable, and the pose is not even noticed. You don't have to contort someone's body to take a good photo. The best thing to remember is to keep it simple.

chapter 12
THE MECHANICS OF GROUP POSING

Whenever I teach at my national and international posing workshops, photographers share with me that one of the most common and greatest challenges they face is how to properly photograph groups. I am frequently asked questions such as, "How do you handle so many people?" and "How do you keep track of what everyone is doing?" And most importantly, "How do you keep everyone focused and attentive to what you are saying?" As you are reading this, you are probably nodding your head, remembering past frustrations.

The two key differentiating factors between family photographers (or any other photographer who commonly photographs groups) and wedding photographers are *time* and *purpose*. When a photographer is taking a family photograph outside of a wedding event, the family is there for that specific purpose. They can and want to give you all the time you need. The family has invested money on coordinating clothes, set aside an afternoon when everyone can be together, and made sure everyone looks their best.

By contrast, people do not attend weddings to be photographed. They are there to see friends, eat and drink, enjoy themselves, and be supportive during a loved one's important day. People at weddings are distracted and overwhelmed by the number of people they want to reconnect with and talk to. Weddings are social events, not an eight-hour photo shoot. Regardless, people at weddings fall into three different groups that wedding photographers must deal with: the wedding party, the family (direct and extended), and the guests. These three groups have varying levels of interest and patience when posing for photos. Being aware of their differences regarding group photos can help photographers be more efficient with what little time they have.

WEDDING PARTY

The wedding party is heavily invested in the wedding photos. These are the photos for which you should spend the most time posing and lighting the scene correctly. Even though some of the wedding party members are not particularly excited about taking group photos, they will most likely cooperate to prevent any conflict with the bride or groom on their wedding day. It is to be expected that if a guest is chosen to be a member of the wedding party, he or she will be photographed. They have also rented tuxedos, bought dresses, and are the bride's and groom's closest friends. They are with the couple from the very beginning of the day. This means that you should try to schedule more time with the wedding party earlier in the day before the wedding becomes hectic. I think it's also important to photograph the groomsmen before they are dressed in their formal attire. This gives you time to get to know them in a more casual environment.

With the wedding party, you definitely have more freedom to experiment with the different sets and poses, and even scout for great locations. I have identified four different kinds of group poses for wedding parties.

Four Types of Wedding Party Group Photos

- Simple and traditional (standing next to or framing the bride or groom)
- Together, reacting to something or someone
- Mutual activity or excuse to have them all together
- *Vanity Fair*-style group portraits

At every wedding—and depending on how much time I have, of course—I try to create at least one of each of these kinds of group shots. Doing so correctly greatly increases the variety and stylistic options for the album and your clients.

Most wedding party members are young and don't mind the variety of options, but their patience is limited. Wedding party photoshoots are accomplished more smoothly for the photographer if they are clearly scheduled on the wedding timeline, hence the wedding party knows when to arrive for the shoot. People become frustrated when they are caught by surprise. I go as far as telling them when and for how long I will I need them so that they know what to expect. I find that by keeping people informed, they become much more cooperative. A great danger with wedding party photos is how many of them are over-staged and thus appear corny, unsophisticated, and senseless. As I have said before, my best advice is to keep the pose simple and elegant, rather than force a group pose idea without proper execution.

Failed Wedding Party Group Posing

Figure 12.1: This is a good example of trying too hard. During my first years as a wedding photographer, I tried to create poses that portrayed the groomsmen as being tough men. To be honest, I didn't have much guidance then. As a result, I created this image that has all the groomsmen spread out, grimly crossing their arms, and looking in different directions for no reason whatsoever. As you are reading this, you are probably wondering, "How am I supposed to know if my group photo idea is stupid?" Actually, there are many questions you can ask yourself that can give you some hints:

FIGURE 12.1

- Is the pose so senseless that it is distracting?
- Do the people in the photo appear to be trying too hard?
- Are they all in the same pose/mirroring each other?
- Is there a logical or natural reason for the people in the photo to be posed that way?

Mentally going through this list while you are preparing to take the photo will definitely help you make adjustments and avoid corny photo ideas.

Figure 12.2: This example is not necessarily a big failure. The photo is simple, and it achieves its purpose of showing the bridesmaids with the bride. However, this book is about elevating the approach to wedding photography. The greatest flaw with this photo is that all the bridesmaids are mirroring each other. There is no visual variation among any of the women. They are also holding their bouquets in exactly the same way. At the bare minimum, if I am in a rush and need the wedding party photos finished quickly, I will put the bridesmaids and bride together and make sure they are not mirroring each other's poses. A suggestion as simple as holding the bouquets in a different way and at different heights would eliminate the mirroring issue.

Figure 12.3: This photo severely violates the last question mentioned above. Is there a logical or natural reason for the men in the photo to be posing that way? No! There is no reason why the groom would naturally squat in the street while his groomsmen, positioned together in the background, are awkwardly looking at him. If you really want to think outside of the box and create different types of wedding party portraits—which is a good thing—just remember that the key to proper execution really depends on your creating a pose that could have happened on its own. It must make logical sense to the viewer.

FIGURE 12.2

FIGURE 12.3

Figure 12.4: The idea here was to create a photo in which the bridal couple is dancing in the center of the gazebo while the wedding party stands around the perimeter of the gazebo as if they don't notice the couple. At first glance, this photo screams, "Over-staged pose composed by the photographer!"

FIGURE 12.4

Think. Why are the members of the wedding party so evenly distributed around the gazebo? Why are they not looking at the couple? Why is each couple standing so closely in each other's personal space? Why is the bride's bouquet on the ground in front of them? You would have a hard time answering any of these questions with any kind of satisfaction. The reason is because nothing about this photo makes any logical sense. The concept is gimmicky and lacks sophistication.

Successful Wedding Party Group Posing

Figure 12.5: From the list of the four types of wedding party group photos above, this photo is an example of a simple and traditional pose. However, if you just have people stand together and take a photo, this does not mean that you have elevated your work above other photographers. To do so, you need to be aware of a few posing elements.

Keep in mind that this is a book on wedding photography. I make such an obvious statement to bring attention to a not-so-obvious fact. The fact is that it is very difficult to remember or try to implement all the posing mechanics listed below when shooting under the relentless pressures of a wedding. For this reason, I suggest you do your best to implement as many of these as you can remember. These five suggestions below yield the highest impact when creating a flattering group pose with the lowest amount of required effort.

FIGURE 12.5

Basic Mechanics for Group Posing of a Higher Standard

- **Subjects' collarbones are not all facing the same direction.** This breaks any obvious patterns or mirroring in the pose.

- **Either heads or hands are posed at various heights.** This forces the eyes to travel up and down throughout the frame.

- **People are leaning their heads toward each other.** This makes individuals appear emotionally closer to each other.

- **They are leaning slightly toward the camera.** This move highly increases people's interest and engagement toward the camera

- **Their body weight is shifted so they don't stand equally on both feet, and one leg is bent.** This move flatters women's curves, and it creates a sense of relaxation for both genders.

These five instructions are key to elevating your group portrait work to a higher level. You want to create poses that force the viewer's eyes to naturally wander around the whole frame. You can achieve this by making sure that the second item on the list is present in the group portrait, meaning that you want to give the eye a reason to travel up and down the frame. You can position people at different heights by having them lean down, kneel, sit, or stand. In this photo, since everyone is standing on level ground and they are holding their bouquets, I created the height differences using the bouquets. If I had asked the bridesmaids to hold their flowers in the same way at the same height, the photo would have lost much of its natural impact and would have appeared much more robotic and stale. In this type of traditional group portrait, it is quite important to have the wedding party lean a little toward the camera. This creates the feeling that they are interested in their photo being taken and appear highly engaged with the camera—and thus the viewer of the photograph. If they had simply stood straight, the group would appear much less interested and not as dynamic.

Figure 12.6: This is an example of the second type of group photo on the list: together, reacting to something or someone. In this case, I scattered the wedding party in such a way that it appears imperfect. The goal is to frame the groom with his friends but not make it look as if the photographer had staged their positions. It must look natural. To do so, I broke up any possible symmetry that might be a telltale sign that I posed it. For this reason, I placed four groomsmen to the groom's right and two groomsmen to his left. I also positioned the groom's collarbones directly toward the camera to make him appear larger and more important; he is taking up more space than his groomsmen. The last piece of the puzzle was to make them react naturally. By this time, I had gathered enough information about each of them to tell an appropriate joke that would be funny to them but not offensive to anyone else.

FIGURE 12.6

Figure 12.7: Here is a similar photo as the previous example, except that this time I posed the bridesmaids. The ladies are all naturally reacting to something I said or to each other, and they are asymmetrically framing the bride. Their hands gently resting on each other creates an extra layer of emotional connection. It is important to know that I don't necessarily love everything about this photo. The biggest issue for me is answering the question of "Why?" Why are they all huddled up together in the corner of a room? Would people normally stand there? The answer is no. Most likely, people would not find themselves in this position unless they were asked to do so. However, at weddings, the photographer must make many quick decisions based on time. As at most weddings, these bridesmaids were quite late getting ready. We had very little time left to do bridesmaids portraits or even portraits of the bride. For this reason, I decided to sacrifice the believability of the pose in order to prioritize the quality of light.

FIGURE 12.7

Figure 12.8: This photo represents the third type of wedding party group photos: mutual activity or excuse to have them all together. This photo is a portrait of the bridesmaids without making it so obvious. Since they are all helping the bride finish up the small details of putting on her dress and veil, you are able to see the bridesmaids and their expressions. In order to change the height of their heads, I asked the bridesmaid on the right to kneel down and adjust the bride's dress. This was a perfect request to lower her head. Try to imagine the bridesmaid on the right standing up like all the others. Not as good, right? The fact that her head is at a lower level than the rest causes your eye to travel around the frame and gives the photo a nice balance both horizontally and vertically. I also took a few extra seconds to make sure that their hands were positioned at different heights by asking them to hold a different part of the dress or veil. Also, notice how the positions of the bridesmaids naturally frame the bride.

FIGURE 12.8

Figure 12.9: This is a traditional photo of the ring bearer and flower girls with the bride. By taking an extra 20 seconds to find a chair for the bride, I was able to keep the various heights more equal while still maintaining a variety of heights for the eye to travel throughout the frame. This basically puts everyone at the same general level. I also put the ring bearer on one side to provide balance against the three flower girls on the other side. Furthermore, their hands are in different places.

FIGURE 12.9

Figure 12.10: This is another variation of the flower girls photo, but this time, instead of being so "portrait-like," I had the girls gently play with different parts of the bride's dress in order to achieve an active portrait. I wanted them to perform this mutual activity as an excuse for them to be together, while effectively framing the bride.

Figure 12.11: This is a portrait of a large wedding party. After taking a traditional photo of them dressed elegantly and looking at the camera, I then mixed things up by having many of them change position. I found chairs for them to sit on and created two shorter rows instead of one long row. This is a fine example of a large wedding party reacting to something or to each other. Since everyone is reacting differently, it gives you a sense of their unique personalities. Taking the extra effort to create this fun group portrait gives the clients a great contrast to the traditional yet indispensable wedding photo. To take a photo such as this, you must be confident. You cannot possibly expect a large wedding group to respect you or react to what you are saying if you are timid and unsure of yourself. You must be confident, or this will go very wrong. Trust me. Let go of your inhibitions and have fun with them.

FIGURE 12.10

FIGURE 12.11

Figure 12.12: Finally, let's discuss the more *Vanity Fair*–style group portraits. I use the term loosely because "*Vanity Fair* portraits" means different things to different people. For me, the core of this style is a highly composed photo with great attention given to composition and to creating a sense that every person in the photo is relaxed and very much showcasing their own individual personalities. These portraits are usually taken of people in various positions, such as sitting, lying down, and standing. This variation of heights is key to this type of portrait. In this example, I used the couch and the armrests to seat people at different heights. To create an even greater variety of heights, I asked two of the groomsmen to sit on the ground. Now you can see how your eyes travel across the frame, up and down inspecting each person's facial expression.

FIGURE 12.12

Figure 12.13: The same principles apply in this photo as in the previous image, except that I posed all of the bridesmaids. Notice everyone's hand positions. Also notice how I used the bed, the floor, and chairs to create different positions that place everyone at different heights. The subjects' collarbones are facing so many different directions. Collectively, these adjustments add to the success of this highly stylized group portrait. If anything, remember this: *variety equals interesting*.

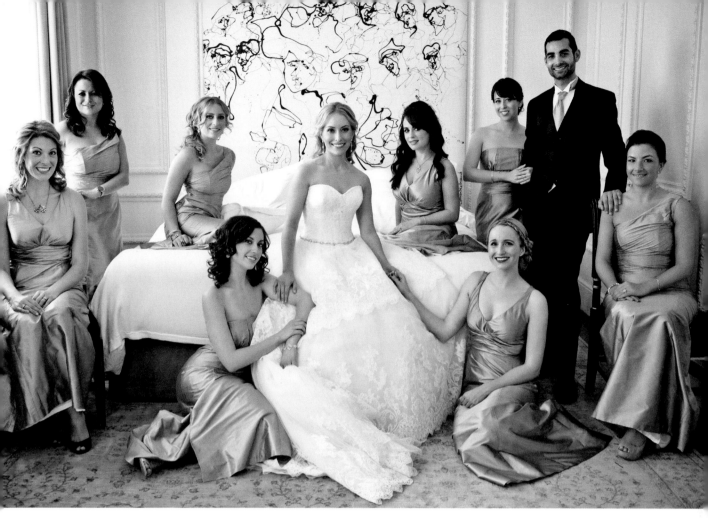

FIGURE 12.13

FAMILY GROUPS

When photographing family groups, your posing should show the viewer a sense of unity and family togetherness. The pose should reveal that these people love each other as a family. I see far too many family photos in which people are posed like robots, standing like stiff soldiers, looking at the camera, and smiling awkwardly. Remember there is a *big* difference between taking a photo of what people look like and taking a photo that captures the essence of who they are, which gives the viewer a hint of their true personalities. A master wedding photographer will always create family photos that convey more than just the fact that family members were there and what they looked like. Work just a little harder to create photographs that have soul and that display loving energy among the people in the photograph.

Failed Family Group Posing

Figures 12.14 and **12.15:** These two family photos represent the millions of soulless family portraits that photographers have taken at weddings. They are simply photos of people standing next to each other but with no visible connection at all. Their arms are not touching, their heads are not tilted toward each other, and their expressions are empty or awkward.

FIGURE 12.14

FIGURE 12.15

I understand that during these family photos, time is not on your side. Usually they occur when the sun is setting, and most family members would rather be catching up with old friends and other family members. Working quickly is very important, but not at the expense of the family photos. After all, a wedding is a family affair. In the Persian community, the family photo session is the most important part of the entire day. To work as fast as possible, I keep the poses relatively traditional and very simple. But I do follow the five basic mechanics for group posing listed above. They will greatly help you create photos that show the emotional connection between the various family members in each set of photos.

Successful Family Group Posing

Figures 12.16 and **12.17:** Figure 12.16 represents a quick photo with beautiful light on the groom and his father. There was a language barrier for me because the father was Egyptian and did not speak English. However, I understood enough to realize that he wanted me to take a quick photo of him with his son. That's wonderful. Mission accomplished.

FIGURE 12.16

FIGURE 12.17

But to elevate your work, you must take an extra step to transform a simple photo into a great moment that your clients will always cherish. Figure 12.17 is exactly that. Taking advantage of the beautiful window light, I quickly asked the groom to give his dad a warm embrace with his head over his dad's left shoulder. I asked this because I wanted the groom's father to receive the full glory of the window light in order to best feature his face. I wanted his son to remember this moment forever. If you have a little more time, always try to create emotional photos such as this one between the bride or groom and their parents or grandparents.

Figures 12.18 and **12.19:** During the family portrait portion of a wedding, the grandparents are almost always important family figures for the couple getting married. In this case, the groom's grandmother was not too happy to have her photo taken. To show her displeasure,

she refused to look at the camera, no matter how hard the groom and his brother tried to coax her. I could have taken the photo shown in Figure 12.18 and called it a day. It's not my fault that she doesn't want to be photographed, right? And who can blame you?

FIGURE 12.18

FIGURE 12.19

But I don't want to take that attitude when I know this photo could be a treasure for the family someday. I motivated myself not to be satisfied. I asked the groom and his brother to give their grandmother an unexpected kiss on her cheeks at the same time. She couldn't resist, and began to laugh. Now the family will cherish this photo for the rest of their lives.

The moment you begin to feel complacent about family photos at weddings, you should probably find another line of work. Weddings are all about families coming together and celebrating the beginning of a new family. It is crucial to recognize and respect the importance of doing a great job during the family portraits. Throughout my career, I have come across wedding photographers who say they refuse to take family photos because it's not stylistic or it cramps their style. That's a real shame to deprive your clients of photos that could be deemed priceless in the future.

Figures 12.20 and **12.21:** During a beautiful Indian wedding in Southern California, I found myself rushing through the family photo shoot due to a lack of time. I did a credible job of keeping the photos warm and traditional. In Figure 12.20, you can see that the family members are leaning slightly toward each other, that they have nice smiles, and that their arms are positioned in different places.

FIGURE 12.20

However, for Figure 12.21 I asked the bride if we could do another quick set of photos with her parents that would have much more warmth. I just needed them to be close together and forget about the camera for a second. I positioned their hands and then asked the father of the bride to look at his daughter, the groom to look at his new mother-in-law, and her mother to look at her husband. This created the perfect amount of awkwardness due to their close proximity to each other. Guess what people do when they are in this situation? They begin to laugh. It's a human defense mechanism to laugh when you feel awkward. A little awkwardness is a powerful tool that a wedding photographer can use to create genuine expressions.

FIGURE 12.21

Figure 12.22: This is a photo of the bride and her sisters. Again, I used awkwardness to create this portrait. I strategically told the sister on camera left to look at her other sister's (camera right) wrist. Then I told the bride to look at her sister's strand of hair coming over her shoulder. Finally, I told the sister at camera right to look at the bride's bouquet. But not to do so until I told them. I then counted to three and said, "Ok, now." The odd spots they were asked to look at on the count of three caused the perfect amount of awkwardness to create these beautiful expressions on each of their faces. The fact that I'm absolutely confident while I'm setting up this photo, which could very easily be perceived as silly, is what makes the subjects not mind my direction and just go with it.

FIGURE 12.22

GUESTS

In my experience, guest photographs are quite interesting. They are the most underrated photos a photographer takes at a wedding and are possibly the most financially lucrative. Guest photos require the least maintenance during and after the photo is taken. As you know, guests almost always attend weddings accompanied by one or more people they care about. If it is a family, they come together. If it's a single man or woman, he/she brings a significant other. Therefore, for guests, a wedding is an excellent reason to dress up, do their hair, put on some make-up, and spend time with people they care about. For these reasons, you can be sure that when guests see a photo that the photographer took of them in a web-gallery service, such as Snapshots, they will buy it in different sizes and use them as gifts for other loved ones.

In terms of posing, these photos are as low maintenance as can be. You don't have to do much except place the subjects together, make small adjustments to the poses (and perhaps their clothes), and make sure that they smile nicely. The aesthetics of the background are not as important, either. If the lighting is flattering, guests just want to stand where they are and have a quick photo taken of them. It takes perhaps five seconds, tops.

part four

STORYTELLER
APPROACH COMPONENTS

chapter 13
THE STORYTELLER'S APPROACH

During my years as a professional classical guitarist, I had the privilege of learning music and guitar techniques from some of the best in the industry. I would attend master classes, perform solo concerts, and listen to classical guitar competitions at the University of Arizona in Tucson. During those years, I had a guitar on my lap eight hours a day, including Sundays. I was hungry for knowledge, and I was determined to overcome the greatest obstacle facing any classical musician: "technical virtuosity." That term almost drove me crazy in my quest to achieve it. But as I matured as a musician, I realized that it can never be truly achieved. There will always be a better guitarist than oneself, and there will always be a master's opinion that contradicts another master.

When interpreting a piece of music, I encountered some of the most intense music purists who would condemn anyone who strayed from the exact music interpretation markers and timing of the notes that were written in the score. After such encounters, I tried to replay the sheet music with the precision of a computer. During that unfortunate phase, countless friends in classical guitar circles told me that I had lost my soul, and that I played like a robot. I decided to dump it all, and I went back to playing the way that resonated with me and my audience. I kept learning and attending masterclasses, but the information was used to complement my style of playing. Unknowingly, this experience as a musician prepared me a great deal for the peculiar world of wedding photography.

I hear photographers at conventions make their case about how the photojournalism (PJ) approach is the way weddings were always meant to be documented. Some hardcore PJ purists even go so far as to say that they document an entire wedding without ever intervening in any way, shape, or form. These photographers go on to say that they do not take family photos during a wedding because that would require the photographer's intervention. My jaw drops in disbelief. No family photos? Not even a single portrait of the bride and groom? Really?

At the other extreme, I also sit through many seminars given by internationally well-known wedding photographers who treat a couple's wedding as their personal playtime. These photographers schedule four hours or more just for the photos of the bride/groom, wedding party, and getting-ready portraits. These weddings turned into a daylong photo shoot so that the photographer can win photography competition awards and show off how talented he or she is at the expense of the couple's wedding day.

Just as during my music career, there were all these extreme and opinionated experts, except that in wedding photography I wasn't going to spend years learning the hard way. Extreme approaches very rarely work, if they work at all. After shooting more than 500 weddings in my career, I have learned that the more knowledge I have about all aspects of wedding photography, the better equipped I am to use my skillset as needed or at my own discretion.

This means that learning how to pose people well so that they look completely natural is a skill that could not possibly hurt you to learn. Even if your preferred style is photojournalism, there may come a time when you are asked to arrange some photos for the couple or for their families. At the very least, if you have the skill to arrange and pose clients well, you can accomplish it with ease. In my opinion, it is simply better to have the option to use the skills you have acquired rather than not have the option at all and appear unprepared or unprofessional. I consider some people to be true masters of wedding photojournalism. Interestingly, most of the people who are world-class wedding photojournalists have taken the time to learn posing, even if they don't use it for most of their work.

Simply stated, a photographer who is well rounded in the five storytelling approaches covered in this chapter will be best prepared to deal with any situation that this profession can throw at him or her, and will also be best positioned for long-term financial success as a wedding photographer.

For example, during the getting-ready portion, you can photograph all the moments without saying a word. There are also plenty of opportunities to perhaps pose the bride for a quick portrait, or arrange a shot between the bride and her bridesmaids, or the bride and her parents. Any combination of these approaches is appropriate and advisable during this time.

Obviously, during the ceremony, you are not going to be interrupting to pose the bride or groom, which is why the only approaches that are appropriate at this time are pure photojournalism and story development.

Here are the five different approaches that a photographer can choose from during every phase of a wedding:

- Photojournalism
- Interactive photojournalism
- Stylized aware posing
- Stylized unaware posing
- Story development

These five approaches are part of your toolset, which you can use to tell the wedding story. They are all distinct approaches, and they aptly fit different storytelling pieces of the puzzle. It is important that you become well aware of the unique characteristics of each of these five storytelling approaches, because they should all come together to beautifully complete the story. Let's go over them one by one.

PHOTOJOURNALISM

The photojournalistic approach is implemented when the photographer quietly documents the wedding moments without any intervention, suggestions, or input. A highly skilled photojournalist draws attention to the intended story through clever use of circumstantial light and, most importantly, visually intriguing composition, such as framing, balancing, and the use of contrasting elements. The goal of this approach is to capture emotional moments that tug at the viewer's heartstrings. Moments can be tender, sad, happy, or filled with pure joy. A great photojournalist captures this array of human emotions at their peak in order to achieve the highest impact in a photograph.

Figure 13.1: This is a photojournalistic photo showcasing a special moment when the father of the bride is helping his future son-in-law put on the traditional Sikh turban. Although this is a nice image that depicts two stories happening at the same time—the woman on the left is placing objects on an ironing board—the two stories are just not on the same level. The woman's story is not powerful enough to distract from the true, main story of the two men. If she had actually been ironing clothes or getting ready herself, that would have been better, but simply placing something on the ironing board is a weak moment. It doesn't tug at my heartstrings at all. It's just an action, not a moment worth remembering.

FIGURE 13.1

The Semantics of "Posing" in Wedding and Portrait Photography: From "Staging" to "Posing" to "Adjustments"

"Posing" is a word that has a negative connotation for most people. The only worse word that a photographer can use is "staged." Even though I wrote an entire book about posing (*Picture Perfect Posing*), I rarely use the word when discussing with clients how I photograph a wedding. After interviewing hundreds of brides for my wedding business, as well as for this book, I realized that, although a great majority of couples say they prefer not to be posed for photos, they all agree that they still want to look great and have memorable photographs. Do you notice the contradiction? As it turns out, the culprit isn't the actual act of posing; it is the word "posing." Once I discovered this resistance, I simply replaced the word "posing" with the word "adjusting."

I talk to the bride about making adjustments so that she looks beautiful. I even show her examples of photos in which a bride is putting on her shoes without any adjustments, and she is hunched over. They are not flattering photos! In the next photo, I show that I simply made some minor adjustments, and that same photo of the bride putting on her shoes looks absolutely beautiful. Suddenly, my client's eyes light up, and she says, "Yes, I that is what I want! Please, feel free to make any adjustments you need, so I look great." The irony here is that when a photographer is making adjustments to the subject's body, they are posing that person! Adjusting is 100% posing. It is like saying "working out" instead of "exercising."

These are the findings of my research. Most brides prefer that their entire wedding be photographed in a photojournalistic approach, but at the same time, they want to be flattered and feel beautiful in their photos. There is no compromise. To make brides look their best in the photographs, posing is absolutely required, though a bride's or groom's stomach turns at the very thought of being "posed." They associate it with being fake, contrived, static, robotic, and unnatural. And if you use the words "staged photos" during your prospective client meeting, they will most likely walk away from you. But use the words "making adjustments" and they will admire you for it. They associate that phrase with being themselves but still looking wonderful.

Throughout this book, and especially in this chapter, I use the word "posing." However, what I mean is to make simple adjustments to better flatter your clients. Who doesn't want to look good in their wedding photographs? So keep in mind that when you read the word "posing" in this book, I mean adjusting. Implementing this special vocabulary in your client meetings will definitely help you with how a prospective client feels about your approach and whether or not they want to hire you.

Figure 13.2: In this photograph, I changed to a vertical crop to remove the woman on the left from Figure 13.1 out of the composition. This image is nicely balanced with the father of the bride on the left and the groom on the right. It's a good moment, but we can do better.

Figure 13.3: Finally, I achieved the moment I was looking for, and this is the best of the three images. Remember, in photojournalism, the more effectively you draw the viewer's eye to the story, the more skillfully crafted the PJ photo will be. In this case, I have removed all distractions from the intended story of the father of the bride helping his son-in-law with the turban. This moment is especially touching because the groom is of Latin descent, which suggests that he is experiencing a cultural difference between his and his father-in-law's cultures. Also, two generations are depicted in this photo. Generations are highly respected hierarchies in most religions and cultures.

Next, by switching my shooting angle, I achieved a "rim light" effect that surrounds the groom's face, creating a great separation between his face and the background. Lastly, we have balancing and framing. The photo is balanced by having the father-in-law on the left and the groom on the right. Best of all, by paying close attention and being prepared, I captured the exact moment when the father-in-law's head and arms are perfectly framing the groom's face and expression. This is what photojournalism is all about: the photographer's use of light and unique composition captures amazing and highly emotional moments that the viewer is drawn to.

FIGURE 13.2

FIGURE 13.3

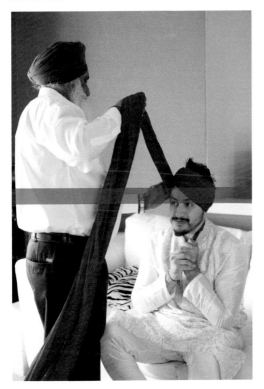

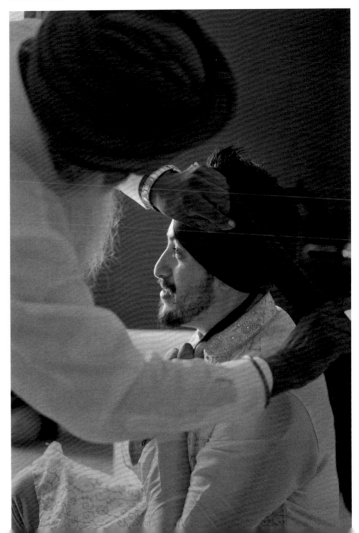

Recommended Camera Settings for Photojournalism

When shooting in PJ mode, I strongly recommend that you shoot in Aperture Priority and have your aperture set to a very wide aperture, such as f/2. These settings will highly increase your chances of capturing fleeting moments, and you'll be able achieve separation between the subjects and the rest of the scene.

Also, don't worry about high ISO settings when you are shooting PJ. In fact, most camera manufacturers have an auto ISO setting in which you can set your own minimum and maximum ISO parameters. This auto ISO setting, combined with Aperture Priority mode and a shallow aperture, is a very helpful way to not have to think about your camera at all, but instead focus on capturing the moments in front of you.

From an aesthetic point of view, shooting at a very wide aperture such as f/2 will be far more pleasing to the eye because the intended story will be the only element in focus. For this reason, when shooting in PJ mode, I almost always use my prime lenses and shoot with an aperture between f/1.2 and f/2. If you can nail the focus exactly where you want it, utilizing such shallow depth of field will elevate your photos and give them a much more elegant look and feel.

Figure 13.4: When shooting using a photojournalistic approach, it's important to remain ready and alert for the small things that could happen. For example, in this situation, I kept my distance far enough away from the bride that as we walked outside to the car that would take her to the ceremony, I noticed the arched doorway. This was enough information for me to stand back and use it as a framing device. Before anything else happened, I instinctively changed my shooting mode to Aperture Priority and my aperture to f/2. Sure enough, seconds later, a strong gust of wind came by and swept the bride's veil away.

I was able to capture this beautiful moment because I was ready. Had I not changed my camera to Aperture Priority mode, I would have had to adjust my settings from inside the mansion to outside where the bride was standing. It would have taken far too long, and the moment would have surely been missed. The framing of the door was another strong element that impelled me to stay behind and use it to frame any possible memorable moments.

Figures 13.5 and 13.6: Search for the peak of emotion. That is precisely what should be on your mind when shooting PJ. You must capture that magical moment when human emotion is at its strongest. While you are holding up the camera to your eye, ready to fire, stay aware of your surroundings because it will help you anticipate powerful moments that will surely include emotions at their peak.

Notice how in both of these photos, I placed the couple on the right side of the frame and balanced the composition with guests on the left side of the frame. If you look closely at Figure 13.6, you will notice the bridesmaids' emotional reaction to the powerful moment the bride is experiencing. Those expressions are part of the story, and they are what can propel a normal PJ photo to becoming a great one. So be ready with the closest focusing point on your camera to the main subject's eyes—or whatever the story is about.

FIGURE 13.4

FIGURE 13.5

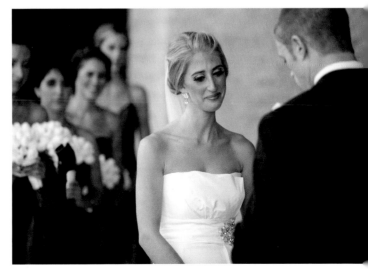

FIGURE 13.6

Figure 13.7: The story could be the body language. A wedding can take anywhere from many months to a couple of years to plan. Every detail is revised and thought about with microscopic precision. The days prior to the big day are full of emotions, family visits, and a great deal of activities planned with family and friends. All for this moment!

This photo represents a snapshot of the plethora of strong emotions going through the groom's mind, as he sees the woman he has decided to spend the rest of his life with walk down the aisle as they become a brand-new family. That is a pivotal moment. In high emotionally charged moments such as this one, you must concentrate and be aware of what this moment represents. As the bride walks down the aisle, I take a couple quick photos of her at the very beginning of the aisle, but

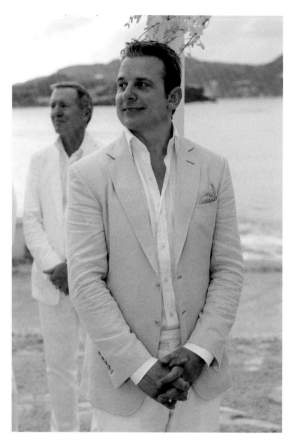

FIGURE 13.7

then I quickly turn to photograph the groom's expression. I was shooting with a 24–70mm lens at 70mm for the images of the bride, but I quickly zoomed out to 60mm to include the groom's hands in the shot. When a cascade of emotions goes through our minds, we instinctively manifest how we feel through our hands and body language without even realizing it. Notice how tense the groom's hands are compared to his groomsman behind him. To me, that was the photo. Had I not zoomed out to include his hands, the photo would have still been a great capture because of the strong emotion on his face. But showing his eyes and capturing the tension in his hands made this shot much more special. Keep your eyes open for body language, not just facial expressions.

Figure 13.8: Be on the lookout for anything that could be used as a frame or reflection. In photojournalism, you must learn to react quickly! Anything you can use to your advantage will help. For example, as soon as I walked into this room, I noticed that the mirror had multiple decorative frames. Whether I used this mirror or not, the point is I was aware of it. To my surprise, the bride was doing a final touch-up, so I quickly moved to the left in order to position the bride directly in the middle of the left side of the two narrow vertical frames and fired the shot.

Figure 13.9: Expect the unexpected. I know it's hard to stop ourselves from looking at the back of the camera to check out our photos. But during a wedding, the unexpected can happen in a split second, then the opportunity disappears. Concentrate on what you are shooting because great moments, such as this one, do not come with a warning. At the end of this ceremony, the rabbi announced that the groom could kiss the bride. At first, the groom did just that: he kissed the bride. After some time, he was still kissing the bride. The kiss's length finally made everyone explode into laughter. I kept my eye in the viewfinder and had my shutter ready to go. I didn't take the first photo of the kiss and then look at the back of my camera; if I had done that, I would have missed this amazing moment when the rabbi burst out laughing at the unexpected length of the kiss.

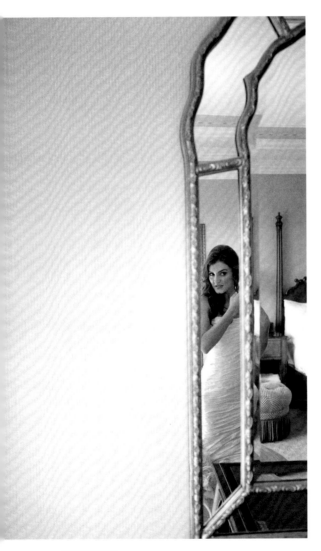

FIGURE 13.8

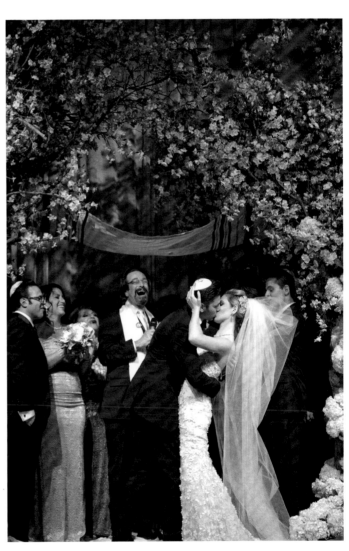

FIGURE 13.9

Figure 13.10: Explore different perspectives. One of the many traditions that occur during a Persian–Jewish reception is having the guests surround the couple, and when instructed by the DJ or MC, they throw rose petals at the bride and groom as they dance. This is a fun event, but it is a very important tradition, so the photographer must capture the energy and love at this moment. For this reason, I looked around and tried to find a better vantage point to capture this event in all its glory. I politely asked the band manager if I could jump onto the stage to gain a higher perspective. This angle allowed me to show not only the bride and groom surrounded by flower petals, but everyone around the couple actively taking part in this beautiful tradition. This photo has become one of the couple's favorites. So, the next time something important is about to happen, think fast and find a better vantage point that will better portray the vitality of the moment.

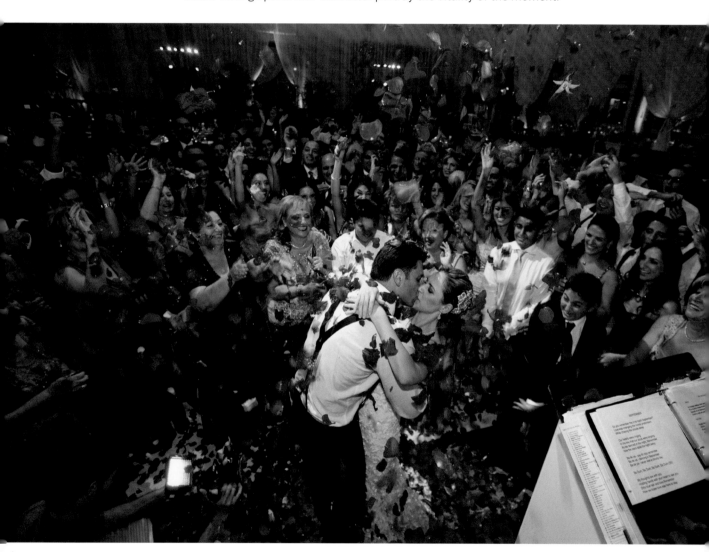

FIGURE 13.10

INTERACTIVE PHOTOJOURNALISM

A photographer is implementing "interactive photojournalism" when he or she arranges certain people together, makes adjustments, moves subjects to a location with better lighting, and/or strategically injects verbal inputs to coax the subjects to naturally react to the situation. Interactive photojournalism is activity-based, meaning that it centers around a natural action such as putting on the dress or adjusting earrings, etc. A highly skilled interactive photojournalist uses both circumstantial light and helper light to create the most flattering light on all subjects.

I understand that for many photographers out there, "interactive photojournalism" is an oxymoron; it's either photojournalism or it's not, and they take a hard line at this: if the photographer influences the scene, it's not photojournalism. In contexts outside wedding photography—such as news or combat photography—I completely agree. But in wedding photography, it's different because besides capturing the stories of the day, our job is also to do so in the most flattering way possible. People understand that you captured a moment as it happened, but if they look horrible in that moment, they might not appreciate it for the photojournalistic capture that it was. People spend a lot of money and time to look good at weddings. They will not mind if the photographer uses his or her expertise to help them look their best in the photos. For this reason, I strongly believe in the term "interactive photojournalism" as it relates to the many aspects of what it means to have great wedding coverage.

Team Interactive Photojournalism

One of the very best interactive photojournalistic techniques I implement is to work simultaneously with my second shooter. Here is how it works: The main photographer is actively interacting with the people being photographed and says something to obtain a reaction from them. As the main photographer is taking their photos, the second shooter is standing nearby, photographing their expressions from a different angle. The subjects are so focused on the main photographer that none of them is aware of the other camera. The second shooter's different viewpoint provides a candid look and feel that your clients will absolutely love and did not expect!

I see very few wedding photographers implement this technique, which is too bad because this approach can yield truly amazing results. Also, note that you can always switch roles with the second shooter, if you want to be responsible or credited for the photos taken from the second angle.

Figure 13.11: Photos such as this one are what made me fall in love with wedding photography. My father passed away not long before my own wedding, so moments like this strike a chord with me that goes deep. This is such a simple photo, but it's so meaningful. In this case, the father of the groom was helping his son adjust his tie so that it would look better.

As I mentioned in the photojournalism section, it's important to be aware of all framing and reflection possibilities in any room you are working in. Many houses in the old city of Boston have large arched entryways from room to room that are perfect for framing! I politely asked the groom and his father if they could continue adjusting the tie but to do so in front of the couch. Now they were framed by the arched entryway. I simply let them continue without interruption and took this photograph. This captured moment is great on its own, but having the moment framed this way creates a feeling of isolation, and it gives the moment much more importance. What I would give to have a photo like this of my father on my wedding day!

Please note that the only difference between this photo and a purely photojournalistic photo is that I asked them to move to a place where I could frame them. That's all. I did not tell them how to act, what to say, or even what to do. I just asked them to move a few steps. The clients appreciated that move because this photo became quite special for them, as well.

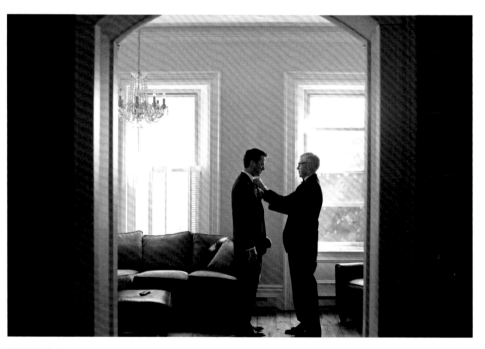

FIGURE 13.11.

Figure 13.12: Remember that interactive photojournalism is "activity-based," not "portrait-based." The activity in this photo is similar to the previous image, with the groomsmen are completing the final touches on their suits and tuxedos. To capture this photo, I became more involved than in the previous example. This time, I asked all the groomsmen to stand on either side of the groom and his father. Once positioned, I just asked them to continue getting ready. Three men went to the left, and two of them chose to go to the right. Now the wedding party is framing the groom and his father.

If you don't find structural frames, you can always use people to do the framing for you. Had I not said anything, the groomsmen would have been spread all over the room. This would have made it impossible to capture all of them getting ready together.

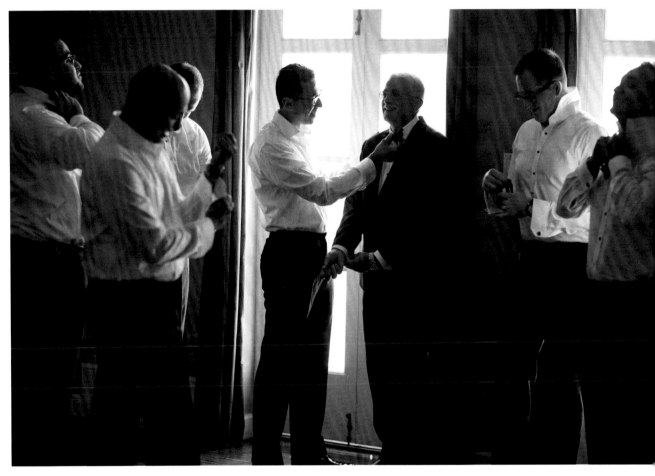

FIGURE 13.12

Figure 13.13: This is a prime example of interactive photojournalism. Naturally, the bride needs to put on her earrings, necklace, and other accessories as she gets ready. Unfortunately, mirrors in most hotel rooms are located at the back of the room, near the restroom. This photo is classified as interactive photojournalism because I asked the bride to move to the chair by the window for better lighting. Additionally, I moved the wedding dress and hung it in front of the window.

By strategically moving the dress, I accomplished three goals. First, the dress on the left creates a balance with the bride on the right side of the frame. Second, the dress covers some of the overwhelming white light coming in from the window, making it easier on the eyes. And third, the dress is an emotional object and symbol of a wedding. It shows how the bride is preparing for the important moment of finally putting on her wedding dress. I will talk more about this in the "expert components" section of the book. Once the bride sat down, I let her be. The only adjustment I made was to keep her elbows pointed toward the ground.

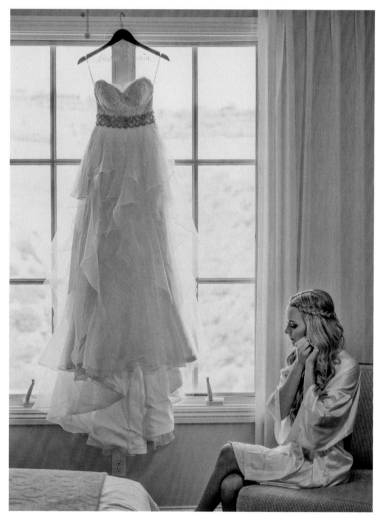

FIGURE 13.13

Figure 13.14: During this beautiful wedding near Malibu, California, I saw an opportunity to coax members of the bride's new family to be more involved in the process of getting ready. I strategically positioned the chair near the large window to take advantage of the room's circumstantial light. Instead of having the bride put on her shoes by herself, I asked the groom's sister if she would help her soon-to-be sister-in-law with her shoes. This photograph brings members of both families together working as a unit.

When possible, and if the time is right, I try to choose a person who is close to the bride, such as her mother or maid of honor. However, I have learned that whenever I include a member of the groom's family, the response is much more emotional because the two families begin to see themselves collectively as one.

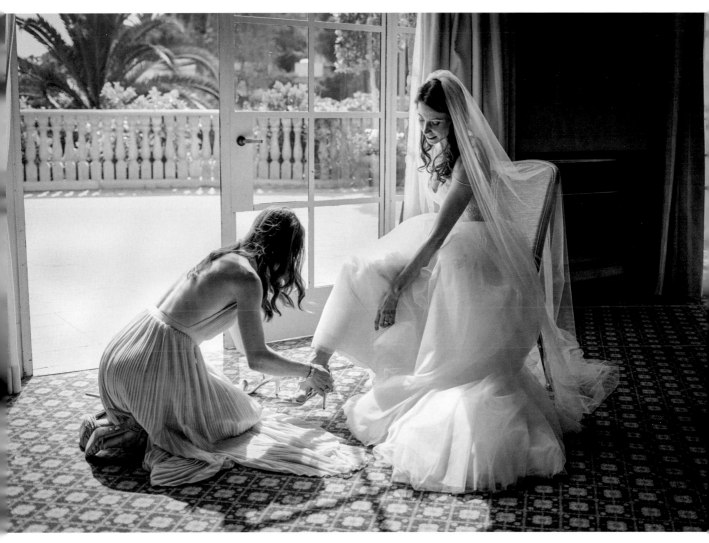

FIGURE 13.14

Team Interactive Photojournalism Examples

The following set of photos is displayed in pairs (**Figures 13.15–13.26**). These photos are simple examples of how the main photographer and the second photographer can work together simultaneously to capture finer expressions and reactions when the subjects least expect it. As I mentioned in the "Team Interactive Photojournalism" sidebar above, this is a coordinated effort with equally important parts. While the main photographer is actively taking photos and causing the subjects to react with verbal inputs, the second photographer is standing nearby at a different angle and capturing their expressions from that "unaware" perspective.

During my own weddings, sometimes I choose to be the main photographer and sometimes I choose to be the second shooter. It all depends on who the second photographer is, and if I believe he or she can handle the job. If the second shooter is not very experienced, I would never have them assume the role of the main photographer.

The photos below were all chosen from a single wedding shot by myself and the second photographer. As you can see from the examples, we used this technique throughout the entire wedding. The results are truly beautiful! Your second photographer should not just be someone with another camera working independently from you. To maximize your storytelling approach, you and your second shooter should work in unison with a strategic plan. When I am about to set up a shot with the wedding party or anyone else, I simply tell my second shooter, "Second angle," and that's the code for him or her to know what's going on and what their purpose is in that moment. The second shooter allows me to interact with the subjects while he or she stands in position, ready to capture their expressions from a different perspective.

FIGURES 13.15–16

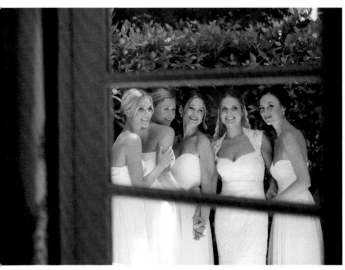

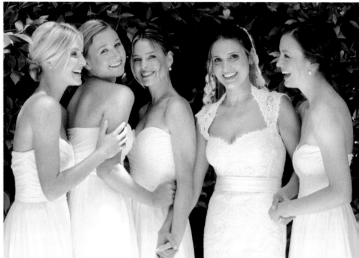

FIGURES 13.17–18

FIGURES 13.19–20

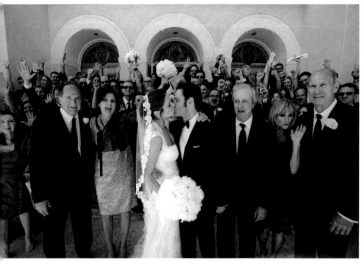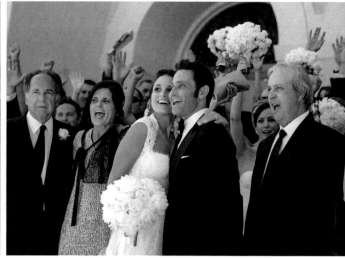

FIGURES 13.21–22

FIGURES 13.23–24

FIGURES 13.25–26

STYLIZED AWARE POSING

"Stylized aware posing" occurs when the photographer helps subjects look their best by suggesting how to adjust or position different parts of their bodies, all while they are making direct eye contact with the camera. This approach encompasses arranging, posing, and directing in order to take a subject's portrait. Posing can also be used to execute an idea, mood, or feeling via the pose. During stylized aware posing, the subject is aware of the camera and looking straight at the lens. To maximize the overall impact of this approach, clever use of both circumstantial light and helper light is necessary to best flatter the subjects.

This approach is used for portraits when you want the viewer of the photograph and the subject to have a *direct* relationship with each other. For the following examples of this approach, I keep the explanations limited to the two core elements that need to be considered when shooting stylized aware posing portraits: feeling and lighting. Feeling is based on how the viewer feels when looking at the portrait. Feeling is determined by the different combinations of the collarbones, the chin, and the eyes' position relative to the camera. (This is explained in detail in the Three-Point Check Combinations chapter [Chapter 4] of my posing book, *Picture Perfect Posing*.) Lighting is determined by a combination of circumstantial light and helper light, which includes the use of reflectors, video lights, or flashes.

Also, I chose mostly individual portraits to demonstrate this approach because there is more possible variety in that kind of shot. I did include one traditional but very important bride-and-groom portrait in which both subjects are looking at the camera.

Figure 13.27: *Feeling:* Straightforward with a painterly feel. Strong emphasis on his face and expression. *Lighting:* Window light on camera left and a reflector on camera right.

Figure 13.28: *Feeling:* Strong emphasis on her dress and eyes. Because her head is turned a bit to the side, there is a softer feel to this portrait. *Lighting:* Window light on camera left, wall reflecting light back on camera right.

Figure 13.29: *Feeling:* Relaxed with a sexy appeal by unbuttoning part of his shirt. *Lighting:* Window light on camera left.

Figure 13.30: *Feeling:* Highly dynamic portrait because the collarbones, the chin, and the eyes are all pointed in different directions. This creates a very striking feeling, almost mesmerizing. *Lighting:* Natural light coming from camera right. Wall on left reflecting light back to the right side of subject's face. No helper light needed.

FIGURE 13.27

FIGURE 13.28

FIGURE 13.29

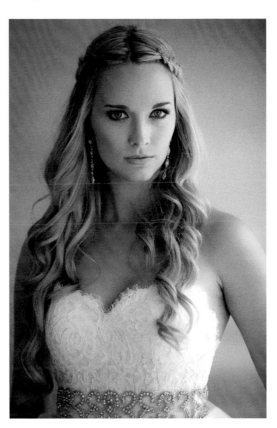

FIGURE 13.30

Figure 13.31: *Feeling:* Strong emphasis on his eyes. Serious but soft expression. *Lighting:* Direct sunlight slightly softened with a diffuser held approximately a meter over his head.

Figure 13.32: *Feeling:* Seductive and mesmerizing. *Lighting:* Flash through a diffuser on camera right, reflector on camera left.

FIGURE 13.31

FIGURE 13.32

Figure 13.33: *Feeling:* Strong emphasis on his eyes. Soft but confident expression on his face. *Lighting:* Window light on camera right, video light on camera left.

Figure 13.34: *Feeling:* Traditional portrait of bride and groom looking at the camera. *Lighting:* Strong sun behind their heads. Strong reflected light from the smooth and light-colored sidewalk on the ground.

Note: Although this is not a creative photo, I find it to be one of the most important photos a photographer can take. To be sure, I actually take three to five of these traditional photos at different places. As simple as they are, people love them. If you don't take this type of photo, the couple or the family will most likely ask you for it. They will be very disappointed if you tell them you didn't take one.

FIGURE 13.33

FIGURE 13.34

STYLIZED UNAWARE POSING

"Stylized unaware posing" is a form of posing where the subjects are not looking at the camera and appear to be unaware of being photographed. Unlike interactive photojournalism, which is activity-based, stylized unaware posing is portrait-based, meaning that the purpose of this approach is to pose and create an actual portrait of the subject. When the subjects are unaware of the camera, it gives viewers the sense that they are peeking through a window at that photographic moment.

Similar to stylized aware posing, a creative pose can also be used to reveal an idea, mood, or feeling via the pose, except that there will be an *indirect* relationship between the viewer of the photograph and the subject. This indirect relationship plays an important role in your storytelling because it gives the viewer of the photograph a unique ability to connect with the subject at a deeper level. The reason for that is because this approach keeps the viewer speculating about what the subject is gazing at or what they are thinking about when the photo was taken.

In broad terms, I see stylized aware posing as showing what a person looks like, while I consider stylized unaware posing to be a snapshot of the subject while they are in thought or interacting with something or someone.

A skilled photographer will finish the pose by specifically posing the subject's eyes and injecting strategic verbal inputs that result in the desired reaction and expression while simultaneously using circumstantial light and helper light to create the most flattering light possible on the subject. If done correctly, the pose becomes invisible and believable, and the subject's expression is completely natural and true to the subject's personality. If executed badly, it appears obvious that the subject was only following the photographer's instructions, and something will feel out of place or forced.

Figure 13.35: *Feeling:* Pensive, serious, and moody. By strategically posing the eyes, the subject doesn't have to wonder where to look. By controlling the eyes, you can create a much more candid expression. *Lighting:* Window light spilling through a narrow gap between curtains.

Figure 13.36: *Feeling:* Reacting to something comical. *Lighting:* Natural light outside.

Figure 13.37: *Feeling:* Reacting to something charming with an elegant feel. *Lighting:* Window light on camera left and a white reflector on camera right.

FIGURE 13.35

FIGURE 13.36

FIGURE 13.37

Figure 13.38: *Feeling:* Reacting to something beautiful with a contemplative feel. *Lighting:* Natural light with a manual flash fired through a diffuser to open up the shadows and improve lighting on her face and dress.

Figure 13.39: *Feeling:* 100% contemplative, serious, and moody. *Lighting:* Natural light with a manual flash fired through a diffuser to open up the shadows in the room and improve lighting on her face and dress.

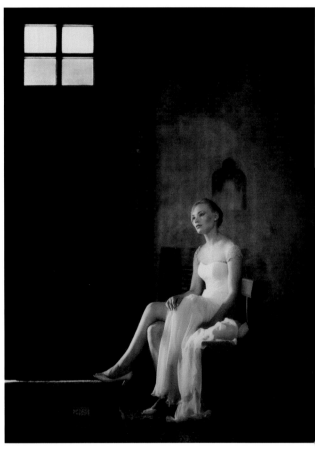

FIGURE 13.38

FIGURE 13.39

STORY DEVELOPMENT

Story development is a critical component of being a great wedding storyteller. Story development involves putting emotionally valuable people and/or objects of the bride or groom together to be photographed or to take part as a "supporting cast" in the "main story." Story development happens when the photographer captures a main story and then finds other moments that complement the main story photo. This gives the viewer an idea of what else was happening when the main story photo was taken. It also gives

the photographer a reason to keep moving and thinking, instead of standing static for long periods of time photographing numerous frames of the same moment.

For example, the photographer could take a large group portrait of the entire wedding party (main story), then follow that up by moving around and photographing individual close-up portraits of each of the wedding party members doing something slightly different and perhaps looking in different directions for variety (supporting cast). Together, the main story and supporting cast photographs tell a well-developed story that can be presented as a layout in a wedding album.

Figure 13.40: Before we begin with story development, look at this photo by itself. This photo was taken as the bride found a place to hang her dress in preparation for putting it on. Notice the delicate touch with which the bride holds the dress and the look in her eyes. To me, the look in her eyes indicates that a lot went into making the decision about that specific dress becoming *her* dress. Her future husband will see her in this dress, and she will marry in this dress. She has tried it on multiple times, had it adjusted multiple times, and has imagined how she would look wearing it on her wedding day. The simple gaze in the bride's eyes says all of this to me. For this reason, I chose this photo to be the "main story" photo.

Now, I find ways to expand on this main story. I need the supporting cast. In the next example, you will see how the supporting photos complement the main story of the dress and the long-awaited moment of putting it on.

FIGURE 13.40

Figure 13.41: I had already taken the top photos on the right side of the layout earlier in the day. But they go together as part of the "dress story" perfectly. The photo at the top-left shows the dress by itself using a unique composition with the painting on the wall. The rest of these photos were taken for story development purposes. The photo on the top-right shows the bride doing the last-minute make-up check to make sure that everything is perfect before putting on the dress. The photo in the middle shows the moment before she finally takes the dress off the hanger and puts it on. The window blinds were used as a compositional element to enhance the feeling of peeking in at that moment. The blinds also guide your eye to the dress and back to the bride's face. The bottom-left photo introduces the bride's mother to further increase the emotional value as this story develops. The mother is an Emotionally Valuable Person (EVP) to the bride and the dress is an Emotionally Valuable Object (EVO) to the bride. This photo shows both working together in the same photograph. Finally, the photo on the bottom-right finishes the story with a strong exchange of emotions through their eyes as the bride tightly holds her mother's hands.

Now that you have had a chance to see the main story photo by itself and compare it to the fully developed story, you can see how much more of an emotional impact this story has as a whole compared with any single photograph.

FIGURE 13.41

FIGURE 13.42

Figure 13.42: This story depicts the comical struggle experienced by all who put on a bow tie. Clearly, no one in this wedding party had a clue about how to tie a bow tie. One of the groom's closest friends had to find a YouTube video on his iPad to help them. The three different angles go from ultra-wide (fish-eye) to medium to close-up. These three different perspectives keep the story development interesting and fun to look at. At last, when you see the final photo of the groom on the right, spruced up and perfect, now you have a deeper appreciation for the struggle they all went through and the team effort required to look as sharp as he does.

Figure 13.43: This is one of my favorite examples of why story development is so important for becoming a highly skilled storyteller. This story shows the younger flower girl completely missing the timing of her duties, throwing the flower petals on the ground at the wrong time. She is so innocent and adorable about it because clearly she is under the impression that she is doing the right thing in the middle of the ceremony. As her older sister looks on, the little flower girl, in her own small world, throws the flower petals on the floor, and

upends the basket to make sure she threw all of them. She bends down to pick up the flowers, just to throw them back down on the floor again. People were chuckling at the adorable situation unfolding in front of them, including the bride and groom during the ceremony. The photo on the bottom was taken during the recessional. It clearly depicts the couple's amused reactions to the flower girl situation as they walk by them.

When photographs connect to tell a story, the emotional impact and appreciation for your art as a great wedding storyteller will transform your clients into loyal followers, praising you wherever they go. Remember this: at any given time, a story could develop. If you are paying attention, you will notice it. As soon as you take the main photograph of the story, immediately move around and look around for supporting photos. I have had brides in tears and grooms give me hugs when we reminisce about their stories in their wedding book.

FIGURE 13.43

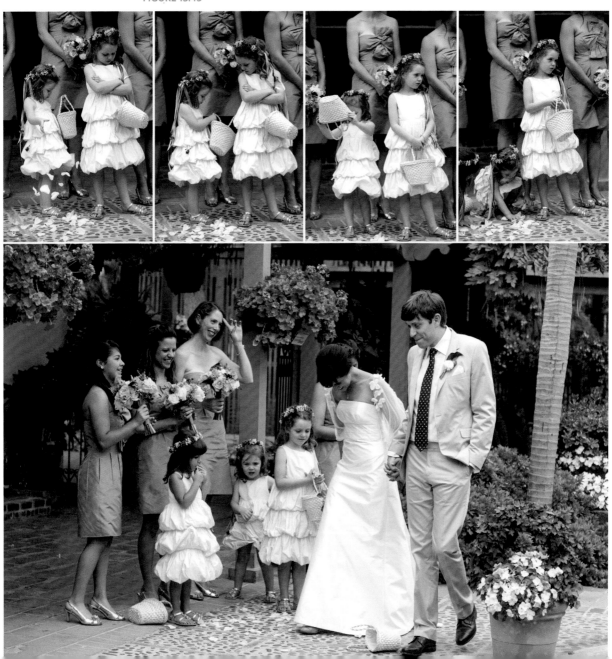

WEDDING STORYTELLER'S STYLE DEVELOPMENT

The following style development chart (**Figure 13.44**) shows the various approaches (from the five discussed) a photographer can choose to implement at any given segment of a wedding. For example, during the Bride and Groom Getting Ready segment, depending on your style, you may choose to include some of each of the approaches to tell that story. Or you may choose to include just two of the five approaches. During this segment, the opportunity to use all five approaches is there.

However, during the Ceremony segment, there are only two possible approaches that make sense. You are not going to be posing the couple while they are exchanging vows, right? Therefore, the only two logical approaches during the ceremony are photojournalism and story development.

The segments that include the word "portrait" in them, such as Wedding Party Portraits, Bride and Groom Portraits, and Family Portraits, don't present the opportunity for a photojournalistic approach because the very meaning of the word "portrait" already excludes the possibility of a purely photojournalistic approach.

FIGURE 13.44

Style Development

Style Development	Photojournalism	Interactive photojournalism	Stylized aware posing	Stylized unaware posing	Story development
Bride & Groom Getting Ready	●	●	●	●	●
Wedding Party Portraits		●	●	●	●
Family Portraits		●	●	●	
Ceremony	●				●
Bride and Groom Portraits		●	●	●	●
Cocktail Hour	●		●		●
Reception	●	●	●	●	●

How to Use These Approaches to Develop Your Unique Style

In my own weddings, I choose the most well-rounded approach to storytelling, with a heavy emphasis on interactive photojournalism. I consciously try very hard to make sure that for each segment of a wedding, each of the storytelling approaches listed on these charts is represented. That does *not* mean that each approach must be represented equally, meaning that each approach would be equal to 20% of your total coverage. For example, looking back at some of the weddings I photographed over the last year, my usual breakdown of these approaches for the Bride and Groom Getting Ready segment was the following:

- Photojournalism = 20%

- Interactive Photojournalism = 35%

- Stylized Unaware Posing = 15%

- Stylized Aware Posing = 10%

- Story Development = 20%

As you can see, my style for this segment relies very heavily on interactive photojournalism, with story development and photojournalism tied for second. I also seem to take more stylized unaware posing photos than stylized aware posing portraits.

This is my individual style. Yours will have different proportions for each approach and segment of the wedding. Through the years, my photographic style has changed more times than I can count. Six years ago, I didn't even know about story development. Now, it is a major contribution to my style. Another major change in my style is how I photograph the Wedding Party Portraits segment. I used to simply assemble the wedding party, instruct them to look at the camera and smile, then take the picture. Now, I use all four approaches listed on the chart. The results have been better than I expected, and this effort has contributed to my booking higher-paying jobs and not having to discount myself to remain competitive. People love the variety they see in my work.

Furthermore, I have trained the second shooters who work with me at most weddings to help me achieve a variety of these approaches for every segment of the wedding. They should also utilize these approaches and do what they can to complement my work. We work as a true team with a common goal. If I am taking photos of the families, my second shooter should be looking for photos that would work for story development. Or as previously mentioned, if I am photographing with the interactive photojournalism approach, my second shooter is photographing my subjects' reactions from a different angle to create the "team interactive photojournalism" approach.

At the end of the day, these are the five approaches we can use as tools to tell the story of our clients' weddings. It is up to you how you use these tools. I have found success not by limiting myself to just a few approaches but by embracing them all. Wedding photography can be so repetitive because many photographers treat weddings like an assembly line. This book's purpose is to elevate wedding storytelling. By implementing these approaches with your own unique proportions, you will deliver a much more profound product that is both true to your style and mindful of your clients' wishes. Why settle for a decent job when you can blow your clients' expectations out of the water?

part five
EXPERT COMPONENTS

chapter 14

STORYTELLING EXPERT TECHNIQUES: EMOTIONALLY VALUABLE PEOPLE (EVP)

From the moment I had the idea to write this book, I have been looking forward to writing about "EVP," my abbreviation for the Emotionally Valuable People at a couple's wedding. In fact, the entire concept for this book began with this topic. Great wedding photography depends heavily upon the stories, connections, and relationships of the people who are most important to the bride and groom. Awareness of these relationships will keep you constantly thinking about creative ways to include EVP within your composition and reveal a story through photographs.

From a generational perspective, weddings are unique events. There may be three or even four generations gathered together to celebrate a family member's wedding. As you can imagine, this is a rare occurrence. So why is this chapter so important? Because, through your inclusion of EVP in your photos, you will tug at your clients' heartstrings and create photographs that will be truly cherished by the entire family.

During my first years as a wedding photographer, I thought the wedding was just about the bride and groom. The only photos of the EVP I took were during the family portraits segment when everyone just stood in a row, waiting to be photographed. In hindsight, I find that approach to be very unfortunate. I can say with confidence that a great deal of my success as a wedding storyteller has been from including EVP in photographs of the bride and groom. In other words, the ultimate goal is to entwine the moments that happen spontaneously at weddings with EVP.

So, who are the EVP? Well, they vary. During client meetings before the wedding, I have a conversation with the bride about family dynamics. It is important to know who the couple is very close to. Perhaps the groom has a very special relationship with his grandmother, or perhaps the bride does not get along well with her father. Having a clear understanding of some of the key family dynamics will better equip you to include the right people in the photographs. Can you imagine not being aware that the bride does not get along with her father, and you include the father in all her significant moments during the wedding? Most likely, the bride will not be pleased with you. Being informed and doing some basic homework during the pre-wedding meetings ensures that you avoid making embarrassing mistakes.

The main idea is to incorporate EVP strategically through framing, reflections, opportunities, and balance to increase the emotional power of your photographs. If you are skilled enough to capture EVP in tasteful, visually creative, and unexpected ways, you will be perceived by your clients as a third-degree black belt of wedding photography. Everyone has a great camera built into their smartphones and can possibly have the intuition to photograph EVP, but only a skilled photographer can do so using compositional elements that draw viewers in, through techniques such as creative framing or capturing the expression of a beautiful moment of an EVP through a unique reflection. The key word here is "tasteful." If the EVP reflection appears staged by the photographer, it will lose its charm immediately.

EVP Hierarchy

Everybody is different, but in general, if the bride and groom already have children of their own, the children will automatically become the highest-ranking EVP. If the couple do not have children, then the oldest generation becomes the highest-ranking EVP: great grandparents, then grandparents, then parents, followed by siblings, and finally the wedding party, especially the best man and maid of honor. This is a hierarchy system that I created to help me with decisions about who to include in certain photographs. Depending on which culture(s) the bride and groom belong to, the hierarchy ladder presented here might be quite different.

Even though great artistic photos of the bride and groom are beautiful and have great visual impact, that impact will always pale in comparison with the emotional impact that well-executed photos involving EVP have on your clients. In fact, nothing will convince a prospective couple to hire you more than photos that have a strong emotional connection. The couple will envision themselves in beautiful photos enjoying precious moments with the people they care about the most.

Many years ago, before I realized the importance of EVP, I had post-wedding meetings when I would show the couple a series of great "hero" photos. They would love them and smile. But when they saw the few EVP photos I took at their wedding, their entire demeanor would change instantly, and they would be overcome with emotion and begin to cry. They would often hug and thank me. It was truly an eye-opening experience.

This is an expert technique because in order to take these types of photographs correctly, you should capture the EVP not looking at the camera but being authentically engaged with whatever is going on. The key here is "authentically" engaged. If the EVP appears to be following directions from a photographer, the photo will lose its spark and emotional power. You must find a way for the EVP to actually be engaged.

EVP FRAMING

Figure 14.1: This is precisely what an EVP photo is all about. This photo not only has the bride framed by her mother, her sister, and one of her bridesmaids, but it also has multiple layers. In the foreground, you have the bride's flower girl curiously watching a moment that she has probably imagined through movies or books about princes and princesses. The middle layer contains the bride putting on her wedding dress. This is a significant moment. The fact that she is surrounded by her loved ones (EVP) makes this moment so much more special.

This EVP photo also contains double frames. The bride is framed by the various EVP, and the moment is framed by the door entrance. The background gives the viewer a sense of place by showing the window, curtains, and whatever is outside.

Not all EVP photos have to be this complex, but whenever possible, your goal should be to add multiple visual layers to bring attention to the EVP in the photo. Notice everyone is authentically engaged. You can see from

FIGURE 14.1

their expressions that they are focused and concentrating on the task as hand, and not a single one of them seems to be aware of the camera.

Figure 14.2: For this photo, one of the groomsmen brought a gift from the groom to the bride. To create an EVP photo, I quickly asked key EVP, especially her mother, to stand behind the bride while she opened her gift. The mother has a high EVP ranking, so her presence in this photo was vital. The rest of the moment happened spontaneously. As the bride opened her gift, everyone reacted as they naturally would. Had I not had EVP in mind, the bride would have opened her gift by herself—which is totally fine, by the way. But this photo became very special to the bride because she and her loved ones are sharing a beautiful moment together.

FIGURE 14.2

Figure 14.3: Sometimes the photographer only has to move to a different location to create a composition with a double frame. This photo happened 100% organically. This was a photojournalistic moment. However, to create the double frame, I backed up quite a bit toward the rear of the room in order to include the groomsman taking a photo of the groom and his friend, who is helping him with the bow tie. The room's supporting beam with the sconce creates a visual separation between the stories.

This example highlights how important the architectural elements around you can be. I highly recommend that you pay particular attention to them. Don't take them for granted; everything can be used.

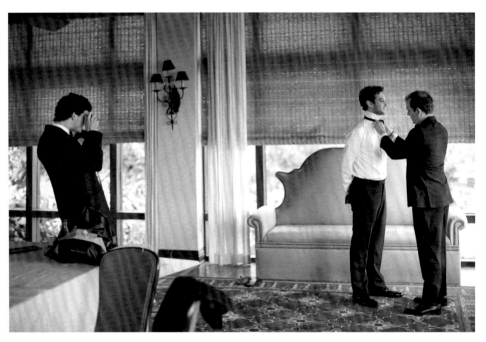

FIGURE 14.3

Figure 14.4: Speaking of paying attention to architectural details, this photo is another example of doing just that. This moment also occurred naturally, and the photo was taken without any direction from me. When I noticed the four groomsmen watching a game on TV, I quickly reacted by looking behind me to see if there was anything I could use to frame them. Sure enough, there was a glass door entrance that divided the living room from the bedroom. I picked up my camera with a 50mm lens mounted on it and took this framed EVP photo. Again, everyone in the photo is completely engaged in what they are watching on TV and not on me. That is what makes these kinds of photographs so special. Adding frames into the composition of EVP makes this an expert technique.

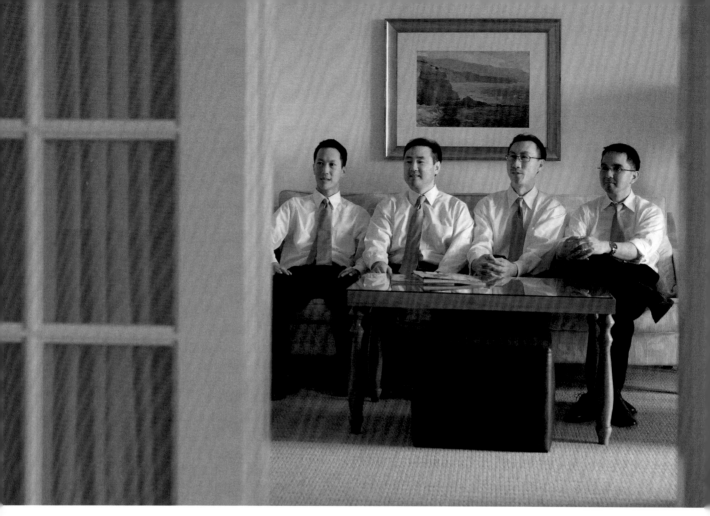

FIGURE 14.4

EVP REFLECTIONS

The concept behind EVP reflections is to create or capture a composition where the main subject is actively engaged in an activity but you can see an EVP reaction to that activity through a reflection. Sometimes you may have to move the reflective surface around for it to be in the right place, and sometimes you have to arrange people to be in the reflection.

These kinds of photos require quite a bit of compositional skills because you are telling part of the story in a nonobvious way. When people see these types of images, their reactions are amusing to watch. It is almost as though they have discovered a hidden message. To excel at this technique takes some practice, and you can practice at home with your TV turned off (so it serves as a reflective surface) or with a mirror. Try to photograph an individual doing something while capturing someone else's reaction to that activity in the reflection from the television, mirror, piano surface, or any other reflective material.

As you walk into the getting-ready room or the couple's home where they are getting dressed, keep an eye out for all the reflective surfaces you could use. I normally use the "interactive photojournalism" approach when shooting EVP reflections.

Figure 14.5: During this wedding, the bridesmaids were scattered around the left side of the room. The mirror was already there. To take this photo, I gathered the bridesmaids in an unorganized manner so that they would all be visible in my frame. I positioned the bride's sister in such a way that you could not see her from my camera's point of view but you could see her face and expression in the mirror. Then, I asked her to continue fixing her hair. Once the bridal party was in position, I simply asked the bride to walk into the room when she was completely ready, so that her bridesmaids could see her in her full glory. Their expressions were completely their own, and I didn't have to say a word. I just arranged the moment. If you are wondering how long something like this takes to arrange, it's very quick. I directed it very casually, and in most cases, this scene would take approximately 20–30 seconds to put together.

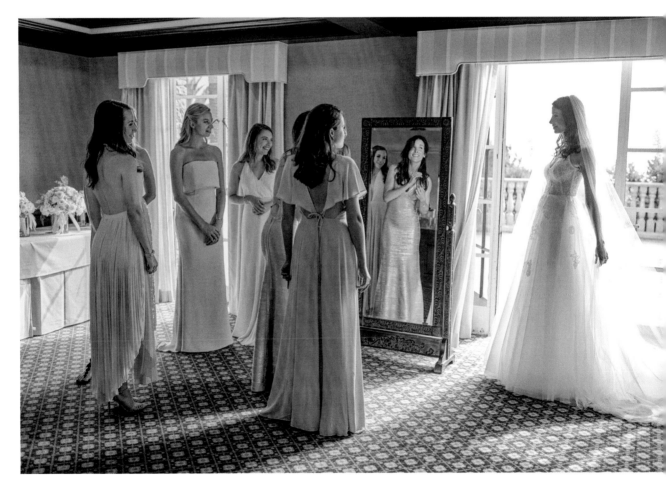

FIGURE 14.5

Figure 14.6: This is a photograph I wanted to include as an example that demonstrates how you can have EVP reflections in your image, but that does not mean that it is a well-executed shot. As you can see from the photo, the idea to split the room into two separate stories is a bonus. The light on the groom is excellent. However, the groomsmen look a bit too arranged by the photographer. My mistake was in trying to fit everyone into a small mirror. You must ask yourself if people would stand that closely together while talking. Probably not. Therefore, the solution would have been to choose higher-ranked EVP, such as the groom's father and best man, and have just them in the mirror's reflection. That would have been much more realistic. Also, the groom appears to be slightly posed. I could have asked him to sit in the chair nearby and tie his shoelaces. It's very important to break the feeling of being posed.

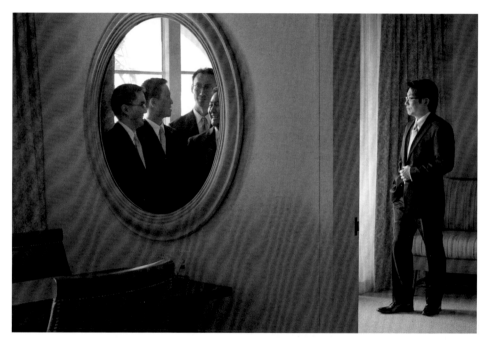

FIGURE 14.6

Figure 14.7: This photo was taken many years ago as one of my first attempts at EVP reflections. There was a mirror mounted onto the door of the groom's bathroom. As the groom was getting ready and his best man was assisting him with the bow tie, I quickly opened the door just enough to reveal the best man in the mirror's reflection.

Figure 14.8: This photo represents one of those very rare moments when the EVP reflection happened completely in a photojournalistic manner. I only had to shift my position to the right in order to place the bride and her mother on the left side of the frame and the mother's reflection and reaction to the moment on the right side. I try my hardest to find these jewels of moments occurring naturally without any photographic intervention. But during all the years I've been photographing weddings, I know this happens rarely. For this reason, interactive photojournalism always saves the day.

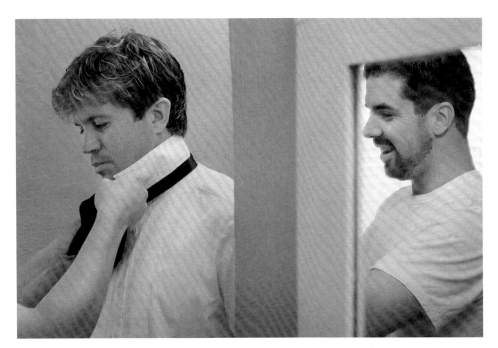

FIGURE 14.7

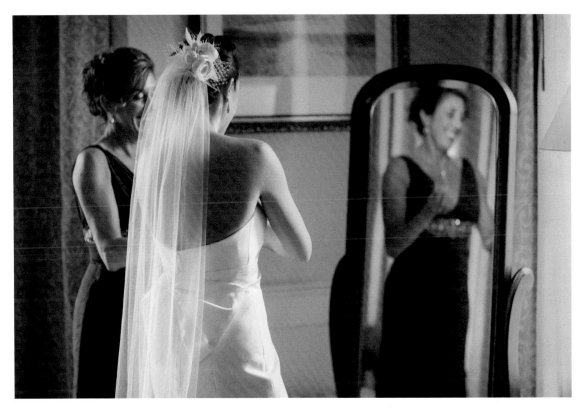

FIGURE 14.8

EVP OPPORTUNITIES AND BALANCE

At every wedding, you make the choice between trying harder to create something extra special or just going through the motions and taking whatever is there. Keep track of the EVP hierarchy around you. When you recognize an opportunity, find a way to take advantage of it and create a more powerful photograph. "Balancing" EVP simply means that you position the bride or groom on one side and the EVP on the other. This gives the composition balance and visual harmony.

Figure 14.9: This photo is an example of making the extra effort. While Cliff (the groom) was finishing getting ready, I noticed that his son was walking around the room. Remember, if the bride or groom have children of their own attending their wedding day, the children become the highest-ranked EVP at that wedding. Naturally, I asked the groom's son if he would sit at a specific spot on the couch while his dad was getting ready and to make sure his father looked good and everything was as it should be. I gave his son a task to focus on. Having his son be a part of this story adds so much more emotional value to the image than if the groom were simply by himself.

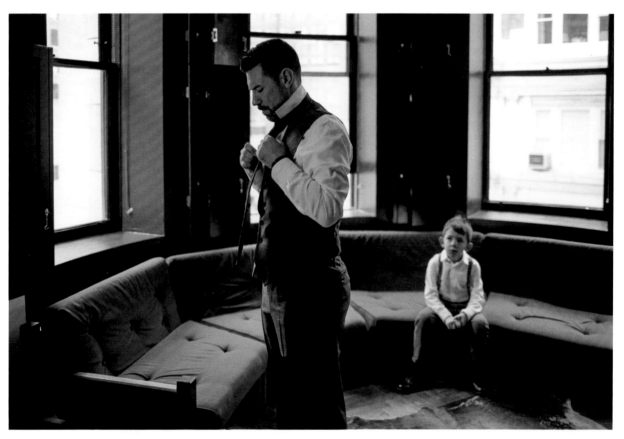

FIGURE 14.9

Figure 14.10: This was a fun, simple, and important photograph for the bride. The best part is, I did not have to arrange it. The bride requested this photo because one of the groomsmen was very important to her. She requested a photo in which the groomsman would be walking behind her, helping her with the dress. She started to laugh at the awkwardness of the situation, and he reacted exactly as she thought he would. This photo reminded me of the importance of EVP in wedding photography. Even though the groom is not the one helping her, this photo means a lot to the bride because of their close relationship.

FIGURE 14.10

Figure 14.11: As the bride was getting ready, I noticed her sisters walking around the room and asked them if they would help the bride. Including all her three sisters collaborating on the wedding dress makes this photo particularly special to the bride. In an effort to create a more pleasing composition, I asked one of the sisters to pull the ribbon away from the dress, so it would be easier for her other two sisters to work on it. Having one of the sisters on the left side of the frame also balances the photo nicely.

Figure 14.12: Simple but powerful. Something as simple as having the groom give his daughter a tender kiss adds so much more emotional value to the wedding book. Capturing a beautiful moment like this, which includes the highest-level EVP (a couple's children), is a major bonus!

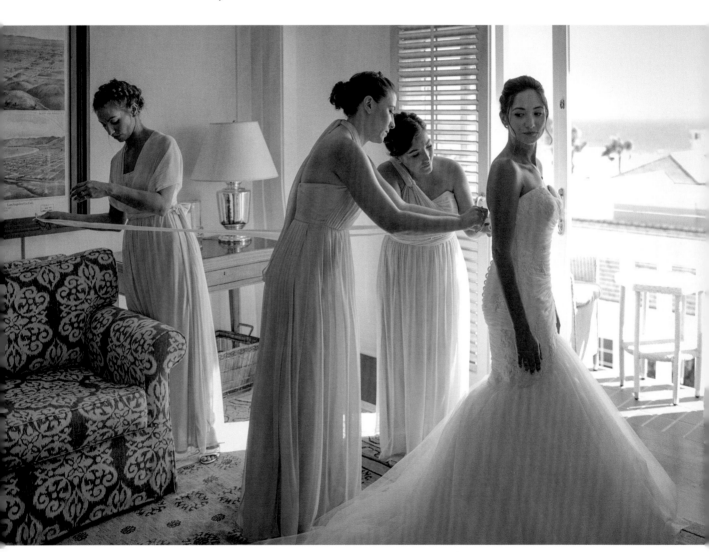

FIGURE 14.11

FIGURE 14.12

Figure 14.13: Just as I mentioned in the last photo, a parent is the highest-level EVP if the couple does not have children. For this reason, I asked the mother of the bride if she would help her daughter put on the veil. In a different photo, I asked the bride's sister to help with the earrings. I'm always looking for ways to include EVP in the photos I take. The more EVP photos you have, the more the family will treasure the photos, and this equates to more sales of prints and larger albums. It's a win-win situation for everyone.

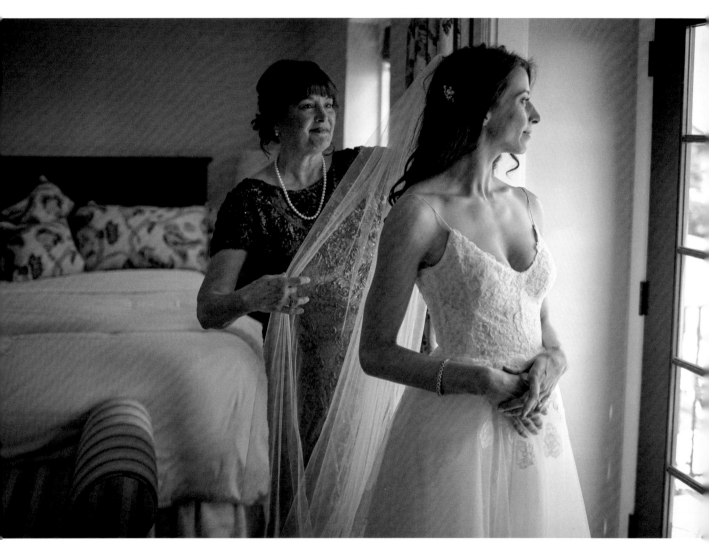

FIGURE 14.13

Figure 14.14: Like many other expert techniques, there are varying levels of success based on the execution of the photo. This photograph combines the opportunity of photographing a beautiful moment with EVP (bridesmaids), FVP reflection (mirror), and EVP balance (bridesmaid on the left). The only element missing is EVP framing. Being able to combine several EVP compositional elements, such as in this example, is a constant goal of mine when photographing weddings. I call it "EVP layering." It creates visually interesting photos that are jam-packed with the people who are most meaningful to the wedding couple.

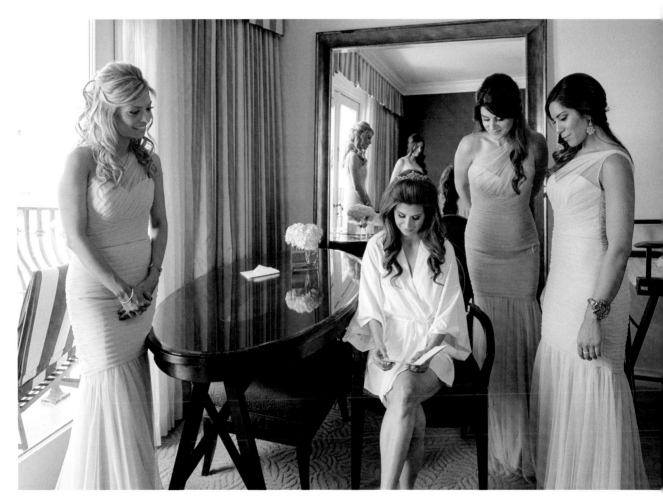

FIGURE 14.14

chapter 15
TECHNICAL EXPERT TECHNIQUES: LENS CHOICE AND HELPER LIGHT

This chapter covers the two technical expert components: lens choice and helper light. Lenses are tools, and there is the right tool for the right job. Although it is true that one or two basic lenses can take care of a wedding, it does not mean that lens was the best choice given the situation. Identifying the very best lens to bring out the most in any given scenario is an expert component because it is not obvious. A scene can be completely transformed by the lens you choose. As you know, lenses can make close objects appear far away, or they can compress distances. Lenses can also change the perspective and exaggerate a location's geometric shapes. It takes experience and a good deal of trial and error to identify what is the optimal lens choice given what is in front of you.

As for helper light, we will take a bit of a different approach than in my lighting book *Picture Perfect Lighting*. To meet the needs of a wedding photographer, we will focus more on using helper light with speed and convenience in mind.

ISOLATION AND PRIORITIES THROUGH LENS CHOICES

In this section, we will have a crucial discussion about lens choices during weddings. Before we begin, I want to make it very clear that lenses won't make you a better photographer. They won't take the photo for you. Lenses won't fix lighting or posing problems. I make such seemingly obvious statements because I witness photographers becoming nearly bankrupt as they get caught up in an endless cycle of buying gear to keep up with the latest and greatest photographic equipment.

On the flip side of the coin, I believe that if you develop a smart financial strategy about how to acquire high-quality lenses and the best cameras available, that strategy can help you significantly. Expanding your tools can help you capture a higher yield of photos that are in focus, are sharper, and have greater contrast and color. The right equipment can help you react to and capture a fleeting moment more quickly, and it can greatly change the aesthetics of your photographs.

Choosing a lens is a very personal decision. It is important to be aware that what works for some photographers might not work for others. Also, please note that the choices and strategy I discuss here are based on my own experiences, which have produced the aesthetics I love and which have resonated with my clients. If you do not choose to utilize the methods I describe here, it does not mean you are doing something wrong. It is a matter of personal taste, and I encourage you to find the lenses that give you the look and feel that you like.

The Complete List of Lenses I Use at Every Wedding

Throughout the years, I have collected, tested, and worked with many lenses. Unlike many other disciplines in photography, top wedding photographers are consistently challenged to produce incredible work in situations where the photographer has very little, if any, control of the location, aesthetics, weather, lighting, time, various personalities, etc. For this reason, I have collected a series of lenses that have helped me to handle every imaginable situation.

Note that, as of the writing of this book, I am a Canon Explorer of Light; therefore, these are Canon lenses. But you can find equivalent lenses from most other manufacturers you choose.

Prime Lenses

- Canon EF 15mm f/2.8 Fisheye
- Canon EF 35mm L f/1.4
- Canon EF 50mm L f/1.2
- Canon EF 85mm L f/1.2
- Canon EF 100mm L f/2.8 Macro
- Canon EF 200mm L f/2

Zoom Lenses

- Canon EF 11–24mm L f/4
- Canon EF 16–35mm L f/2.8
- Canon EF 24–70mm L f/2.8
- Canon EF 24–105mm L f/4
- Canon EF 70–200mm L f/2.8

LENS CHOICE BASED ON MAJOR WEDDING SEGMENTS

There are many kinds of wedding photo shoots that we must complete throughout the wedding day. The lenses needed for the getting-ready portion of a wedding are different from those used for the reception. Here I will explain which lenses I use at each part of the wedding and why. Experience, along with trial and error, have helped me develop a sense of which lenses give me the most impact with the least amount of effort and stealth—in that order. I care about the impact first, then I worry about the effort it takes to use that lens to take a photo.

For all segments of the wedding except for the reception, this is my go-to order of operations when choosing my camera settings based on the lens being used and when shooting in a photojournalistic style (as a photo-taker).

How I Choose My Camera Settings Based on a Photojournalistic Approach Throughout the Wedding with the Exception of the Reception

1. Choose the appropriate lens for the given situation.

2. Set my shutter speed to be at least three times the lens's focal length (for example, when using a 50mm lens I will set the shutter as closely as possible to 1/150 sec.).

3. Choose an aperture that will obtain a proper exposure while maintaining the shutter speed set above.

4. Choose the lowest ISO setting possible that will obtain a proper exposure while maintaining the shutter speed and aperture set above.

LENSES FOR THE BRIDE OR GROOM GETTING READY AND FOR PORTRAITS

I use prime lenses as much as possible. If I must, I use zoom lenses. The getting-ready portion of a wedding is a perfect time to use primes. Since we usually have slightly more time during this portion of the wedding, we can also be more creative with the lenses we use. During the ceremony, you can't always be changing lenses, which would be extremely distracting, but few guests mind how many times you switch lenses earlier in the wedding day. The best thing to do is to have three or four cameras, each with a lens mounted and ready to go from the very beginning. Then, when you need a lens, just pick up the camera that has that lens mounted on it.

Most people getting ready are doing so indoors, perhaps in a hotel room or at their homes. Either way, it is rare that a photographer is able to work in a room with a great deal of light. Furthermore, you must capture people moving around the room. For this reason,

primes are my tools of choice, as they offer much larger apertures that can allow two or even three times more light to enter the lens than the best zoom lenses. More light striking your camera's sensor allows for faster shutter speeds, and faster shutter speeds in a room with weak light provide a greater chance to perfectly freeze the subjects moving around that room.

Also, the smaller size of prime lenses is far less intrusive. When people are just warming up to your presence, the last thing they want to see is you pointing a giant telephoto lens right at their faces. You can be more inconspicuous and capture great moments if you blend in a little. A prime lens is much smaller than a zoom lens, and thus people don't notice you taking a photo of them as much.

Lastly, because of their better quality and their fixed focal length, primes allow you to concentrate and capture what the lens sees more quickly, since you don't have to make any zoom decisions to take the photo. Eliminating this one step can be a real benefit, allowing your brain to simply focus on capturing what's in front of you. These are the prime lenses I use and have ready as soon as I enter the getting-ready room.

Canon EF 35mm f/1.4

This lens is excellent when you want to give the viewer a sense of place and breathing room (**Figure 15.1**). This photograph makes you feel almost as if you are in the room with the wedding party. You can look around and feel that you know where you are in relation to the room.

FIGURE 15.1

Photojournalistic photos properly taken with a 35mm focal length at wide apertures, such as f/2, have been among my most successful photographs according to prospective clients looking for a wedding photographer. The keyword here is "properly." This lens requires that the room be "clean." A 35mm lens is quite wide, so much more of the space shows in the photo. Cluttered rooms must be cleaned up, as I did here.

When using this lens, you should also be aware of the distance from the camera to the subject. If you are too close, you will distort your subjects, especially those subjects who are near the edges of the frame. When using this lens, I find that my optimal distance from the subjects is at least 10 feet. This greatly minimizes any distortion while still giving the viewer a sense of place.

Canon EF 50mm f/1.2

The 35mm f/1.4 and the 50mm f/1.2 share many of the same characteristics. A 50mm lens is said to give the viewer a similar field of view as the human eye. I mainly choose this lens thanks to its incredibly large aperture of f/1.2. This allows me to work with any lighting conditions at fast enough shutter speeds (**Figures 15.2** and **15.3**).

When shooting the bride or groom getting ready, they are almost always moving around. To capture and freeze their movement, you need fast shutter speeds. Since this constant movement most likely occurs in low-light indoor situations, I try to have a shutter speed that is at least three times faster than the focal length of the lens being used. For example, if I'm using a 50mm lens, I try—though, admittedly, it's not always possible—to have a shutter speed of at least 1/150. In terms of full stops, that would be 1/125. Anything slower than that could run the risk of motion blur. Naturally, if I am taking a portrait, the subject is standing relatively still. In that case, I do not have to worry about having a fast shutter speed to freeze movement. You should gauge how fast your subjects are moving to determine an appropriate shutter speed.

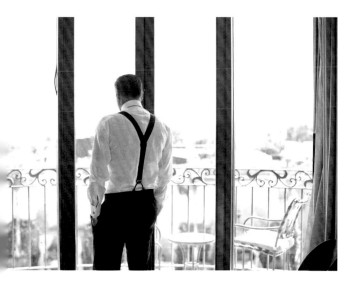

FIGURE 15.2

FIGURE 15.3

The 50mm lens has a narrower field of view than the 35mm, so not as much of the room will show in the frame. This means that you don't have to worry as much about tidying up the room as when using the 35mm.

When using a 50mm f/1.2, there is also significantly less distortion near the edges of the frame when compared to the 35mm.

For all these reasons, this is the lens I use the most when photographing the getting-ready portion of the wedding.

Canon EF 85mm f/1.2

There is one major difference in performance between the 85mm f/1.2 and the 50mm f/1.2: focusing speed. The 85mm is one of the top portrait lenses available, but it does not achieve focus quite as quickly as the 50mm. I only use this lens for actual portraits or for photos I help arrange. Basically, I need to have control of the situation. For this reason, I don't use it for capturing photojournalistic moments. This lens's focal length is better suited for getting close and personal (**Figures 15.4** and **15.5**). At an 85mm focal length, this lens does not allow for much context of the room, so even if the room is a mess, you probably won't see it. The rest of this lens's characteristics are very similar to the 50mm f/1.2.

FIGURE 15.4

FIGURE 15.5

Canon EF 100mm f/2.8 Macro

This is by far one of my all-time favorite lenses. This lens is really two lenses in one. It is a perfect portrait lens and a macro lens for small details. No matter how close you are to your subject, it still achieves focus. This opens up a world of creative opportunities.

That said, this lens does not behave like other lenses. It is more sensitive to movement, so in order to achieve tack-sharp focus, I make sure to move the focusing point exactly where I want it to avoid the need to recompose the shot (more about this at the end of the chapter). If you try to focus and recompose, you will most likely lose focus. When shooting details and I have a little more time, I usually shoot this lens with the mirror locked up to avoid any vibrations from the mirror flipping up and down. This has been a great feature to yield a higher rate of perfectly focused photos. However, when I use this lens as a portrait lens, I do not lock up the mirror. Instead, as soon as I achieve focus, I almost simultaneously fire the shutter. This avoids the focus wandering off when either I move or the subject moves.

Figure 15.6: For this photo, I found a small metal basket that was holding flowers just outside the bride's room. I placed the rings on top of the cute metal bird and used the 100mm f/2.8 macro to move really close and isolate the rings from the rest of the scene. Both rings had to be on the same focal plane; otherwise, one of them would have been considerably out of focus. Keep in mind that this is a very sensitive lens when it comes to sharpness and focus.

Figure 15.7: There is definitely a distinct look and feel to this lens, more so than other lenses of the same focal length. I love photographing in black and white when using this lens. It has a certain romance to it. Also, with its 100mm focal length, there is no distortion when shooting portraits.

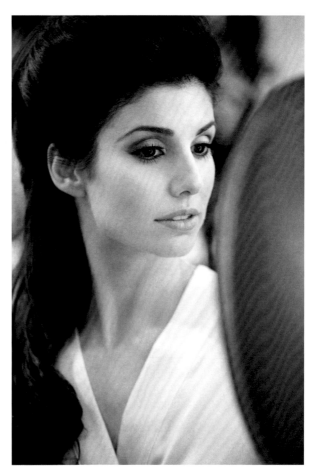

FIGURE 15.6

FIGURE 15.7

Figure 15.8: This photo is special to me because it is one of the most iconic wedding photos of my career and is also the cover photo of my first book, *Picture Perfect Practice.* This photo is the perfect example of why the 100mm macro is such a wonderful portrait lens. A photo taken this close to the bride's face with another lens would not have been in focus. The lace you notice in front of her face is not the veil, by the way. I have seen many photographers try to replicate this photo, and they always use the veil. Actually, what you are seeing is the hem of her wedding dress. There was beautiful lace decorating the dress, and we arranged it in front of the bride's face to frame her beautiful eye. The 100mm macro was the perfect lens to achieve this look.

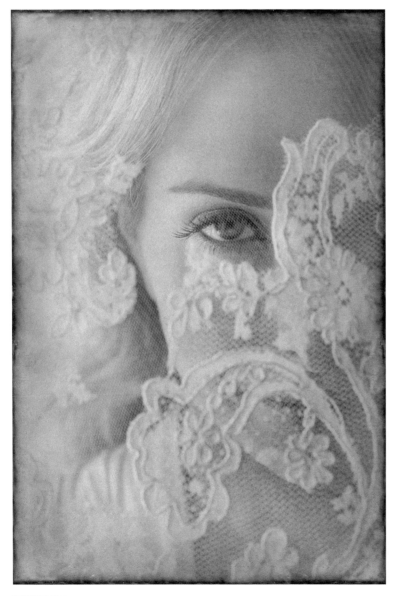

FIGURE 15.8

The rest of the bride and groom portraits, as well as the family and wedding party portraits taken during the time when the bride and groom are getting ready, are all taken with the four prime lenses listed in this section. When I'm photographing the getting-ready segment, I have four cameras ready to go. Each camera has one of the four primes mounted to it. Since the cameras are ready, I don't have to think about pulling a lens out of my camera bag. It's all ready to go, and I can focus on what's happening in front of me.

LENSES FOR THE CEREMONY

There are two kinds of wedding ceremonies: indoor and outdoor. Let's take each in turn because each location presents unique challenges and opportunities when it comes to lens choices.

Indoor Ceremonies

When shooting ceremonies indoors, I rely on the fast prime lenses listed earlier. These are the 35mm f/1.4, the 50mm f/1.2, and the 85mm f/1.2. They all have the unique ability to operate extremely well in low light. Most indoor ceremonies are quite dark, so even shooting at large apertures such as f/2.8 is often not good enough to gain a fast enough shutter speed to freeze the motion. I try to stay between f/1.2 and f/2.8.

And yes, you can always raise the ISO, but for me that is the last possible resort. I want my clients to receive the very best quality files, and noisy photos are just not acceptable. Remember, noise in a file is damage to the file. When you try to edit it, you damage the file even more. For this reason, I do whatever it takes to keep my ISO as low as possible throughout the entire wedding. That being said, some venues are so dark that you have no choice but to shoot with high ISO settings. Most importantly, there will be moments that are so precious and important that you should not care about the lens you have on your camera or what the ISO setting is. In such situations, I just take the photo before I lose the moment.

Remember this: *It is of the utmost importance that a wedding photographer captures amazing moments as they happen, for these moments will be treasured by the families for the rest of their lives.* That is priority number one! Clearly, if I am given the choice between taking a photo with a slow shutter or with a high ISO, I will choose the high ISO every time to avoid an unusable, blurry photo. Although I work hard to have little or no noise in my images, I can always use software to remedy the noise or I can turn the photo black and white to lessen the problem. But there is absolutely nothing you can for a photo that has motion blur due to an inadequately slow shutter speed.

Figure 15.9: This is a typical example of a dark church during a ceremony. Referring to the section above ("How I Choose My Camera Settings Based on a Photojournalistic Approach..."), all four decision points are well represented here. Let's go over them:

1. *Choose the appropriate lens for the given situation.* I chose a 35mm prime f/1.4 to reveal the beautiful architecture of the church, as well as the entire wedding party.

2. *Set my shutter speed to be at least three times the lens's focal length.* I set the shutter speed to 1/90. This is not exactly three times the lens's focal length of 35mm but it's close enough. However, at this shutter speed with the 35mm lens, I can rest assured that if anyone slightly moves during the ceremony, I will be able to freeze that motion. During a ceremony, you don't expect any significant movement anyway, so 1/90 should do the trick.

3. *Choose an aperture that will allow the shutter speed to be at least three times the lens's focal length and still obtain a proper exposure.* In order to keep my shutter speed at 1/90, I had to set the aperture to f/2.5.

4. *Choose the lowest ISO setting possible that will allow for the shutter speed to be at least three times the lens's focal length, the aperture to maintain its setting above, and still obtain a proper exposure.* So that I could keep my shutter speed at 1/90 and my aperture at f/2.5, I had no choice but to dial up the ISO to 1600. These settings make it evident that photographers need to know how to work in very dark, indoor locations. It's hard to believe that although I was shooting at a large aperture of f/2.5, I still had to raise my ISO to 1600 to obtain the proper exposure. But any attempts to lower the ISO would have required the shutter speed to be slowed down below 1/90. That would have been too risky. A noisy photo is much better than a blurry photo, which would automatically be unusable.

FIGURE 15.9

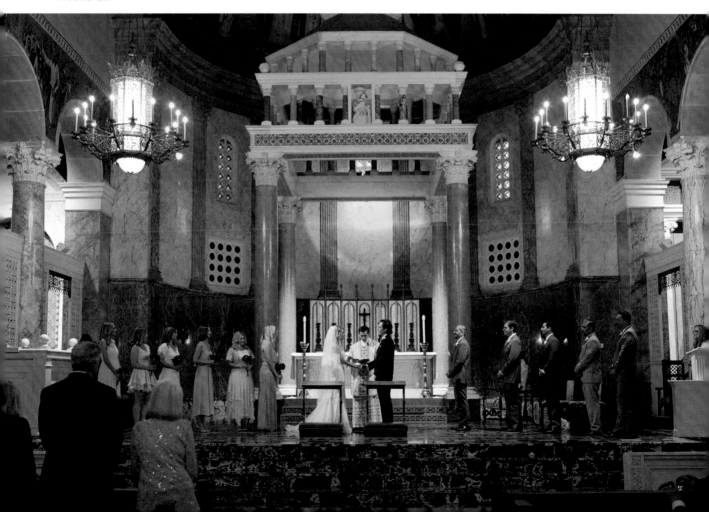

Figure 15.10: This photograph is an example of how important it is to be able to think on your feet. I had already walked inside the church and set my camera settings to 1/90 sec., f/2, and ISO 1600 in preparation for the ceremony. However, when I walked into the narthex, I was captivated by the beautiful light illuminating the groom. This photo gives you a sense of anticipation just moments before the ceremony. In situations like this, you just have to think quickly and react, because if the groom had turned around, the beautiful light on his face would have disappeared. The fastest setting I could think to change was to raise my shutter speed from 1/90 to 1/180 to achieve a perfect exposure. I kept all other settings as they were. There was no time to change them. The painterly feel of this photo is one of the reasons why I'm such a fan of shooting with primes at big apertures between f/1.2 and f/2.8.

FIGURE 15.10

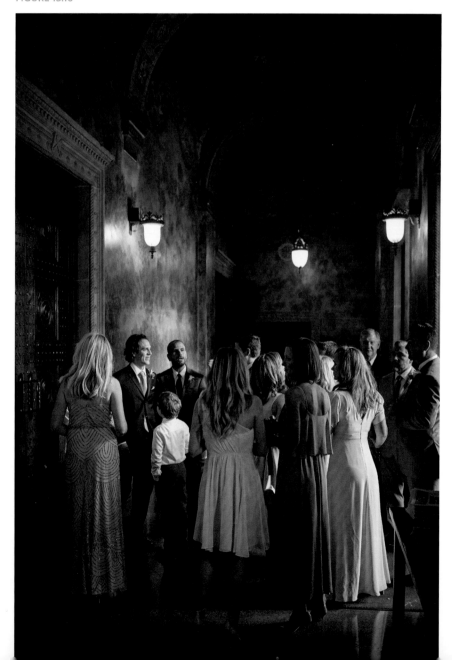

Figure 15.11: This photo demonstrates why it is smart to be prepared for the unexpected at weddings. Although I prefer to use fast prime lenses at large apertures, I still have my trusty 70–200mm f/2.8 workhorse lens ready to use in case I need to be much closer to a great moment. I don't switch lenses much at ceremonies because it's very distracting, and you can drop lenses easily. Instead, as I have mentioned, I have my cameras already mounted with the proper lenses for immediate use. One of my four cameras is equipped with a 70–200mm lens. For this photo, I did not want the little girl to see me or even notice my presence. For this reason, I grabbed the camera with a telephoto lens on it and captured this moment of the flower girl spacing out in her own world with her eyes just peaking above the pews. Although I had to shoot this at ISO 6400 to obtain a proper exposure, the moment was totally worth it.

FIGURE 15.11

Outdoor Ceremonies

Outdoor ceremonies provide much more flexibility regarding lens choices and shooting angles. At indoor ceremonies, we are asked to stay within certain areas and to avoid going to many others. We are at the mercy of the people who run the establishment. But at most outdoor locations, we can move around the couple and shoot from any angle. However, outdoor ceremonies are subject to changing weather conditions, so outdoor ceremonies tend to be much shorter; sometimes they can be as short as 15 minutes.

Because of this potentially small time frame, every part of the ceremony must be wrapped up in a very short time, and things move fast. In response to the fast pace of outdoor ceremonies, I tend to use zoom lenses, mainly the 24–70mm f/2.8 and the 70–200mm f/2.8. In the event that there is plenty of space and I have a little time, I occasionally take

out the large 200mm f/2 prime lens to achieve the unique bokeh and separation that the lens provides.

With these two zoom lenses, I can more easily create the exact composition I want while still considering the fast pace of the events. And at f/2.8, I can still achieve a decent separation between the intended subjects and the background.

Canon 70–200mm f/2.8

The 70–200mm f/2.8 lens is arguably *the* must-have lens for all wedding and portrait photographers. It's focal length of 70–200mm is the perfect focal length range to achieve great compression of the scene, it is very flattering for people, and at f/2.8, you can make the background completely out of focus, leaving your subjects tack-sharp for great separation. In fact, if someone were to ask me, "If I had to choose one single lens to photograph an entire wedding, what would it be?" My answer would be the 70–200mm f/2.8, 100%.

Figure 15.12: As mentioned, with most outdoor ceremonies there is a good chance you can walk around the couple. By doing so, you can actually capture a unique angle not usually seen. And in the rare event that every person in the background has a good expression on their faces, you can create a very special photo for your clients. This photo represents that unique angle. You can see the bride's expression as the groom recites his vows to her, and you can also enjoy the bride's parents' expressions during this very special moment. The 70–200mm lens was the perfect choice to create compression in the scene and place the viewer very close to the moment, as if he or she were witnessing this ceremony just inches away. Notice that the bride's face is the only one that is in focus. That's beautiful, because it is her expression during this special moment in her life that I wanted to feature in this photograph.

FIGURE 15.12

Figure 15.13: This is a great example that shows how, even when the photographer is fairly far away, the 70–200mm lens allows you to zoom in enough to be right with the action and achieve the perfect composition without having to move an inch. This photo appears as if I were standing just a few feet from the Sofreh.

FIGURE 15.13

Figure 15.14: Having the ability to be far enough away to be undetected allows you to capture moments that would otherwise be impossible. I love the intensity of this flower girl during a prayer. I just adored her perfect posture and delicate demeanor. If she had detected my presence, there is a good chance this moment would have been ruined.

FIGURE 15.14

Figure 15.15: The same fly-on-the-wall technique can and should be used to preserve the parents' reactions to their children getting married. I enjoy using this telephoto lens because you can capture these intimate emotions in a way that would never be possible if people noticed you.

FIGURE 15.15

Canon 24–70mm f/2.8

I consider the 24–70mm f/2.8 to be a mini-version of the 70–200mm f/2.8 in most of its characteristics. Like the 70–200mm, this lens also has a great focal range and a big aperture of f/2.8. I use it when I simply want to show more context in the location (**Figure 15.16**). Also, during the ceremony's processional and recessional, this lens performs better at focusing on moving subjects. The best part about using this lens for the ceremony is that if the people walking toward you blink, don't smile, make a strange face, sneeze, etc., you can always zoom out and try again, as they continue to walk toward you. Also, during the processional, you must worry about two people having a good expression, not just one.

This is, by far, the best lens for this portion of the wedding. I always start at 70mm and take a series of photos as the people walk toward me for expression purposes, widening the focal range and continuing to shoot until my lens reaches 24mm (**Figure 15.17**). I find this to be a terrific and proven technique to ensure touching expressions during the processional and recessional.

FIGURE 15.16

FIGURE 15.17

LENSES FOR FAMILY AND
WEDDING PARTY PORTRAITS

Depending on the wedding timeline, of course, most family portraits taken with the bride and groom together and their families usually occur after the ceremony. Why? Because most couples still prefer not to see each other until the ceremony. The photographer's challenge is that after the ceremony, the light is not very strong, since it is often close to sunset. Also, the groups you are photographing vary in size from two people to 20 people, or even more. For this reason, I use three zoom lenses for this segment of the wedding. The zoom allows me more flexibility to accommodate larger groups. However, please note that when photographing people, it's best to keep your focal length as close as possible to 100mm. This will avoid any distortion near the edges of the frame.

My three go-to lenses for this portion of the wedding are the Canon 70–200mm f/2.8, the Canon 24–105mm f/4 with image stabilizer, and the Canon 24–70mm f/2.8. I don't have any examples of the 24–105mm f/4 because I dropped mine and broke it to pieces years ago. But I loved using it because its focal length covered the 100mm threshold and it had a great image stabilizer built into the lens. Also, its largest aperture of f/4 worked great, because in groups not everyone is standing the same distance from the camera. I don't want to risk anyone being out of focus when shooting at f/2.8, so it's nice to know that with this lens, f/4 is as big as it will let me go. This ensures that I have more people in focus if their distances to the camera varies.

Figure 15.18: This photo was taken with the Canon 70–200mm f/2.8 lens at f/4, 1/350 at a 90mm focal length, and ISO 400. As soon as I begin taking the family photos, I've trained myself to automatically change the aperture from f/2.8, which was used during the ceremony, to f/4 for portraits. I have made the mistake of forgetting to change my aperture to f/4 several times in the past, and I had to explain to my clients why some of the people in their group were out of focus.

For these kinds of photos, I work hard to ensure that nobody is very close to the edge of the image, the reason being that most people buy these photos with an 8x10 format for their homes. The 8x10 is almost a square. Therefore, I give myself plenty of space to crop images to an 8x10 and have them look superb. During my early years, I lost a great deal of money on print sales because I used to shoot people edge to edge. When my clients found out that they couldn't buy the photos for their 8x10 frames without cropping people out, they simply did not buy them.

Figure 15.19: This is the same photo cropped to an 8x10 format. This is the proper way to maximize print sales. Notice that even though it's cropped to the 8x10 format, there is still a nice space on each side of the composition, giving the photo a pleasing breathing room. I can't express how important this has been in not only increasing print sales, but in making clients very happy. I have heard countless stories from people complaining to me that their photographer was only thinking of the wedding album, for which size could be altered to their liking. But they couldn't use the photos for their picture frames at home, and they were quite disappointed.

FIGURE 15.18

FIGURE 15.19

Figure 15.20: This photo was taken with the Canon 24–70mm f/2.8 lens. This is a situation when I would have preferred to use the 24–105mm f/4, but of course I didn't have it. I shot this at f/4 anyway to ensure that everyone was in focus. Because there was a wall behind me, I stood as far back as I could to try to reach the preferred minimum focal length of 100mm. However, the best I could do was 59mm, so I made sure that no one was close to the edges; otherwise, there would have been some noticeable distortion.

FIGURE 15.20

LENSES FOR THE RECEPTION

From a lens standpoint, receptions are very similar to the first part of a wedding when the bride and groom are getting ready. The getting-ready and reception environments allow the photographer a great deal of creative flexibility to interpret a wide variety of scenarios. Both segments require the photographer to photograph details, portraits, and action shots. The major difference between these two segments is that the getting-ready portion is shot with mainly natural light, while receptions, for the most part, depend on the photographer's style with flashes or strobes.

For this reason, there is a wide range of lenses photographers can use during receptions, from 15mm fisheye lenses all the way to 200mm focal lengths. After over a decade of trial and error using different lenses for receptions and learning from my mistakes, I narrowed my choices down to three main lenses I use at receptions. They are the Canon 16–35mm f/2.8, the 35mm f/1.4, and the 15mm fisheye. If I'm feeling creative and have the time, I will occasionally use the ultra-wide Canon 11–24mm f/4 lens for a few specialty photos. Why these lenses? I find that wide-angle photos are preferable to show more live action. Also, the big apertures these lenses provide (such as the 35mm f/1.4) allow me to deliver photos that retain the mood the clients imagined when they paid a small fortune on lighting and décor for the reception.

Note that when I set up flashes around the room to help with lighting, my rule of shooting with a shutter speed at least three times the focal length does not apply. In fact, I usually shoot at slow shutter speeds of 1/30–1/90 to maintain the ambiance of the room while relying on the flashes to fire and freeze any movement.

The 35mm f/1.4 is my most frequently used lens during all receptions. If I had to decide to use just one camera and put the rest of my gear away for the night, it would be a camera with the 35mm f/1.4 mounted on it. As an aside, I'll note that the reception is the time when your gear is the most vulnerable, and it's when most photographers' and cinematographers' equipment is stolen. With all the commotion, music, and people drinking, who is going to notice another person near your camera bag with the intention of stealing it? Even if you trust the DJ or feel that your camera gear is safe near the band, realize that these performers are just as distracted as anyone else. It is best to trust no one. To avoid having my gear stolen like many of us have during receptions, I pack all my stuff and put it away, except for two cameras, one with the 16–35mm f/2.8, and the other with the 35mm f/1.4.

FIGURE 15.21

Figure 15.21: This photo was taken with Canon's ultra-wide 11–24mm f/4 lens. I do not normally use this lens at receptions; however, this photo was taken before the guests were allowed into the room and I had a few moments to myself to photograph the reception details. Because this lens's maximum aperture is f/4, it would not be my preference during the actual reception. At f/4, too much of the mood of the room would be eliminated and replaced by flash. For me, keeping the mood of the room is key, which is why, for the most part, I photograph receptions with apertures between f/1.4 and f/2.8. This 11–24mm lens is unique in that it is as wide as you could possibly wish without the extreme distortion of a fisheye lens. It's a great lens when you want to show an entire room in its full glory with one single photo. Wedding coordinators will love you for such a great perspective of their work.

Figure 15.22: This is a great example of staying true to the mood of the room while still freezing the movement on the dance floor. This photo was taken with the 16–35mm f/2.8 lens at ISO 800, f/5.6, 1/30. That's right, 1/30. At a shutter speed so slow, this would have come out completely blurry with just the available natural light. But firing the flashes takes care of the freezing of the moment, while the slow shutter collects as much of the ambient light in the room as possible. Notice how nicely balanced the ambient light is with the light from the flashes. Photos such as these have been a tremendous success for me when meeting with prospective clients.

Figure 15.23: This photo was taken at a focal length of 16mm, using the 16–35mm f/2.8 lens. That focal range is very effective at allowing me to zoom out to 16mm and quickly capture as much of the action as possible. Now you can see how many people were in the room participating in this enjoyable Persian tradition. I used the same slow shutter with off-camera flash technique as in Figure 15.22.

FIGURE 15.22

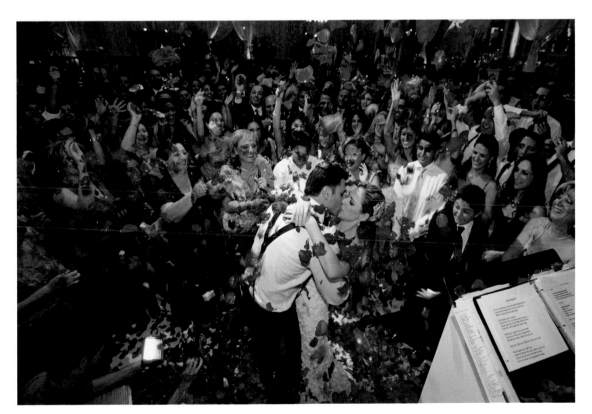

FIGURE 15.23

Figures 15.24 and 15.25: Although the 15mm fisheye lens can be a bit much for most situations, it can be quite effective for a couple of photos here and there during the reception. Both of these images have a unique energy to them because you can see the entire room at a glance. This unique perspective gives the viewer the context of how grand the event was. However, to make the photo more elegant, I thought it was important to hide the fact that the photo was taken with the fisheye lens. The first thing I did was crop out 10–20% of the outside of the frame. This is the area where most of the heavy distortion occurs. Next, I used the lens correction tool in Photoshop to further fix the distortion. The results are not perfect, but they are far better than the initial gimmicky look of the fisheye lens.

FIGURE 15.24

FIGURE 15.25

Figure 15.26: The mood of this photograph with the bride's precious expression has made this photo one of my favorites. This photograph was taken with the 35mm f/1.4 lens at f/2.8, 1/125, ISO 640. Had I kept my aperture wide open at f/1.4, the groom would have fallen out of focus too much for my taste, considering he is a major part of this story. Therefore, I quickly changed my aperture to f/2.8. Although f/2.8 is still risky, I didn't want to lose the ambiance of the room. One of the characteristics of wide lenses such as this one is that the focus falloff from shallow apertures is not as sensitive as with telephoto lenses. This is very important to keep in mind. Although this photo was taken at f/2.8 and focused on the bride, the groom is still in decent focus.

Wedding photographers around the world have developed unique styles that resonate with themselves as well as with their clients. Lens choice is a matter of personal taste and style. I make these recommendations based upon my experiences and what has worked well for me from years of trial and error. However, my recommendations are not and should never be interpreted as the only way or the one "right" way. Experiment for yourself and see what works best for you.

FIGURE 15.26

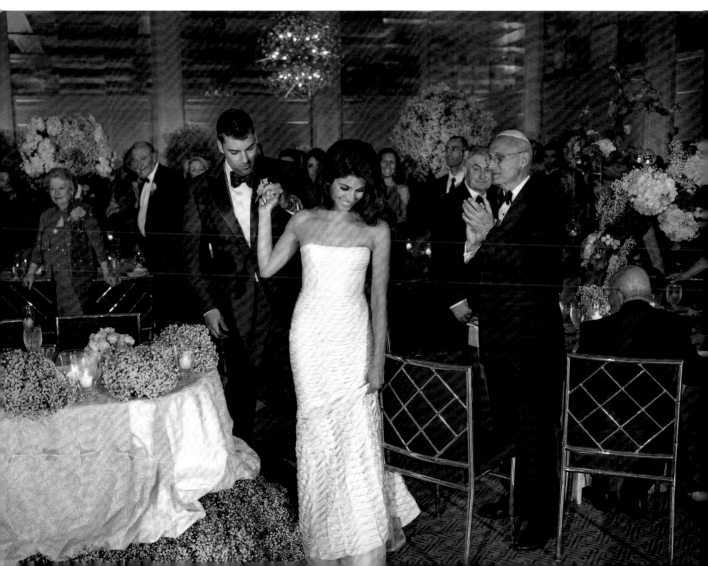

Focus Point Techniques to Avoid Heavy Recomposing

Most modern cameras offer more than 50 focus points. Of these, the most commonly used point is the middle focus point. When photographers tilt their cameras up, down, left, or right until the middle focus point is right over the subject's eyes in order to lock focus, they will have to recompose their photo to create their desired composition. The problem with this focus-and-recompose technique is that, if the subjects are moving, by the time you lock focus and then recompose the shot, they will have already moved away from the focal plane. This is especially true during the wedding processional, when people are walking up the aisle toward the camera. It doesn't take much distance for subjects to become completely out of focus when they are walking toward you.

To avoid this, learn your camera's focusing system and practice moving around the focus points so that you are fast and able to this with your eyes closed. Throughout this chapter, I have often recommended photographing at a shallow aperture range between f1/2 and f/2.8. This creates a much-needed separation between the subject and the background. However, these apertures are ultra-sensitive and have a very narrow focus plane. Therefore, the less you have to recompose your shot after achieving focus, the better your chances of achieving tack-sharp images.

FIGURE 15.27

Figure 15.27: The far two rows in any direction of the focus point system are the focus points I practiced on to improve my ability to select a distant focus point. You could use your camera's focus point shortcuts or any other technique. For this image, I asked the bride to slowly take a few steps forward. Before she started walking, I selected the focus point that would result in the least amount of recomposing distance so that I could achieve a nice composition with the subject and the rest of the frame. Had I chosen the middle focus point, I would have had to shift my camera far left and up, lock focus on her eyes, and then recompose all the way back. By the time all that happened, the bride would have been long past the focal plane.

Figure 15.28: This is an example of the processional when the wedding party is walking quickly toward the camera. The risk of the subjects walking past the focal plane before you can take the photo is at its highest. So right before the processional was about to begin, I quickly had my second shooter stand where the wedding party would be walking up the aisle and chose the appropriate focus point that would be the closest to their eyes while still achieving a balanced composition. By choosing the correct focus point, it allowed me to minimize the distance required to recompose.

FIGURE 15.28

HELPER LIGHT: A WEDDING
RUN-AND-GUN APPROACH

Helper light is, hands down, the most helpful yet underutilized technique that wedding photographers can implement. First, let's define the term. "Helper light" is light that is added by a photographer to a subject via reflectors, diffusers, LED continuous lights, or flashes (these could be regular flashes or larger strobes, such as Profoto wireless units). The purpose of helper light is to give existing light—or circumstantial light, as I call it—a small boost in intensity, color, or direction to best flatter the subject(s).

There are three major reasons why most photographers don't implement helper light in their work. Reason 1: There is usually no time to set it up. Weddings proceed at such a fast pace that there is not much time to even think about adding light to the scene. During weddings, most photographers are in a survival mode rather than in an artistic or storytelling mode. Reason 2: Laziness. Deciding to add helper light to a scene in front of you requires more mental and physical work. Reason 3: Technical know-how. Even though most photographers spend a great deal of money on equipment such as flashes, most don't take the time to really learn those flashes' features and capabilities, and they don't know how to work through their menus quickly. A great majority (though not all) of wedding photographers put their flash on TTL mode and hope that the flash's internal computer can do all the work and thinking for them. When the results are not what they had in mind, they don't know how to correct for them. For these reasons, most wedding photographers' work looks almost identical. Which is also why clients have a hard time paying a premium for a photographer if, in their eyes, the results of one photographer look more or less the same as all the other photographers whose work they've examined.

This explains why so many wedding photographers rely on discounting their services or collections to the point of minimal profit just to book a wedding. But I can tell you this with confidence: a photographer who uses helper light will stand out. You don't have to be an expert in photography to recognize the tremendous benefits helper light has on a subject. Helper light can turn average lighting into unbelievably flattering lighting. The difference between helper light for portraiture and helper light for weddings is that, for weddings, you need speed. You must get into the habit of being ready before you even need the helper light, which means you must have your gear ready to go whether you think you need it or not. If you are in the middle of photographing a scene and you realize that the shot could really benefit from some helper light, but you still must pull it out of the camera bag, it will be far too late.

A run-and-gun approach to helper light requires practice and forethought. When under pressure, you can't be fiddling around with buttons on your flashes and trying to guess how to achieve a specific look. Learning the basics of your flashes is an absolute necessity.

Figures 15.29 and **15.30:** These are two images that demonstrate why I strongly believe that if you truly want to create something most people can't or won't attempt, you will need to implement helper light into your work. The first photo (Figure 15.29) shows the groom resting against the window with one of his groomsmen helping him with his bow tie. Clearly, to improve the photograph, their positions should have been reversed to give the groom the window light. However, look closely. Although the groomsman is receiving direct light from the window, the light is still far too weak. It was cloudy and stormy outside, so the window light was not very intense. Without helper light, I would have had to shoot at ISO 6400 or more to obtain a decent shutter speed.

Now look at Figure 15.30. My assistant was holding a video light at camera left, pointed at the groom's nose. This beautiful light gave the groom the same great window light that would only be possible if the subject were standing right in front of a strongly lit window. Notice how nicely and elegantly the groom is lit. It is much more flattering than flat and weak window light, right? This process is not complicated, but it did require some forethought. Remember that being prepared before you even need helper light is the key to applying it. As soon as we walked into that room, I noticed the weak window light streaming in. A storm was brewing outside, and therefore the light intensity was never going to get better, only worse. Immediately, I pulled out the video (LED) light and asked my assistant to point it at the groom's nose. If the groom moves, my assistant moves with him. "Follow the nose," I told him. We did not interfere as the groom was naturally going

about his business. But we did explain to him that since there was a storm outside, we needed to add light to his face. Not only did he understand, but he really appreciated it!

Once you take a few photos of that particular moment, be considerate and turn off the light. Only turn it back on the next time you want to capture another candid moment. If you are always considerate, your subjects will be far more willing to cooperate with you. With an LED video light, what you see is what you get, so it is a very simple and quick solution for adding light to your main subject and capturing the scene with a much lower ISO setting.

FIGURE 15.29

FIGURE 15.30

REACTIVE VS. ACTIVE HELPER LIGHT

Unlike portraiture, wedding photography is an ongoing combination of photojournalism, portraiture, family photography, etc. Therefore, we need to know what tools and techniques will maximize our efficiency and lower our footprint.

Reactive Helper Light

"Reactive helper light" is used when photographing with a photojournalistic or interactive photojournalistic approach. You are basically "reacting" to the moments unfolding in front of you. Reactive helper light is stationary, meaning that once you place or clamp the off-camera flash somewhere and the perfect settings are dialed in, you leave it there and let it fire away as you capture photographs from the opposite side of the room. The flash is simply adding a bit of fill light to the window light without overpowering the ambient light and without any supervision or attention.

The two main sections of a wedding where I implement reactive helper light are during the getting-ready segment and the reception. During these two segments, the photographer is reacting and capturing the interactions between, for example, the bride and her bridesmaids, the groom and his parents, etc. These interactions happen quickly and without warning, so reactive helper light is the only real option.

Getting Ready

Figure 15.31: Before I begin the coverage of any wedding, I arrive earlier than I said I would so I can make sure all my gear is ready to go. The major reasons for this gear check are to synchronize all the time stamps and to have my helper light(s) linked and ready. Notice that I have my transmitter on my hot shoe; I do not mount a flash on my camera. One of my two flashes is set to group A and the other to group B. I always keep the flashes in Manual mode and, depending on the size of the room, at the weakest or second-weakest power setting, which would be at 1/128 or 1/64 power.

FIGURE 15.31

Remember that the purpose of helper light from a flash is to give the amount of light in the room just a slight boost. If you do it correctly, you will barely be able to notice the influence of the flashes in the scene. Because the light from a flash is a bit warm, I change my white balance on my camera to a range between Kelvin 4500 to 4700. Assuming the color of the walls is a neutral color, this will balance the window light and the warmer color of the flash light very nicely.

Figures 15.32 and 15.33: These are the two major ways I position my helper light flash in a room where the bride or groom are getting ready. In Figure 15.32, using the little flat flash stand that comes with the flash, I mounted the flash to the stand and simply placed it on top of a bed. I pointed the flash toward the wall opposite the window and set the flash to a very weak power on manual mode. Once the flash was set, I took a few test shots and examined my camera's histogram to see how it moved to the right when the flash was turned on, contributing slightly to the exposure. Figure 15.33 shows the second most common way I position a flash for helper light. In this case, I used the adjustable clamp to affix the flash to a lamp in the room and pointed the flash at the wall, as usual. Then I moved to the opposite side of the room and began to photograph the moments as they occurred without having to worry about the flash.

FIGURE 15.32

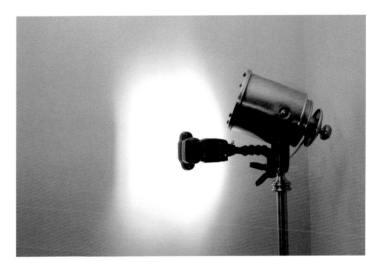

FIGURE 15.33

Figures 15.34 and 15.35: This is how subtle using a flash for helper light in a room should be. Figure 15.34 has no flash helper light contribution. The photo looks fine, but the bride's face and hair have almost no shadow detail. This is how most wedding photographers would take photographs during this part of the wedding. However, look what a beautiful difference it makes to add just a pinch of light to the scene. Figure 15.35 benefits from the flash's extra light, which is resting on the bed (which you can see in the bottom right corner of the photograph) pointed at the wall opposite the window. Notice how beautifully the bride's hair and face are lit. The photograph still looks 100% natural, but now you can better appreciate how dazzling the bride looks. In fact, I'll bet that if I hadn't told you that I used a flash for Figure 15.35, you probably would not have guessed. When I explain this difference in the photos to clients, this becomes one of the major reasons why they book me instead of the competition. They appreciate that extra lighting effort that makes them look their very best.

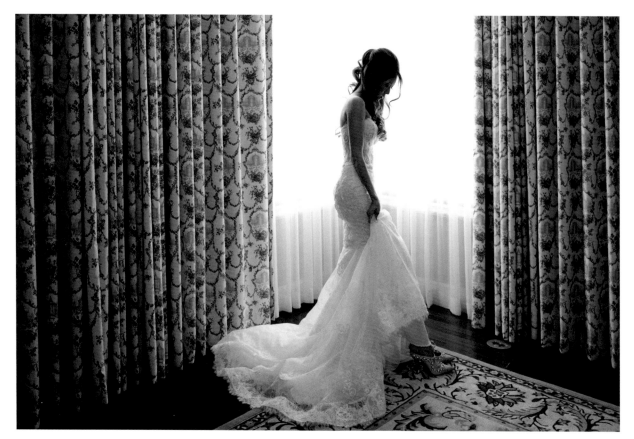

FIGURE 15.34

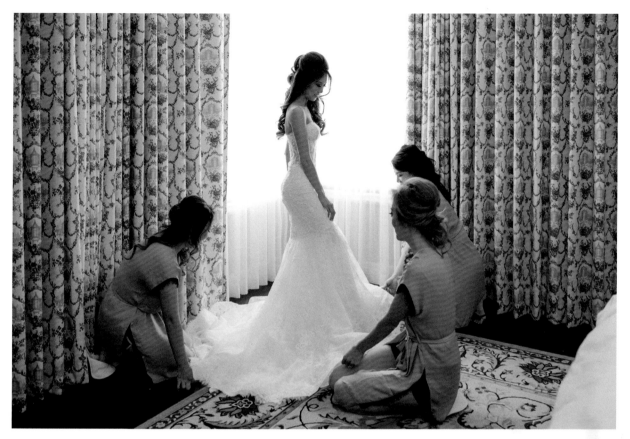

FIGURE 15.35

Figure 15.36: I think this is one of the best examples of the importance of flash helper light. I recognize that it can take a few extra seconds to set up, but it is very hard to deny the rewards. For this photo of Esther, I adjusted the position of the flash, which was already set up on the bed, so that it bounced light right where this portrait was going to be taken. To camera right, there is a large window. I asked the bride to turn her head slightly toward the window, and then I filled the darker side of her face with a gentle use of fill light from the flash. I loved the results! If you look closely, you can actually see a telltale sign of the flash in the slight highlight created by the fold of the veil near the bottom left of the photograph. Without the flash, that highlight would not be there, and the right side of her dress would have been much darker.

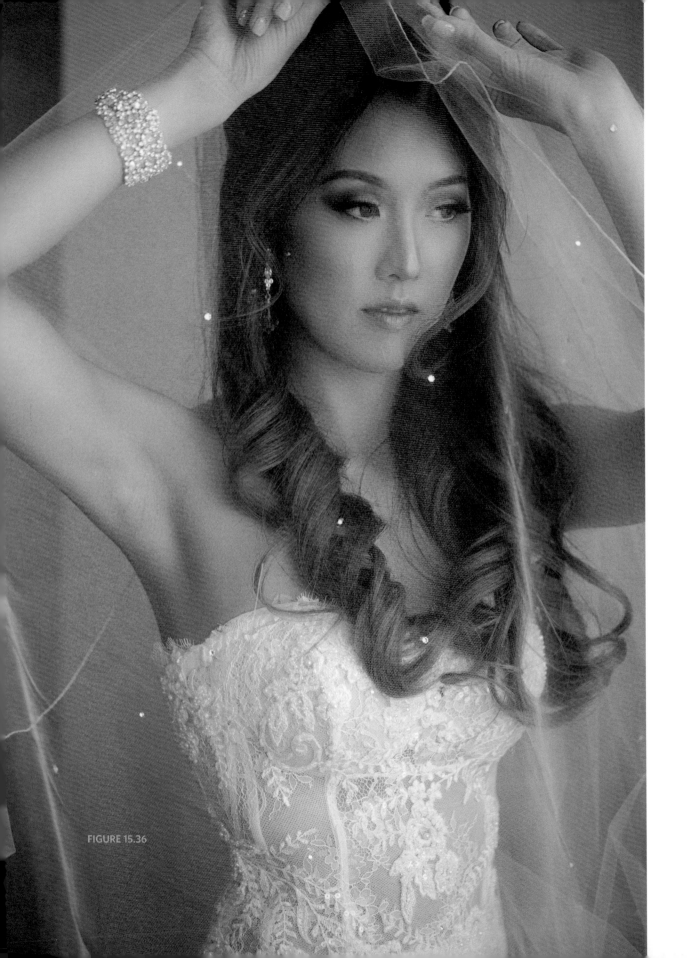

FIGURE 15.36

Reception

My reception setup has been modified over and over throughout the years. By diligent experimentation, I have nailed down a look and feel that both I and my clients love. The setup requires three flashes. One flash is on my camera's hot shoe, and the other two are placed high up on either side of the band stage, approximately 12 feet high and pointed down toward the center of the dance floor. The light stands holding the two flashes are each weighted down with 25-pound sand bags to prevent them from being hit and falling on someone. That would be a lawsuit waiting to happen.

The use of reception helper light needs to be subtle in order to maintain the ambience that the couple worked hard for and paid a lot of money to obtain. Reception lighting, table flower arrangements, décor, candles, etc., all contribute to a specific mood. It is very important to maintain the reception's mood and integrity. When considering lenses to maintain the mood, I rely on fast, wide-angle lenses, usually the 35mm f/1.4, the 16–35mm f/2.8, and the 50mm f/1.2. Depending on the situation, of course, I try to keep my camera's ISO at receptions to around ISO 800. The rest of the gear gets put away in the car where it will be safe.

The flash on the camera's hot shoe is at a low manual power of around 1/64; its function is to provide a little fill flash and to act as a transmitter for the two off-camera flashes. The two flashes on either side of the reception give the dance floor an exciting nightclub feel. Let's look at some examples.

Figures 15.37 and 15.38: In these two examples, you can clearly see my flash setup. To locate my flashes, just look to either side of the band over the speakers. (Here I used two flashes on each stand, but could have used just one on each stand; using two on each stand just makes the flashes able to fire more quickly.) To show the difference between flat lighting a reception with a single on-camera flash and creating a nightclub scene, I turned off the off-camera flashes in Figure 15.37. I bounced the on-camera flash on the ceiling. You can automatically see how flat the reception lighting appears. Most of the mood is gone, and there is no dimension to the scene. Compare that with Figure 15.38. I turned on the flashes next to the band, then dialed the flashes' power on manual up or down until the mood was just right. Quite a difference!

FIGURE 15.37

FIGURE 15.38

Figures 15.39 and **15.40:** As you probably know, during receptions people often come up and ask if you would take a quick photo of their group. This can happen at any place at the reception venue. The lighting setup described above is meant to create a nightclub feel around the dance floor, but that won't help you if the people you are photographing are somewhere else. The solution is to use the flash you already have on your camera. In these instances, I quickly turn off the flash transmission to the dance-floor flashes and put the on-camera flash on TTL, angled at 45 degrees with the white bounce card out. See Figure 15.39. This gives you the perfect lighting on the group in front of your camera. After the photo is taken, you can quickly turn the transmitter back on and continue shooting the action on the dance floor.

FIGURE 15.39

FIGURE 15.40

Active Helper Light

"Active helper light" means that someone is actively moving or holding the helper light to illuminate your subjects. Unlike reactive helper light, active helper light requires two people: the photographer and an assistant to hold the lights or modifiers. Active helper light is used when I have a little more control over the situation.

I always work with all my flashes on manual mode. The only time I use TTL mode is when subjects are in constant movement toward or away from the camera, such as during the ceremony procession. As soon as the procession ends and the actual ceremony begins, I turn all my flashes off to avoid being a major distraction. Most photos taken at weddings are taken quickly and close to a window or in open shade. Both options have some undesirable outcomes. Window light looks good on the person's side closest to the window, but then the lighting falls off into darkness. Open shade has a blue/green color cast, and it is usually weak light. Either way, there is always the opportunity to improve the lighting on your subjects quickly.

Figures 15.41 and 15.42: For this behind-the-scenes photo (Figure 15.41), the wedding coordinator's assistant was helping me by holding an LED video light that provided fill light to the right side of the groom's face. You can clearly see the effect of the light. The resulting photo (Figure 15.42), is quite flattering to the groom. Without the boost from the LED light, this groom's portrait would have featured an unflattering split lighting. But now you can see a pleasing balance of light between both sides of his face. The gradual decrease in light intensity throughout his face gives this portrait a three-dimensional look.

Figures 15.43–15.45: This example illustrates a frequent situation when photographers rely heavily upon available window light. Figure 15.43 is the result of using only window light in the room to illuminate the moment the bride's sister is helping the bride with her dress. As you can see, this photo is not flattering at all because the window light is simply not strong enough. Helper light is an expert technique because the photographer must realize quickly when the available light is not enough to flatter the subjects. After taking this photograph,

FIGURE 15.41

FIGURE 15.42

I quickly asked my assistant to get the LED lights that were in another room. Figure 15.44 shows the results, which are stunning! My assistant held a strong LED light and pointed it straight at the bride's nose. I always tell my assistants to follow the nose with the light to avoid unwanted shadows on the face.

Figure 15.45 is the final edited photo. It was such a simple adjustment, yet it had such a great impact! I love to see the expressions of my prospective clients when I show them how I choose the lighting for their wedding day. Their eyes just light up! (No pun intended.)

FIGURE 15.43

FIGURE 15.44

FIGURE 15.45

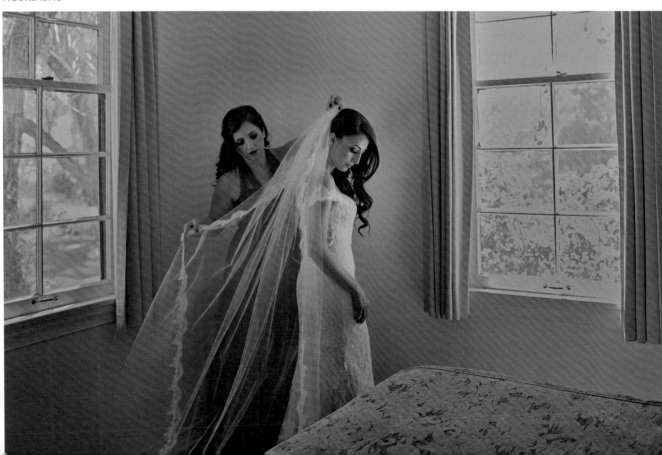

Figures 15.46 and 15.47: Active helper light allows the photographer to harness more beauty and impact from any location. When I arrived to photograph this wedding, I noticed a unique room with very interesting wall art. The fact that the room was quite dark and the couch was far away from any window light did not deter me from shooting there and taking advantage of that unique environment. In this case, an LED light would not have been powerful enough to illuminate the groom or the room. Therefore, I asked my assistant to get a strobe and stand at camera right until just out of frame, then I shot the flash through a Profoto diffuser. The result is Figure 15.47.

FIGURE 15.46

FIGURE 15.47

Figure 15.48: During weddings, I do whatever it takes to use helper light as much as possible. I know for a fact that my portraits will almost always greatly benefit from a little extra light in the right places. During this recent wedding, we had a couple of extra minutes before the couple was called in for their grand entrance. The was in the late afternoon, and the sky was losing much of its intensity. Without even taking a photo, I already knew that this kind of weak, late-afternoon light always leaves dark circles under my subjects' eyes. Since my assistant was away taking reception detail photos, I had to work alone. I simply put a flash in my pants pocket, and I already had the transmitter on the camera's hot shoe. I took the couple up some stairs, looking around for one last quick photo opportunity before it turned dark. I discovered a driveway with this lovely wall of flowers, and I used my 70–200mm to compress the scene. Although it was difficult, I had to hold the camera with that big lens with one hand, while my other hand held the flash with a 1/4 CTO gel and diffuser filter attached, extended as far as my arm would allow. The flash fired, and it filled the darkness under their eyes and warmed up the scene beautifully. Unfortunately, I did not take a photo without the flash firing, but I can assure you that it would have looked bad and the photo would have been unusable.

I want to finish this chapter with these words. Apart from the ceremony, where there is nothing you can do with regard to lighting, all other segments of a wedding will greatly benefit from a boost in light. Implementing helper light is definitely an expert technique because it requires a photographer who is dedicated to providing clients with outstanding and skillfully crafted photographs. Lighting is the main ingredient in photography, and therefore it should be at the forefront of your decision-making before you press that shutter button. Effective use of helper light will contribute greatly to your hiring potential.

FIGURE 15.48

chapter 16

POSING AND EXPRESSION EXPERT TECHNIQUES

This chapter focuses less on traditional posing techniques, and instead emphasizes an approach that removes the "posed look" from your photos. Paying more attention to influencing expression and directing movement will make a significant difference in how couples look in their wedding photographs and how they feel about them.

I consider these posing techniques to be part of the expert components system because they require absolute attention to detail, and you must raise the bar to make sure you are capturing expressions that are realistic and have an exciting energy to them.

I also explain how and when to use touch with EVP to increase the emotional energy of a photo. Imagine that the groom and his father are standing next to each other without any physical contact whatsoever. The photo would appear quite awkward and would convey a very low sense of family affection. Because I have already discussed posing and composition previously in this book, I will focus purely on those elements of posing that will take photos from being simply nice to an expert technique level.

Since you are already reading this book, it is an accurate assumption that you have a deep desire to become a much better photographer than you are today. You want to keep advancing because you realize that being complacent in such a competitive field could lead to failure. For these same reasons, I always ask myself a series of questions that have helped me tremendously in my ongoing quest to keep pushing myself further.

Key Questions to Ask Yourself That Will Help Keep You on Your Toes Before Pressing the Shutter Button

1. Does this photo contain something that will hold your attention?

2. Is this photo intriguing to look at via its composition, lighting, or posing?

3. Does capturing this photo require a higher-level skill than that of the average photographer?

4. Would this photo evoke feeling(s)?

I consider these questions to be my mantra. In fact, the expert techniques in this book were developed to answer these four questions with a resounding "Yes!" I have found that many overly technical photographers can nail the technical side of a photograph, but the photograph looks stale and devoid of emotion or feeling; they answer "yes" to technical question #3, but "no" to #4, and this results in a technically flawless photo that lacks human connection.

I do realize that it is not realistic to ask yourself these four questions for every photograph you are about to take at a wedding. But there are many times when a small adjustment or a little bit of extra effort to draw out an emotion or improve the lighting leads to a vast improvement in the final photo. In fact, by simply having these four questions in the back of my mind, I become a better photographer even if I don't implement them all the time. Trying to answer yes to these four questions as many times as possible during a wedding makes it very difficult to become complacent.

CREATING AND CAPTURING MOVEMENT TO ACHIEVE A SENSE OF SPONTANEITY

One of the most common flaws in posing is when the pose looks contrived or fake. A master's approach to posing renders the pose invisible. In other words, you do not notice the pose. When people who are not used to being photographed see a giant professional camera pointed in their direction, they involuntarily tighten up and freeze. A good and relaxed posture is key to the success of any photograph, but I consider that to be a basic posing skill, not an expert component. However, noticing and gently removing the awkward rigidness that occurs in the human body is a key component to taking posing to a higher level. Two basic methods that eliminate the posed look are: removing rigid posing patterns, and capturing natural poses while the subject is in movement instead of in a static state.

- **Method 1:** Simply adjust one side of the subject's body up or down to remove the mirroring of arms and legs, which creates a rigid look.
- **Method 2:** Add movement. If you capture your subject while they are moving—even if the pose still has elements of mirroring—the repeating pattern will not be very damaging to the believability of the pose. Remember that the goal is to make the pose look invisible.

Method 1: Notice and Change the Pose to Remove the Mirroring

Figure 16.1: This is a very nice portrait of the groom and his father in the stylized aware approach. Although there is nothing wrong with this portrait, the clear mirroring of each other was too much for me, not to mention the hand coming out from the father's waist. You are probably wondering why I'm not happy with this photo. I am okay with it, but any photographer, regardless of skill level, could have taken this photo. That is the issue. If I can try harder to do something special, why not do it?

FIGURE 16.1

Figure 16.2: At a different location during the wedding, I pushed myself harder to break the static, posed look and create a moment of candid laughter. I changed my approach from stylized aware to stylized unaware. To be honest, both photos are good, but which one commands more of your attention? Which photo do you find more interesting to look at? Which one requires more skill to capture? And which one makes you feel something?

FIGURE 16.2

Method 2: Add and Capture Movement to Remove the Static Feeling of Mirroring

Figure 16.3: This is what happens when you create a pose but you don't follow through and finish it. In this case, I felt the urge to showcase the bride's beautifully designed veil. So I asked her to lift it with both hands and look to her right. However, notice the evident mirroring of her arms. Since the wall behind her has even luminosity levels and the circumstantial light on that balcony is great, the photo looks beautiful, but the pose is not invisible. This photo looks as if she is following the photographer's directions. There is something missing.

FIGURE 16.3

Figure 16.4: This is a successful attempt at getting it right. I wanted the pose to be invisible and the viewer to be drawn to the veil. This time, I asked the bride to slowly turn toward the wall and look to her left, which is where the light was coming from. The purpose of the slow turn toward the wall was mainly to create movement. The resulting pose from that movement is not perfect, and it doesn't have to be. This photo has an incredible sense of romance and beauty, and the veil has become the main attraction. By adding and capturing the bride with some movement, there are no signs of contrived posing, even when some elements of mirroring remain. That is another reason why I consider this technique an expert component.

FIGURE 16.4

Figure 16.5: I want to show this last example because I love the results when following through with this expert technique. This balcony at the Bel-Air Bay Club had several great circumstantial light elements that compelled me to use the location to take a portrait of the bride. I could have taken the easy route and asked her to stand and look at my camera mounted with a telephoto lens. However, I wanted to add this expert technique of capturing movement and creating a sense of spontaneity. I decided to use the stylized unaware approach. To create this portrait, I asked the bride to rotate halfway clockwise, then slowly turn back toward me while locking her eyes on a specific point that we agreed on. I am very happy with the results. I did not capture the bride in a static pose, but instead captured her in movement. If you are wondering how long this pose took to set up, it was less than 30 seconds. With practice, you will realize how easy it is to come up with an excuse to add movement to a simple pose.

FIGURE 16.5

CAPTURING PEAK ACTION AND ACHIEVING NATURALLY ENGAGED EXPRESSIONS

One of the most interesting challenges of being a people photographer is to capture a meaningful expression. The difficulty comes from how uncomfortable it is for most people to be photographed. Having a portrait taken often awakens acute self-consciousness in a person. When a camera is pointed in a subject's direction, he or she automatically tenses up and doesn't know what to do. Most individuals have an instinctive desire to appear "socially normal," whatever that means. As photographers, being able to capture an unselfconscious expression from our subjects when they are aware of the camera is an expert technique due to the high degree of confidence and skill the photographer must have in order to coax their clients to let go of their inhibitions.

Creating a Safe Environment for People to Allow Themselves to Become Vulnerable

The first step is that the photographer must be enthusiastic, positive, fun, and radiating confident energy. If you can be like that, clients will reward you by giving you their trust and respect. Their defensive barriers against the camera will begin to crumble, and their emotions, personalities, and thoughts begin to reveal themselves in front of your camera.

Contagious Energy

Figure 16.6: This is a great example of being so close to taking a realistic and beautiful photo but for some reason not finishing the job. The expressions of the bride and groom fall short. The pose can be improved by giving the couple quick instructions to follow, but the expressions are quite different. To me, this is a two-step process. The first step is to position the couple as well as I can and make sure they know where exactly to look (this step poses their eyes). The second step is to have the couple react to something I have said. I put so much effort into what I'm saying that they simply can't help themselves, and they react naturally. By having their eyes fixed on a specific spot, it will reduce the chances of their eyes rolling over or creating a look that is not what you had in mind. If you forget to pose the eyes during step one, the couple will almost always ask you or wonder where should they look.

FIGURE 16.6

Figure 16.7: This is the result of the second step I mentioned above. I push and push to get a reaction. I do whatever it takes to get the couple to loosen up, have fun, and react as they normally would to my bursts of energy. In this case, I told the groom to kiss her quickly on her left upper cheekbone, then pull back a bit and see her reaction. The first time he did it, it was very dull. Instead of giving up or trying to come up with something else to say, I gave it another try and with a high-pitched, high-energy voice, I asked the groom, "That's it? That's all you got? Come on man, kiss that cheek like you mean it! That cheek is yours, it wants your kiss, go give it what it wants!" Laughing, he immediately went for it, kissed her, and they both reacted with a beautiful, tender energy. If what I say doesn't work, I will quickly turn to self-deprecating humor. I would say something like,

"Wow, that did not pan out the way I imagined it," with a humorous tone of voice. Note: Come up with something unique. *Do not use the same lines for all your couples.* They will feel it and not like it! Although it takes a lot out of me, I find the resulting photos to be some of the greatest rewards of being a wedding photographer. I can't help but love their smiles and wonder what was going on to capture that moment. When photographers feel shy or lazy, they never accomplish this second step. They simply tell the couple to stand together and look at each other and smile. They may even say it in a monotonous voice that inspires no one, and the resulting photos will most likely show artificial smiles and emotionless expressions.

FIGURE 16.7

Create Anticipation

Figure 16.8: Another technique you can use to achieve a realistic expression is to create a feeling of anticipation. For this example, earlier in the day as I walked with the bride to the spot where the groom would be waiting for her and seeing her for the first time, I noticed that she was just walking from point A to point B, and there was an empty expression on her face. So I decided to use this anticipation technique. I stopped everyone from walking, and I informed the bride that the groom was extremely excited and nervous. Then I pointed to the area where the groom would now be standing. As she approached the area where the groom was waiting with his eyes closed, her face filled with the most beautiful expression of anticipation. I knew that this would happen, so I was ready to capture this moment. This technique can also be used the first time the bride sees her father, mother, best friend, or any other high-value EVP during the getting-ready portion of the wedding.

FIGURE 16.8

Create Concentration or Focus

Figure 16.9: You might recognize this photo if you have read my books. This is the image that was on the cover of my first book, *Picture Perfect Practice*. I consider this to be a great example of the "pay attention" technique. After positioning the dress (it is not her veil) over the bride's head and bringing down her chin to the right level, I told her that I would be taking two photos. I asked her to focus on the shutter inside the camera, beyond the barrel of my lens. The first time she heard the shutter move would be the cue that the second, real photo would follow. I told her that when she heard the first shutter, she should focus on relaxing all of the muscles in her face. Then, the second photo would be taken with her face beautifully relaxed.

FIGURE 16.9

Sometimes I ask clients to look out the window and have them count just white cars, or red cars, or tree leaves, etc. I just need them to have something to focus their mind on. It doesn't matter what it is, but I need them to think less about the camera taking their photo and more on the task given to them.

Figure 16.10: This was an easy photograph to plan. Since I wanted to take this photo in the stylized unaware approach, I needed the bride to avoid looking at the camera. To get her to focus, I simply asked her to keep her eyes on the stairs so she wouldn't trip. I told her to make sure she felt her foot steady on each step and not on her dress. Notice how focused she is. This deep concentration gives the photo a beautiful sense of a moment just unfolding, not a photographer who had an idea. There is a distinct difference!

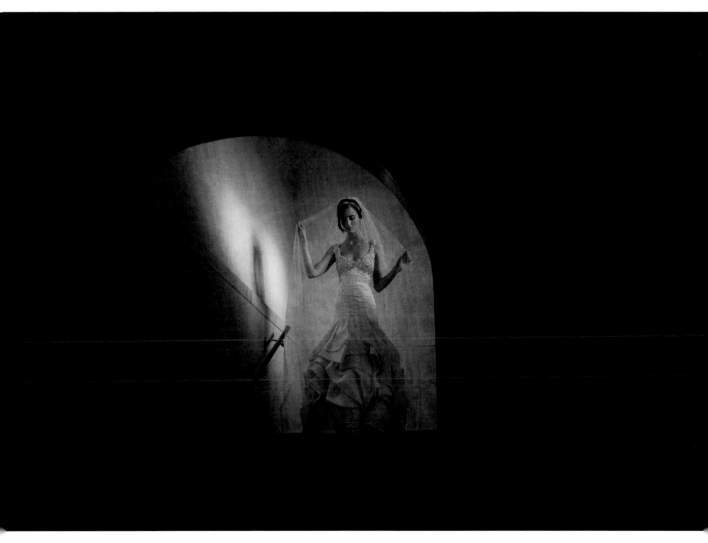

FIGURE 16.10

Recognize a Highly Emotional State

This is a technique for the photojournalistic or interactive photojournalistic approach. Recognizing the highly emotional meaning of an activity means that the photographer should be able to predict that emotions will be running high among the individuals involved, and that anything can happen. Examples include the first time the bride and groom see each other, the first time the bride sees her father, the couple exchanging vows, the couple's first dance at the reception, the father/daughter dance, and the bouquet toss. These are all events that could cause people to cry emotionally or laugh heartily. During these times, the photographer must watch the action like a hawk, because at any time a great display of human emotions could occur.

Figure 16.11: During highly emotional situations, you want to focus 100% on what is in front of you. Be sure that your camera settings are set perfectly before the action begins, because chimping at the camera could cause you to miss a very powerful moment. During these times, the best photos don't come with a warning, so be ready. Look how fun this photograph is. Everyone is at peak emotional action. The expressions on the bride and groom are so real and powerful that you almost feel their emotions through the photograph.

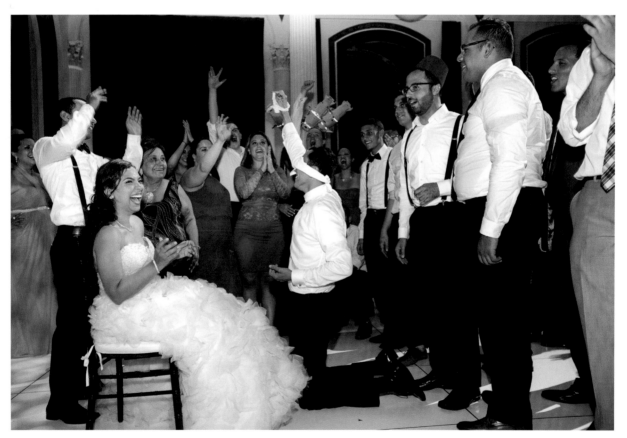

FIGURE 16.11

Figure 16.12: The father/daughter dance is one of the most powerful and emotional moments you can capture. This is a very emotional time for both the father and his beautiful, precious daughter. Photos such as these will be treasured more than the family's most expensive possessions. If you work with second shooters, do not let them chimp at the camera during these events. Both you and your second shooter must be 100% focused on capturing the very best and beautiful human emotions that are unfolding in front of your lens. I feel a wave of emotion running down my spine just thinking about this photo. I remember how beautiful the energy was in the room during this father/daughter dance.

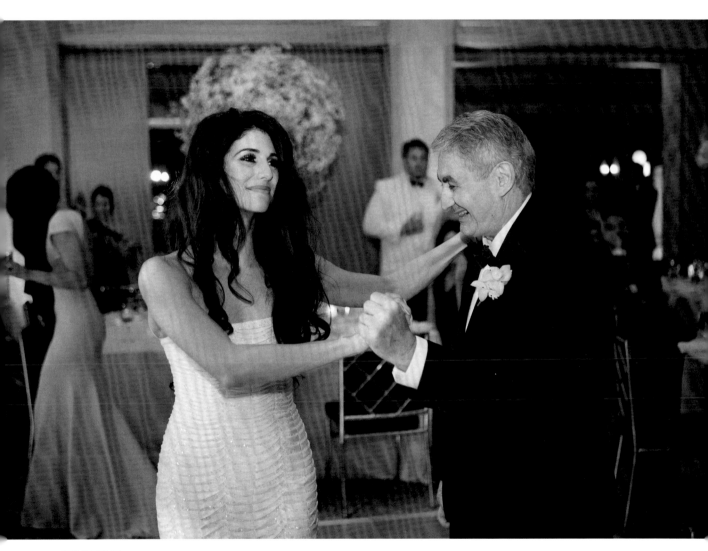

FIGURE 16.12

INCREASING AFFECTION THROUGH TOUCH AND ENERGY

This last posing expert technique is very simple to implement, yet I wish I saw more of it. The theory behind this technique is that when photographing EVP with the bride or groom, you want to be sure that their loving energy is felt through the photograph. You create this through physical touch. Otherwise, you end up with a photo of two or three people standing next to each other with their arms at their sides, looking at the camera with artificial smiles on their faces. This expert technique is about making EVP embrace each other in loving energy, even at the expense of a distracting posing element. Being constantly aware of this expert component will give your photos a much more loving energy.

Figure 16.13: This tender photo showcases precisely the results of implementing this expert technique when appropriate. This is a photograph of the groom with his grandmother, who is a highly valuable EVP. This is a perfect time to take the extra effort to give the photo a more tender and loving feeling by having the groom and his grandma touch foreheads, while the bride watches this affectionate moment.

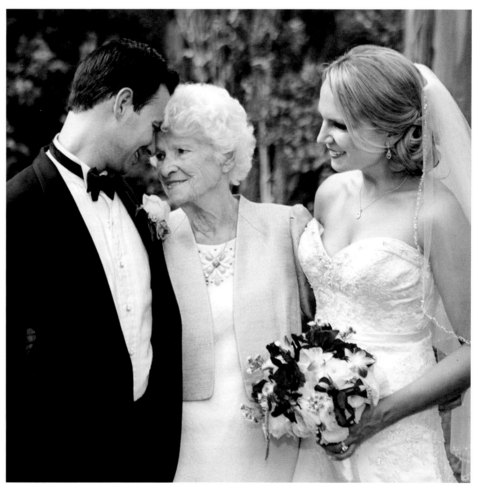

FIGURE 16.13

Figure 16.14: For this photo of the groom with his mother, I wanted them to use both of their arms to embrace each other with their heads so close together that they are nearly touching side by side. Yes, I do notice the groom's fingers coming from behind his mother's back, but honestly, who cares? The photo is beautiful, and they look very happy to have each other at this important time in their lives.

FIGURE 16.14

Figure 16.15: How fun is this group photo? The main element creating the magic here is how much touching and embracing are occurring among the entire wedding party. I'm having fun yelling at them, they are having fun going along with my crazy antics, and

FIGURE 16.15

everyone is hugging or embracing. As I said, increasing affection through touch and energy is a beautiful expert component to include in your wedding photos. Your clients and their families will be so grateful!

chapter 17
COMPOSITION EXPERT TECHNIQUES

This is the last chapter about expert techniques. I will keep it very concise because we have already addressed composition in a few chapters of this book. In addition, the next, final chapter will review and assemble everything together, including photos that utilize these composition expert techniques. Whatever the length of each of these chapters, I consider all the techniques in the expert components system to be equally important for expanding your storytelling abilities and raising them to a world-class level.

One reason why I find the following expert techniques so intriguing is because no matter how much or how little gear you may have, these expert techniques require nothing more than a camera and your creativity. By using inspiring composition and creatively using objects around you to assist in the visual impact of the story, you offer the viewer much more compelling and unique ways of telling the story. This is photographic skill in its purest form. Some photographers have complicated their work with so much gear that they almost need to hire a Sherpa to help carry it all. With great composition skills, a photographer with a basic plastic camera can outperform an inexperienced photographer with the most expensive gear any time.

UNIQUE PERSPECTIVE AND HIGHER SKILLED COMPOSITION

Figure 17.1: This photo was taken from the perspective of a small child, showing how he or she might see the world. I'm six feet tall, and therefore I had to crouch down with my camera to the height of an eight-year-old. This photo was taken during the ceremony, which means I had to think quickly to change my perspective. This photo is quite a treasure, but I can assure you that it would have lost most of its spark if I had simply taken the photo from my own perspective and pointed my camera down toward the praying flower girl. Remember that when your main subject is much shorter or taller than you, take the photo from their height. Adapting perspectives will give the viewer a unique vision of the world.

Figure 17.2: This photo demonstrates the importance of becoming aware of possibilities that do not appear so obvious. This photograph tells quite an amusing story, because we know what usually happens when the groomsmen attend a bachelor party the night before the wedding. I could have taken the obvious photo of the groomsman sleeping in the midst of the chaos around him. However, I was aware of the mirror, so I used it to create a more interesting composition to tell that story. Clearly, the standing groomsman using his cell phone did not party as hard as his counterpart did the night before.

If I had to reflect upon what my major goal is when I show up at a wedding, above all others it would be to tell a poignant story through innovative use of composition. It is a great challenge for me to be able to predict strong human emotion before it occurs and to capture that story by using reflections, framing, contrasts, and the environment around me as compositional tools. It is difficult, but that is precisely what makes it so much more rewarding.

FIGURE 17.1

FIGURE 17.2

Storytelling Through Clever Composition

The comedic nature of **Figure 17.2** is why it is amusing to look at, and telling the story through a clever use of composition takes the photograph to a completely new level.

Figure 17.3: I took this photo at a lounge bar in New York City during the wedding of my friends Brooke and Cliff. I had already taken quite a few photos of them from a normal perspective, so I felt it was time for an unusual perspective. On the top floor of the lounge was this odd bench near the ceiling where a couple could sit and watch everyone below drinking and enjoying themselves. If you are people watcher, this is your seat! In front of that bench was a mirror, so what you are actually seeing is a photo of the mirror's reflection. Clearly there was helper light used to illuminate the couple, who are brighter than the rest of the scene. We used an LED light at half power to create the separation. Note that without helper light, this photo would not have been possible. This photo is somewhat amusing and confusing to look at because you can't exactly figure out the perspective, so I would recommend not going overboard taking these types of photos.

FIGURE 17.3

CREATIVE CROPPING

It's natural that we tend to photograph what we see within our normal line of sight. It is difficult to be able to zoom in and visualize a cropped version of what's in front of us. As you read this, look up and try to "zoom in" on something that you observe. It takes some brain power. I actually spend quite a bit of time practicing this mental exercise. Since my second home seems to be airports, I like to look up from my cell phone screen, people watch, and zoom in on the activity around me. I imagine how I would crop scenes if I had a camera in my hands. One of the best places to practice this is at baggage claim. I watch a parent returning from an overseas business trip, and a daughter dashes excitedly toward her mom or dad. As she hugs her parent, I quickly see the expression of the other parent witnessing such a tender moment. I ask myself, Who would I focus on? What is the most powerful story? How much would I include in the frame?

This constant speculation prevents boredom whenever I'm in public places, and it exercises my storyteller brain. You learn to observe the world in smaller, bite-size pieces that pack a powerful storytelling punch. If you are photographing a person in front of you, it does not mean that you must photograph them vertically from head to toe. Creative cropping allows the viewer of the photograph to see what you consider to be important or interesting.

Figure 17.4: In this example, notice how nicely the groomsmen's suits were color coordinated. Immediately, my eyes were drawn to these superb suits. I knew automatically that this was the story I wanted the viewers to enjoy in this photograph. Therefore, I asked one of the groomsmen to fold his suit jacket and tie over his arm, and I cropped his head out of the frame so that you would focus only on the suit and tie. Don't be afraid to do this. There will be many more photos in which the groomsmen's faces are clearly featured.

FIGURE 17.4

Figure 17.5: I often use creative cropping to feature wedding details. Whenever possible, I try to photograph the details along with a human element. For example, in this photo, the bride arrived and picked up the flower bouquet to admire the florist's beautiful design and workmanship. I couldn't help but notice the bride looking at the bouquet. I decided that the bride with her bouquet would be the story of this photo. But clearly the bouquet is the main subject here, so I used my 85mm f/1.2 lens at f/2 to focus on the bouquet and throw the bride out of focus. Because I chose a location that had a relatively all-white background, little competes with the white and pink flowers of the bouquet.

FIGURE 17.5

STORY FRAMING AND MEANINGFUL OBJECT PLACEMENT

Strategically placing objects that are meaningful to the story in a subtle way can add great impact and charm to your photographs. This technique can really impress your prospective and current clients because it speaks volumes about your keen attention to detail as an artist. Your work becomes much more valuable to them. When I show the following two examples to prospective clients, I automatically sense their instinctive emotional reactions. Note that these two photos of the shoes are indeed part of my sales presentation to prospective clients.

Figure 17.6: This is a cute photo of the groom's son's shoes. Obviously, getting wingtip shoes was a stylistic decision the bride and groom made for the child. I did my job as a photographer by capturing this photo, but the problem is that it's not unique; most photographers would have taken the same photo. Refer to the four main questions I discussed in the previous chapter. This photo just shows you what the boy's shoes look like, and the story ends there. How can we do better as highly skilled storytellers?

Figure 17.7: Let's take another look. Using a few expert techniques, I came up with a better version of the same story. First, I cropped the groom's head out of the composition. This forces the viewer to focus only on the shoes. Second, I posed the groom's legs so that his shoes are the first point of contact, or the closest objects to the camera. This gives the shoes more importance than anything else in the frame. Third, instead of simply capturing the groom tying his classy wingtip shoes, I highly increased the emotional impact of this story by strategically placing his son's matching wingtip shoes next to his. Without having to show their faces, you can immediately recognize that father and son have a very close relationship. This photo also shows in a subtle way that they went out of their way to find matching shoes. Also, you can tell that as soon as the groom finishes putting on his own shoes, he will be assisting his young son.

FIGURE 17.6

FIGURE 17.7

Now compare Figures 17.6 and 17.7. Which one makes you feel something? Which one requires more skill to take? Which one tells a better story? This is the reason why it is so important to implement these expert techniques.

Figure 17.8: I love this photograph, because I remember that I wanted to offer the bride much more than the typical photo of her wedding dress hanging by the window. If you notice the details of the room, there are two frames that can be utilized at the same time. The left side of the room has a frame with the frosted artwork on the glass, and the second frame is the entryway to the other side of the hotel room. That sparked the idea that I could hang the dress on the left frame and add an interactive photojournalistic story of the bride putting on her make-up framed by the entryway. This conveys a very sweet narrative that the dress seems almost "waiting" for its time to shine on the bride. Putting on the wedding dress is a highly anticipated moment for the bride, and this photo builds a sense of anticipation.

When I look back at my early wedding photos of bride's dresses—when I did not know about these expert techniques or storytelling approaches—I appreciate how far I've come, pushed by a relentless desire to improve. Check out this photo from one of my first weddings (**Figure 17.9**).

FIGURE 17.8

FIGURE 17.9

MULTIPLE STORIES CAPTURED WITHIN A SINGLE PHOTOGRAPH

During weddings, you will find multiple stories happening simultaneously. If you can add the story framing expert techniques to these stories as they happen, you will strike gold! Most people are accustomed to seeing photos showcasing only a single story. When you can take this technique to the next level by introducing more than one story in a single photograph, you will be noticed, hired, and praised.

Figure 17.10: There are countless variations of this expert technique, but here is an example of capturing multiple stories in a single photo, and doing so by using the architecture of the rooms to frame each story separately. Framing is not needed, but it helps the viewer separate the stories. These types of photos demonstrate a truly unique storytelling ability.

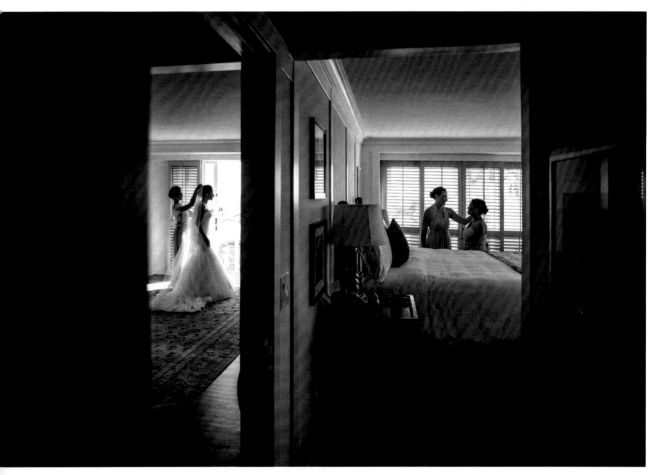

FIGURE 17.10

Figure 17.11: I feel very lucky and blessed to be able to capture moments like this! The bride had just finished getting ready when her father walked into the room to give her his gift. As I have mentioned before, these wonderful moments do not come with a warning. For this reason, you should be keenly aware of your surroundings. By doing just that, I was able to capture this beautiful candid moment of the first time the father of the bride sees his daughter wearing her wedding dress, and at that same moment capture another story of the bride's soon-to-be mother-in-law's reaction in the mirror.

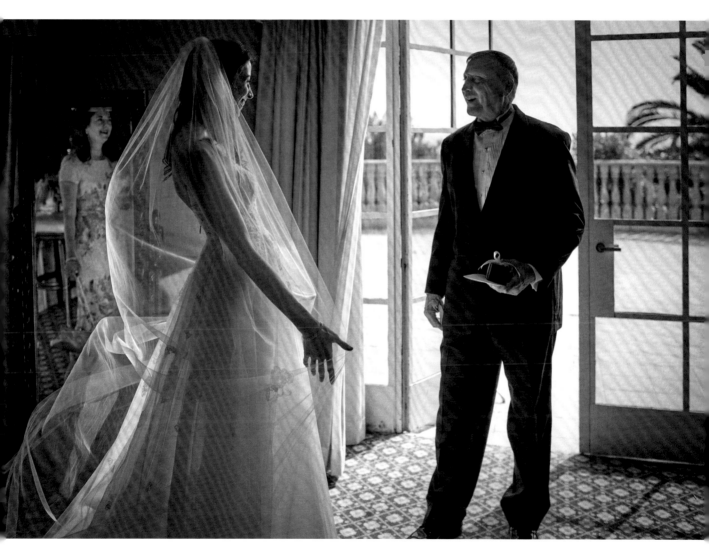

FIGURE 17.11

part six

EXECUTION OF THE WEDDING STORYTELLER SKILL COMPONENTS

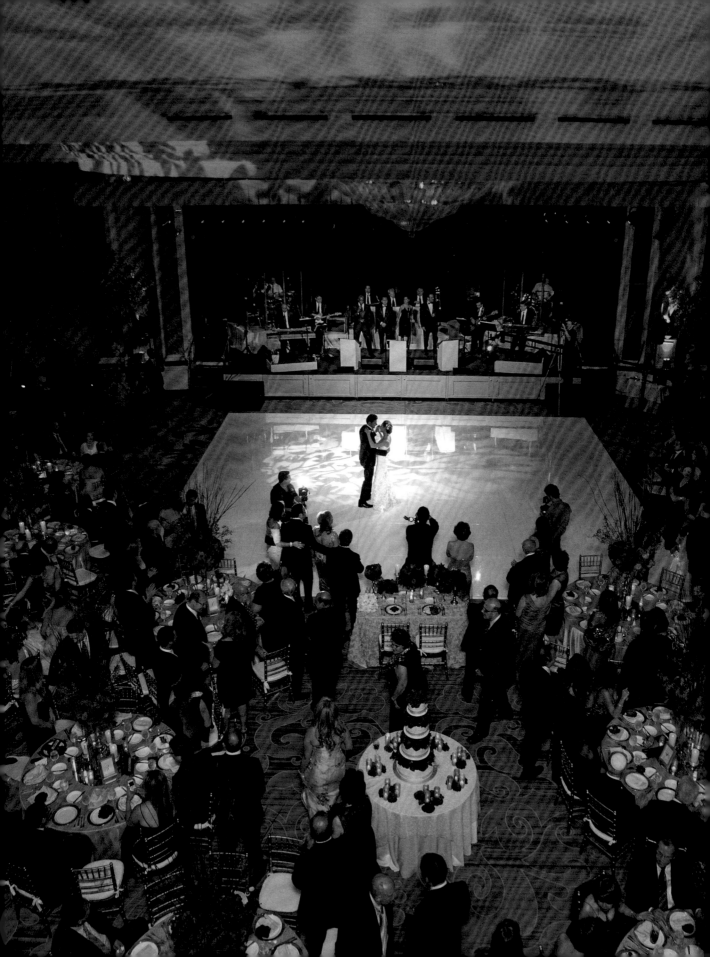

chapter 18
PUTTING IT ALL TOGETHER TO BECOME A MASTER STORYTELLER

We have now examined all the wedding storyteller skill components. You are most likely feeling overwhelmed and wondering how in the world you are going to be able to remember all of them under pressure during a wedding. To answer that question, I want you to know that I cannot keep track of everything, either. What I can say is that as you work through the skill components system, you will remember one component or another randomly during a wedding. What you have read or attempted earlier will start popping up in your head as you shoot.

Here is a possible scenario of what will happen. With experience and practice, the activity, location, or people around you remind you that there are skill component opportunities happening at that moment. You recognize an opportunity, and you quickly have your camera ready to fire the shutter. Then, you notice a streak of sunlight hitting the window blinds, creating interesting rays of light on the wall. That's another opportunity. Seconds later, you watch grandma being brought into the bride's room to see her granddaughter wearing her beautiful wedding gown for the first time. Your storyteller brain fires and realizes that grandma is a highly valued EVP. You position yourself perfectly to capture the moment when the grandma walks in and sees her granddaughter. Another great skill component opportunity has been captured! But then you notice there is a mirror to your left. Your brain fires again. Could you use that mirror to capture the expert component "Multiple Stories Captured Within a Single Photograph"? Is there a way you can reposition yourself to capture not only grandma seeing her granddaughter, but also catch other EVP reactions to that moment through the mirror's reflection at the same time?

This is how it works. The more you integrate these various skill components at weddings, the more your brain will remind you of them at future weddings. Eventually, you will have them stored subconsciously in your brain, and you will be able to simply react to stimuli as a master storyteller. You will begin to see opportunities *everywhere*! It's the craziest feeling. In the beginning, you need to exert quite a bit of conscious effort to remember and apply these skill components, but later, the process will simply become second nature to you, just as speaking your native language is second nature to you now. You won't have to think about it.

FOUNDATION COMPONENTS

LOCATION TECHNIQUES

- Circumstantial Light (Chapter 3)
- Showing or Removing Context and Clutter (Chapter 4)
- Depth and Walls (Chapter 5)
- Compositional Elements (Chapter 6)
- Luminosity Levels and Contrasts (Chapter 7)

PEOPLE TECHNIQUES

- Breaking Down Defensive Barriers (Chapter 8)
- Expert Confidence and Trust (Chapter 9)
- Being Flexible, Likable, and Professional (Chapter 10)
- The Situational Approach to Posing (Chapter 11)
- The Mechanics of Group Posing (Chapter 12)

STORYTELLER APPROACH COMPONENTS

APPROACH TECHNIQUES

- Photojournalism (Chapter 13)
- Interactive Photojournalism (Chapter 13)
- Stylized Aware Posing (Chapter 13)
- Stylized Unaware Posing (Chapter 13)
- Story Development (Chapter 13)

EXPERT COMPONENTS

EXPERT TECHNIQUES

- Emotionally Valuable People (EVP) (Chapter 14)
- Isolation and Priorities Through Lens Choices (Chapter 15)
- Helper Light: A Wedding Run-and-Gun Approach (Chapter 15)
- Creating and Capturing Movement to Achieve a Sense of Spontaneity (Chapter 16)
- Capturing Peak Action and Achieving Naturally Engaged Expressions (Chapter 16)
- Increasing Affection Through Touch and Energy (Chapter 16)
- Unique Perspective and Higher-Skilled Composition (Chapter 17)
- Creative Cropping (Chapter 17)
- Story Framing and Meaningful Object Placement (Chapter 17)
- Multiple Stories Captured Within a Single Photograph (Chapter 17)

APPLYING THE WEDDING STORYTELLER SKILL COMPONENTS TO YOUR OWN WEDDINGS

This book has been written with photographers of all skill levels in mind. If you are reading this book, obviously you wish to take your skillset to a higher level. Regardless of what level you are at right now, there are two starting points for almost every photographer. Then, branching off from those two starting points, you begin a never-ending process of refinement. As you improve, your refinements are accomplished with greater speed and confidence. Eventually, you reach a level where the posing is so well executed that viewers hardly notice it. The lighting illuminating your photos is rich, beautiful, targeted, and consistent; most importantly, expert lighting reaches a point where it is so well balanced that it, too, becomes invisible. Most people won't be able to point out exactly

why they love your photos or what photographic skills you used to create them, but they can't help but be emotionally drawn to the priceless stories in the photographs you so skillfully captured.

These are the two starting points from which almost every photographer begins his or her photography career. From there, amazing transformations happen.

- Badly executed photojournalism
- Overly staged posed photos

Badly Executed Photojournalism

Most often, wedding photographers begin their careers lacking confidence. I'll give you a likely scenario. You want to be left alone, pretending to know what you are doing by snapping away in any direction you see people moving. You have no knowledge or regard for composition or lighting, so you just shoot in order to not look like an idiot. You lack confidence and don't feel comfortable directing or moving people to another spot in the room with more flattering light. No matter what they are doing with their bodies, you keep on snapping away. Your clients could be slouching, pointing their elbows toward the camera, and standing or sitting with terrible posture. You don't care, because you don't realize that these habits could be corrected with some simple adjustments. It is up to you to correct them, but how can you fix a problem if you don't know it exists? You can always justify yourself by saying that you like to capture the moments as they are, as a true photojournalist would. But your photojournalistic photos are taken with the wrong lens that distorts your subjects, you don't stand at the right spot relative to the light, and you don't know how to use framing or any sort of composition to capture the ongoing moments properly. Furthermore, even though the natural light is weak and inadequate, you don't know what helper light is or how to use it. Turning on a flash would be a disaster because you don't know how to use it. If you did decide to turn it on, you would keep it on-camera the whole time and set to TTL so the flash does all the thinking for you. If the photo doesn't look good, it's the flash's fault, not yours.

If this scenario sounds somewhat familiar, you are not alone. I was describing myself in my early years.

I believe we learn a great deal more by understanding why something failed rather than why something worked. Now that you have read the book, you should be able to see for yourself what's missing. I will go over a single wedding that I photographed during my first or second year as a full-time photographer. Note that I presented these photos to my clients. Out of respect for them, I will keep the commentary purely focused on education and the techniques laid out in this book, and how from inexperience I failed to execute most of the wedding storyteller skill components.

Figure 18.1: I'm standing in the wrong place relative to the light. I could have quickly asked the bride to turn toward the window, but I did not due to a fear of interrupting. Considering the location techniques, the walls of this room are red. A simple flash or LED light pointed toward the bride would have helped correct the color. Even so, it would have been too

complicated to fix the lack of light and red colorcast in that room. In this situation, the best decision would have been to ask the bride to move to a better room that was more neutral in color and had much more natural light. Don't be afraid to ask the bride for permission to move to a better place. Remember that brides want to look their best; they are counting on you to get the job done.

Figure 18.2: This is a photojournalistic photo without any regard for composition whatsoever. The scene is far too busy, the viewer doesn't know who the main subject is, and the lighting is horrific. Again, I should have moved them to a more spacious room with better light. There is always a solution if you try to find it.

Figure 18.3: In terms of location techniques, I actually like the beautiful painting as a background. However, the bride is facing away from the light and her posture is unflattering. I'm sure the bride would not have minded fixing her posture and turning around toward the window light. I would have needed helper light to create a fantastic photo in this room with the painting in the background.

FIGURE 18.1

Figure 18.4: In this photo, the lighting is flat, red, and unflattering. I used the wrong lens, and I'm standing much too close to the action. Taking a close-up of someone's ear is not an ideal main subject, and it is not a good story. I should have chosen a 50mm lens at f/2, taken a few steps back, and made sure the bride was in better light. I also should have included the person helping her with the earrings so the viewer knows where those random hands are coming from. As stated in the location techniques, including more context would have made a vast improvement.

FIGURE 18.2

FIGURE 18.3

FIGURE 18.4

Figure 18.5: In this case, I did not have a clear idea of who or what my main subject was. As a result, I just pointed my camera and took a senseless photojournalistic photo with no story and no composition. You can't even see a single person's face clearly. What is the purpose of this photo?

Figure 18.6: Honestly, there is little you can do to control or improve the situation during the ceremony. This is an especially difficult case here because the lighting was so busy and harsh at that location and time. However, in retrospect, I could have used my 70-200mm f/2.8 zoom lens and tried to set the exposure properly on the couple inside the gazebo. The zoom lens choice would have helped reduce the clutter, as stated in the location techniques and in the expert technique "Isolation and Priorities Through Lens Choices."

FIGURE 18.5

Figure 18.7: As discussed in Chapter 2 under the expert components section, just because you implement an expert technique does not necessarily mean that your photo will look great or even good. Look at this photograph of the ceremony framed between the decorative gazebo rods. One of the expert techniques discusses "Story Framing and Meaningful Object Placement." But this choice of story framing is clearly a poor choice. The rods are too close to each other, they are much brighter than the main subject, and they are just ugly and distracting. Don't forget that there is a poor way of executing the expert components, and there is a masterful way of applying the expert components. It all depends on how refined your skills are.

FIGURE 18.6

FIGURE 18.7

Figure 18.8: This is another example of a poorly executed expert component ("Story Framing and Meaningful Object Placement"). In this case, it is the groom and two sons who are framing the main subject, the bride. But again, it's done in poor taste. There is no order to all the distracting compositional elements inside that gazebo. The dark shadow crossing the bride's face is clearly not flattering to her. The white fence in the foreground is far too bright and distracting. Even though it is not possible to control the light during the ceremony, you can control where you stand to improve your odds of achieving a great photograph.

Figure 18.9: This is a photo taken in the photojournalistic style with poor composition and exposure settings. Even though I was wise to include the couple's children, who are the most valuable EVP possible, I did not do the expert technique "Emotionally Valuable People (EVP)" any justice. The tight composition here does not allow for the photo to have any breathing space. Zooming out and giving the photo some space around the perimeter would have helped. Once again, there are good and bad ways of implementing the expert techniques.

FIGURE 18.8

Figure 18.10: During the reception, I noticed that there was very poor lighting illuminating the dance floor, and the floors and walls were red. As you would expect from a beginner who does not know how to use a flash, I placed my flash on camera and put it on TTL mode. The results are horrendous. To fix this problem, I could have placed my flashes in the setup for receptions described in Chapter 15. Another on-camera flash solution could have been to use a flash modifier, such as a MagMod sphere or MagBounce on top of the flash to prevent the flash from bouncing off the red walls. Furthermore, if I was more comfortable in TTL mode, I could have at least used Flash Exposure Compensation to reduce the power of the flash. I could have also increased my ISO to around 1600 and shot with a wide-angle lens at aperture of f/2, which would have fixed most of the issues and would have yielded better results in such a difficult place. Before the wedding, you should always know what the reception room looks like. I ask to see it. You don't want to show up unprepared.

FIGURE 18.9 FIGURE 18.10

Overly Staged Posed Portraits

This is where things get really interesting. It is also the main reason why people are anxious about posed photos. When we don't know how to pose people in a natural, effortless, and non-distracting way, we default to what we see online or in wedding magazines. Again, in an effort not to lose face and appear unskilled, our brains go into survival mode and we try to direct poses that end up looking completely staged and unnatural. When we don't have any ideas, we just ask the couple to kiss in front of every building, wall, or fountain we can find. It's a wedding, so kissing seems to be the normal thing to do, right? No!

Kissing shots are by far the most overused pose photographers use. Having two or three kissing shots among many other types of photos is a good balance. But kissing shots have become a quick go-to pose when our minds draw a blank and we do not know what to do. I believe that if you are photographing events such as weddings, you are photographing people. And if you are photographing people, you should have some level of skill regarding how to pose them well so they look and feel their best. If you call yourself a photojournalist, you should still know how to adequately pose a subject. Then, if you are asked to take some portraits, you will do a good job. Knowledge is power, and more knowledge will never hurt you; it will give you a choice of whether to use your posing skills or not. Stay open-minded. A well-rounded wedding photographer can capture amazing photojournalistic moments with refined composition and attention to light, but he or she can also create elegantly posed portraits where the subjects look their very best and the pose looks completely effortless.

Figures 18.11–18.24 are portraits I took at weddings early in my career. Like the photojournalistic photos I described in the last section, these posed portraits are indeed what my clients received from me. In my early years as a wedding photographer, I never sought to learn more about posing or lighting. I did not have a clue how to direct people, let alone do it with confidence. I was so petrified of the portrait segments at weddings that I began to tell a few of my prospective clients that my preferred style was to be a pure photojournalist. I tried to pitch to them that I preferred to capture the moments as they occurred, uninterrupted and organic. I would tell them that I wanted them to remember their wedding day unaltered as it happened, instead of as a collection of staged ideas from a photographer.

The idea sounded noble, but it did not go well for me. A wedding coordinator called me and asked why I told the couple that I refused to take posed portraits? With a frustrated voice, she told me that people still want family photos, a few bride and groom portraits, and photos with their friends and their wedding parties. Playing the photojournalistic card in an attempt to hide my lack of posing skills just proved to be an uphill battle that I was not going to win. Instead of fighting this battle and trying to convince prospective clients to hire me despite my restrictive conditions, I decided to just buckle down and begin to learn the beautiful art of posing people or, if you prefer the term, "adjusting" people. That decision completely changed the course of my career.

I will save you the pain of going over the countless things that are wrong with each of the poses in these photographs. To do so, I would need to write an entire book. To simplify, here is a list of all the repetitive mistakes that are occurring in the photos in this collection:

1. Because I did not know how to pose, I defaulted to kissing photos for almost 90% of all the bride and groom portraits.

2. The few photos that are not kissing are incredibly corny and ultra-staged. I simply tried to copy popular photos that I found online. I thought taking bride and groom photos meant staging a collection of popular clichéd ideas instead of allowing the couple to be themselves and capturing them in a natural and flattering way with minimal distractions. I never applied the situational approach to posing—where the pose should make sense with the environment—described in the people techniques part of this book.

3. I completely missed the boat on all aspects of circumstantial light and helper light. I was so preoccupied with trying to appear like a pro that I just kept shooting my clichéd poses with zero—and I mean *zero!*—regard for flattering light.

4. The composition in these photos could not be worse. There are so many distracting elements: camera tilt, unflattering perspectives, inattention to the colors or objects around the couple, terribly executed attempts at framing the main subject, and extremely distracting overexposed hot spots all over the frame. Not a single photo contains clean, simple luminosity levels, as described in Chapter 7, "Luminosity Levels and Contrasts."

5. These photos simply lack refinement. Remember, do not let locations seduce you; you must be seduced by the beauty of the light. That advice alone will help you avoid so many issues when posing people. Nobody can appreciate the most well-executed pose if there are a hundred distracting elements in your composition. By showing you these photos, it is my hope that you can understand why I created the wedding storyteller skill components and wrote this book. Every component was created from hundreds, if not thousands, of mistakes due to lack of skill and experience.

FIGURE 18.11

FIGURE 18.12

FIGURE 18.13

FIGURE 18.14

FIGURE 18.15

FIGURE 18.16

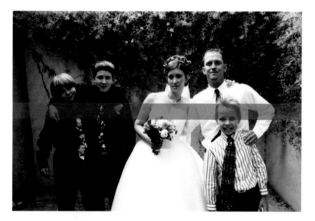

FIGURE 18.17

FIGURE 18.18

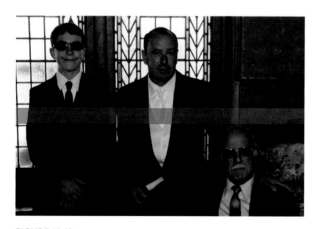

FIGURE 18.19

FIGURE 18.20

FIGURE 18.21

FIGURE 18.22

FIGURE 18.23

FIGURE 18.24

SKILL COMPONENTS TRAINING EXERCISES

If you are truly dedicated to becoming a great wedding storyteller, implementing these exercises properly will set you well on your way to achieving that goal. In the images that follow, you will see thoroughly explained examples that show a similar situation handled very differently: the first photo of each example details how I failed to apply the wedding storyteller skill components with any level of skill. That's alright. I was in the early stages of my career when I took these photos, and I learned. The second photo for each example describes how I handled the same or similar situation with much greater skill by implementing the wedding storyteller skill components. I hope it will be interesting and motivational for you to see how the smallest of changes can have such a significant impact in an image, transforming a stale, badly executed photo into a beautiful one.

There are four examples containing two photos each. I go over the elements of the skill components system and share my decision-making strategy with each technique. Your challenge is to pay close attention to my descriptions for both the bad and good photographs, and then try it on your own. After my completed examples, I provide several more examples of pairs of images that you may use to do your own analysis of what was right and what was wrong for each of the applicable skill components.

Learning photography and being able to perform at such high levels of intensity and pressure requires a great deal of deliberate training. That is why I am showing you numerous pairs of photos. Most importantly, though, I am sharing these embarrassing photos with you—photos that I was once proud of!—to demonstrate what happens when we ignore or have not developed the skills explained in this book. By going through all the skill components and troubleshooting what went wrong, you will learn a great deal more than if I just showed you my portfolio pieces. I am not interested in showing you how good I am. My focus is on your learning experience and progress. When going through the exercises, it will be necessary for you to flip through the pages of this book to review the material. Referring to the various chapters will help you remember specific techniques.

For years, this has been the process that I have gone through with my own wedding photos. By painstakingly going through my work, I grew as an artist, because my training carried me through tough situations. Then, the next time I was in a situation I had previously encountered, instead of blanking out, I would find an answer to the challenge in front of me.

If possible, I would recommend reviewing these images with a group of motivated photographers who share your passion for learning and education. When working with a group, everyone benefits from seeing things from other people's perspectives.

Example 1A: Bride Standing in Front of a Window, Straight Out of Camera—A Failed Approach

See **Figure 18.25** for this example.

LOCATION TECHNIQUES

Circumstantial Light: In Chapter 3, in the section "Circumstantial Light Indoors," I ask three questions that can help you determine the quality of light at that specific chosen location.

If you have forgotten, flip back and look at them, because it's a good refresher, anyway. The large window is the main light source. Even though the window is large, the light seems to be weak because it is coming in indirectly. Judging from the darkness on the left side of the bride's face and back, there don't seem to be any walls nearby that reflect the window light back at her.

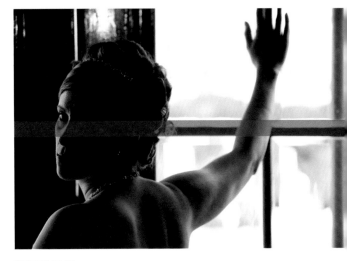

FIGURE 18.25

Context and Clutter: In Chapter 4, I wrote about the three decision points that can help you determine how much or how little context to show in a scene. Revisit that list. In response to the first decision point regarding clarity, this scene definitely takes visual attention away from the bride. And the lack of context given by this tight crop says nothing about the story. The poor way I cropped this image takes away from any possible symmetry or context that I could have used to create a more visually pleasing photo. And by cropping this image so tightly and horizontally, it begs the question, why? Why did I crop out most of the wedding dress if she was already fully dressed? Is the story that I'm just trying to show her upper back, head, and arm? Even if it were, then why is 90% of her face so dark? I know that I was under pressure to get these photos done and move on with the wedding day, but I will always give this advice to any wedding photographer: Take a moment to breathe and think about what you are doing and what decisions you are making before pressing that shutter button. It will pay off tenfold.

Depth and Walls: This photo was taken indoors with a large window in a door frame as a background, which acts like a wall. Per Chapter 5, there are five advantages to using walls in your portraits. Unfortunately, I did not take advantage of any of those benefits.

Compositional Elements: Although this bride was posed in front of a door, which could have been used as a possible frame, the position where she is standing in relation to the door takes away any chance of framing her.

Luminosity Levels: This is probably one of the biggest reasons why this photo failed. Notice how dark the room is inside and how bright the sun is outside. This is a very high-contrast scene. High-contrast scenes are often very hard on the eyes. The sad part is, had I paid more attention to my surroundings as stated in the location techniques chapters, I would have noticed the sheer curtains to the left and right of that door. Had I closed them, I would have drastically lowered the luminosity differences between the outdoors and inside the room. When all the luminosity levels within the whole frame are relatively close, it will lower the contrast levels of the photograph. A low-contrast scene is much easier on the eyes.

PEOPLE TECHNIQUES

Situational Approach to Posing: Chapter 11 discusses whether a pose is a good fit with the environment. Well, let's see. Do people normally put their arm outstretched in that position while standing in front of a large window? Do people keep their arm planted on

a windowpane and then turn around and look at you? I don't think so. Experience or not, it is fair to assume that this pose just doesn't look like it could have happened naturally. The pose is far from elegant or relaxed. Instead, it appears to be quite forced, awkward, and tense. Therefore, the pose does not fit the situation.

APPROACH TECHNIQUES

This photo was taken with the "stylized aware posing" approach; she is being posed and she is looking at the camera. In retrospect, I think the "stylized unaware posing" approach would have been much more fitting.

EXPERT TECHNIQUES

This photo does not contain any well-executed expert techniques. However, if I had to choose one to implement, it would have to be helper light. As you can see, this photograph is in major need of helper light. The room is simply too dark to obtain any kind of reasonable results on its own. Using a reflector would not have worked because the light coming from outside is indirect and too weak. I think a modified off-camera flash on Manual mode would have been the best solution.

CONCLUSION

There are three major problems with this photo. The weak light, the awful crop, and the unnatural and unflattering pose. Her right arm is far exceeding the normal threshold, and the pose makes no sense in this situation. If I had to shoot there today, I would choose a 35mm or a 50mm lens at f/1.4 to gather as much of the light as possible. I would include more context of the scene so that the crop/composition would have space to breathe. I would keep the pose much simpler and more natural. I would ask her to *not* look at the camera so the portrait would take on a more photojournalistic style. Finally, I would add some helper light from a flash as needed to blend the two types of light and give this photo a fighting chance.

Example 1B: Bride Standing in Front of a Window, Straight Out of Camera—A Successful Application of the Wedding Storyteller Skill Components

See **Figure 18.26** for this example.

LOCATION TECHNIQUES

Context and Clutter: From the amount of context I included in this photo, you can clearly discern that the bride is standing in front of a glass door. I chose this glass door because it was clean. There are no wooden frames crossing in odd places.

Depth and Walls: One of the advantages of photographing in front of walls is that they can provide a clean and elegant background. By closing the sheers, I created a sense of a clean white wall in front of the bride. Whatever is going on outside disappears.

Compositional Elements: The composition is clean and very simple. Most importantly, there is nothing distracting you from the bride. With this composition, you can see and admire the beauty of her dress and veil, which are the main subjects in this photograph.

Luminosity Levels: The decision to close the sheers was a key factor in the success of this photograph. Why? Because by doing so, it evened out the entire scene's luminosity levels. The brightest point and the darkest point in this photo are not too far apart. This creates a low-contrast scene that gives the viewer a sense of calm. I learned my lesson through the years. Being so familiar with these skill components and their visual effects, I'm much better equipped to make quick decisions that create a huge impact, such as closing the sheers.

PEOPLE TECHNIQUES

Situational Approach to Posing: Let's ask the key question discussed in Chapter 11: Based on the situation or location, could this photo have happened naturally without photographer intervention? Is it possible that the bride could have been getting ready and became distracted for a second to look out the window to see her guests socializing outside? Is it normal the way she is holding the veil to possibly prevent it from wafting in front of her face? I think you can answer a resounding "Yes" to each of these questions.

APPROACH TECHNIQUES

Because I almost always prefer to keep my portraits looking as if they were captured without photographer intervention, I believe the stylized unaware posing approach was the right decision.

EXPERT TECHNIQUES

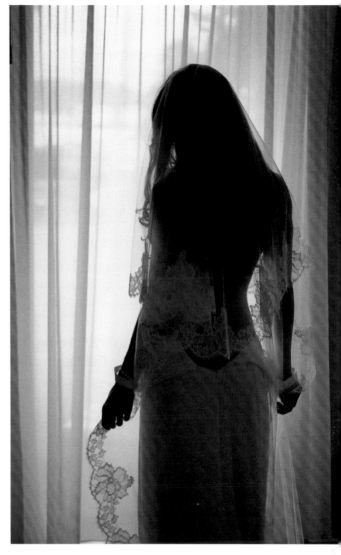

FIGURE 18.26

Isolation and Priorities Through Lens Choices: I chose the 24–70mm lens at f/3.5 for this portrait. I believe this combination of focal length and aperture shows just enough context to keep the photo clean while remaining soft enough to convey a romantic mood.

Helper Light: My assistant was holding a white reflector as helper light behind the bride to ensure that there was plenty of detail in the back of her dress, which was facing away from the window light. Without the reflector's helper light, this photo would not have worked. Remember, I am showing you this photo straight out of the camera. No edits have

been made to this photograph. Showing detail throughout the back of her dress would give me much more flexibility in the edit.

Capturing Peak Action and Achieving Naturally Engaged Expressions: Although the bride was not moving when the photo was taken, I did ask her to see who was outside the window. The purpose of this question was to have her legitimately engaged in something other than the thought of being photographed. I had already finished the pose, given her arms a gentle bend, shifted her weight, arched her back, fixed her posture, and made sure she was holding the veil in a soft manner. The very last step was to achieve a naturally engaged expression. Even though you cannot see her face, you still have a feeling that she is engaged with something going on outside. That's why this is an expert technique. If a photographer had simply said, "Look outside," the feeling of being naturally engaged would have disappeared.

CONCLUSION

The most beautiful photos are the simplest. And the difference between an elegant, simple photo and a corny, failed image is nothing more than a series of small but very powerful decisions. Remember that the next time you show up at a wedding.

Example 2A: Young Ring Bearer Walking Down the Aisle During the Ceremony—A Failed Approach

See **Figure 18.27** for this example.

LOCATION TECHNIQUES

Context and Clutter: This photo fails because I included too much wasteful context. It's all about the decisions you make that give your photos the finesse that separates an average wedding photographer from a great one. I did not pay attention to the context, so from the angle this photo was taken, grass and bushes dominate most of the frame. Well, who cares about the grass and bushes? It's not good enough that I just photographed the ring bearer. I could have captured this moment with much more meaning and charm, as you will see in the next photo.

Depth and Walls: This photo was taken with depth, though it is not very meaningful.

Compositional Elements: My composition decisions also failed me. In Chapter 17, I mentioned the importance of photographing children from their height. Here I didn't do that. Clearly, I photographed this scene from my own height, and now the perspective looks off. Because of my decision, much more of that distracting, bright grass shows up in the frame.

Luminosity Levels: Because of poor composition, I have a walkway and grass that are much brighter than the ring bearer's face. My exposure was off, but better composition would have helped. Furthermore, since this is an outdoor ceremony, I could have easily used an on-camera flash on Manual mode to give this backlit ring bearer a small boost of frontal light.

PEOPLE TECHNIQUES

No people techniques were applied.

APPROACH TECHNIQUES

I took this photo during the ceremony. Therefore, it must be captured with the photojournalistic approach. However, that does not mean you lose all control. If I had positioned myself in the center of the aisle and waited for the ring bearer to walk halfway through the crowd, I could have captured the guests' expressions as they watched the adorable little youngster carry the rings. That's the power of a great photojournalist—angles and timing. Unfortunately, my timing was off, and I captured none of the guests' expressions because they were looking away from the camera.

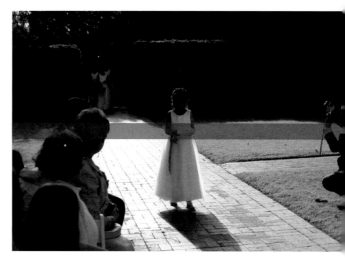

FIGURE 18.27

EXPERT TECHNIQUES

No expert techniques were applied.

Example 2B: Young Ring Bearer Walking Down the Aisle During the Ceremony—A Successful Application of the Wedding Storyteller Skill Components

See **Figure 18.28** for this example.

LOCATION TECHNIQUES

Context and Clutter: Now, context is a significant part of the story. By using the widest focal length my lens offers, and by shooting from the correct angle and perspective, almost every item in the frame is part of the story. There is no wasted context. That's awesome! Photos in which everything in the frame plays a role in the story can be very difficult to compose.

Depth and Walls: This photo was taken with meaningful depth. This time, the depth consists of the many wedding guests cheering on the ring bearer. That's fantastic!

Compositional Elements: Unlike the previous photo, this one was indeed taken from the ring bearer's height. Notice how much better this looks? Additionally, I have a large amount of both sides of the aisle included in the composition.

Luminosity Levels: This photo was taken on a cloudy day so all the luminosity levels are quite even and easy on the eyes.

PEOPLE TECHNIQUES

No people techniques were applied.

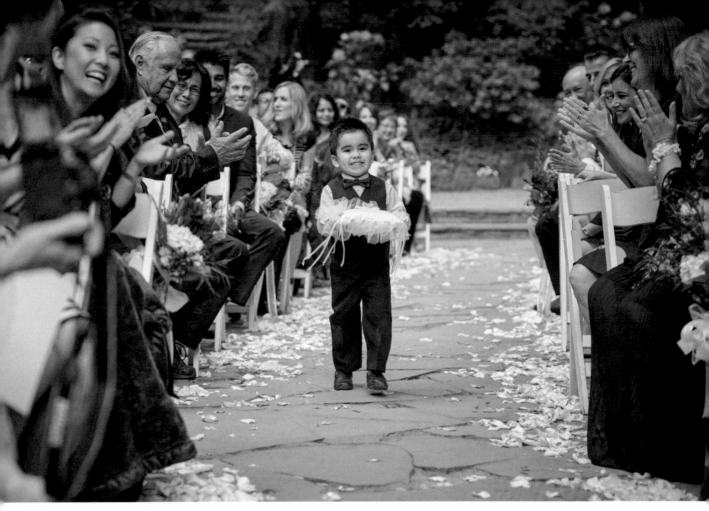

FIGURE 18.28

APPROACH TECHNIQUES

Obviously, you can't pose during a photojournalistic moment such as this one. But knowing that my tools as a photojournalist are angles and timing, I did a much better job here with both of those than in the previous photo. This time, I waited until the adorable young ring bearer was halfway down the aisle. That way, I could capture a great number of the guests' expressions smiling and cheering the youngster on his long walk. You can feel the energy, right? What these skill components are all about is creating something truly special at any moment. Look at this little guy. He totally stole the show! A relatively dull moment was transformed into an exciting one by making the right decisions.

EXPERT TECHNIQUES

Emotionally Valuable People (EVP): There are multiple EVP situated on both sides of the frame. Capturing EVP with such joyful expressions on their faces at a moment of peak action is a double bonus!

Isolation and Priorities Through Lens Choices: The 70–200mm lens shot at 75mm and at f/3.5 created a flattering compression with an elegant bokeh that isolates the ring

bearer from anything behind or in front of him. This keeps all the viewer's attention on the main subject.

Helper Light: On-camera flash was used on Manual mode to give the subject a little boost of light on a cloudy day. You can see the effects of the flash if you look closely at the catchlights in his eyes. This is an expert technique because the flash does not overpower the scene; it simply complements the light perfectly.

Capturing Peak Action and Achieving Naturally Engaged Expressions: This is definitely a prime example of capturing peak action and naturally engaged expressions.

Unique Perspective and Higher-Skilled Composition: Recognizing the need to synchronize the child's height with my shooting angle definitely makes this an expert technique. As you can see from the previous example, without this perspective decision, the photo would have lost much of its charm. I always find it so exhilarating that in wedding photography you must think so quickly and be so well trained; the smallest or most subtle decision can have a huge impact—positive or negative—on your work.

Example 3A: Groomsmen Group Photo with Son—A Failed Approach

See **Figure 18.29** for this example.

LOCATION TECHNIQUES

Context and Clutter: It was quite a poor decision to place the group at this dismal location. The context in the background adds zero value to the group photo. The mix of colors from the green grass, the rocks, the dark reflective windows, and the brick creates too many distractions.

Depth and Walls: This photo is taken with a wall in the background. As you know by now, one of the great benefits of walls is that they can provide you with an easy, clean background for your subjects. Unfortunately, I chose a wall full of distracting shapes and colors.

Compositional Elements: There is little to no thought given to composition. The group is not even centered in the frame.

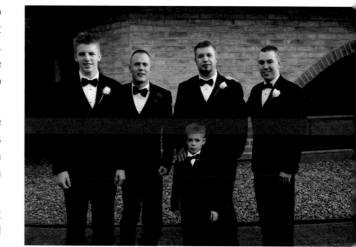

FIGURE 18.29

Luminosity Levels: This photo was taken on a cloudy day, so the luminosity levels are quite even and easy on the eyes. However, overcast skies always require helper light. Notice the darkness in everyone's eyes? An off-camera flash set on Manual mode would have helped bring more life into this group portrait.

PEOPLE TECHNIQUES

Mechanics of Group Posing: In Chapter 12, I listed four types of wedding party group photos. This photo represents the first type, "Simple and traditional (standing next to or

framing the bride or groom)." Choosing the simple and traditional group photo choice does not mean it must be boring. The reason why this photo is dull is because I failed to incorporate any of the "Basic Mechanics for Group Posing of a Higher Standard" techniques, also discussed in Chapter 12.

Breaking Down Defensive Barriers: This is an often-overlooked people technique. Why? When people are not being photogenic or don't seem to cooperate, we simply wash our hands of the problem and blame them for not wanting to cooperate. I have heard countless photographers share stories complaining, "The groom was just not into it," or, "The couple was just giving me nothing; it was like pulling teeth getting them to relax," or, "My last clients were just so depressing; what's up with their constant, fake smiles?"

I want to tell you that when your clients do not seem motivated to cooperate with you, it is more your fault than theirs. A major part of being an outstanding wedding photographer is having great people skills. Implementing the people techniques laid out in Chapter 8 will help you break down those inevitable defensive barriers people put up when being photographed. Your clients are not actors; they are not used to having a giant lens looming in front of their faces. It is up to you to make them laugh, relax, have fun, and feel comfortable with you. Then, and only then, will the most serious of people open up to you and give you the most beautiful smiles and candid camera-unaware expressions. The reason for the odd expressions on everyone's faces in this photo is that I was hesitant when posing them, which made them lose confidence in my abilities. Once I was in position, I just stooped in front of the group without making conversation or trying to keep their minds off the shoot. I made no jokes. I said nothing to make them laugh, relax, or elicit a reaction. I just said, "Okay, guys...looking good, go ahead and smile for me." Why should they smile for me? The worst part of it all is I asked them to smile for me in a monotonous tone of voice. There was no energy in my voice, so why should I expect them to give me great energy back?

APPROACH TECHNIQUES

This group photo was taken with the stylized aware posing approach. This is a good approach for a classic group photo where everyone's face must be clearly seen.

EXPERT TECHNIQUES

No expert techniques were applied.

Example 3B: Groomsmen Group Photo with Son—A Successful Application of the Wedding Storyteller Skill Components

See **Figures 18.30** and **18.31** for this example.

LOCATION TECHNIQUES

Context and Clutter: This group portrait of the groomsmen was taken at the groom's home. There are a few clutter items left, but we did clean up as much as we could with the time that we had. That's all you can do, because at a wedding you can't spend 45 minutes tidying up the place for a single photo. You do what you can, and you shoot. The

group is spread out enough from edge to edge that they cover most of the frame, allowing little room for clutter to show through.

Depth and Walls: This photo was taken with a wall behind the group. But the wall's artwork is part of the story since it is the groom's home.

Compositional Elements: N/A.

Luminosity Levels: The group was posed in front of a large window to achieve flattering lighting on everyone. Because the group itself was the closest thing to the window in the photo, the subjects are, and should be, the brightest points in the composition.

FIGURE 18.30

FIGURE 18.31

PEOPLE TECHNIQUES

Mechanics of Group Posing: Now let's apply storyteller skill components to this group photo to make it shine. As in the previous example, this photo was taken with the "Simple and traditional (standing next to or framing the bride or groom)" option out of the four listed in Chapter 12. This time, all five of the "Basic Mechanics for Group Posing of a Higher Standard" criteria were fulfilled. By placing everyone at different heights, notice how your eye travels up and down across the frame. Some people are standing, two are sitting in chairs, one is sitting on the table, and the groom's son is standing on the table so that his head becomes the tallest head you see. Being the most valuable EVP, this was a good choice. Notice how the three people on the left side of the image and the four people on the right side of the image are framing the groom and his son in the center. Everyone's collarbones are facing different directions, which keeps the composition interesting. It is amazing how, by applying the lessons from Chapter 12, you can transform a simple wedding party photo into something visually interesting and well crafted.

Breaking Down Defensive Barriers: I was polite and handled myself with great confidence. When I was posing the group in front of the table, I showed conviction. If I didn't like something, I didn't worry about it; I simply moved them around with confidence. People respect that! I kept making funny comments while posing everyone, almost like an entertainer. In less than two minutes, I had everyone in position. Without an ounce of hesitation in my voice, I smiled, took the first photo, and said, "Boom! You guys are killing it! Look at you (insert name of person), you are putting everyone to shame! What kind of group is this?!" Get my drift? I was just saying silly things that made them feel engaged with my personality, and not with the camera. As a result, we have a group photo where everyone is relaxed and their expressions are indicative of their true personalities.

APPROACH TECHNIQUES

This group photo was taken with the stylized aware posing approach. This is a good approach for a classic group photo in which everyone's face must be clearly seen.

EXPERT TECHNIQUES

Emotionally Valuable People (EVP): The groomsmen are automatically EVP. Including the son makes this photo much more precious to the group, since a son or daughter is the most valuable EVP you can include in a photograph.

Increasing Affection Through Touch and Energy: Being familiar with all the expert techniques will allow you to recognize when it is a great time to use a particular one. For example, this group photo with the groom and his son prompted me to use touch and energy to increase affection. I made the conscious decision to have the groom's son put both of his small hands on his dad's shoulders. By doing so, the connection between the father and his son is even closer. This is such an important expert technique because adding touch increases the affection between people, and it can make a photo priceless. Imagine how wonderful it will be when the groom's son is 30 years old, holding this photo in his hands.

Example 4A: First Dance—A Failed Approach

See **Figure 18.32** for this example.

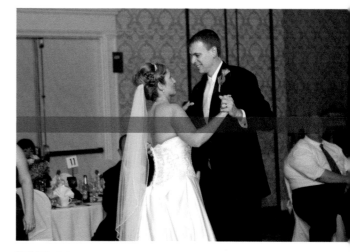

FIGURE 18.32

LOCATION TECHNIQUES

Context and Clutter: In Chapter 4, I discussed the three decision points to consider when deciding how much or how little context to show in a scene. Review that chapter to refamiliarize yourself. The second deciding question on that list, regarding storytelling, is particularly important: "Does the scene or context add to the visual story or setting in the photograph, or does it distract the viewer from the story?" Let's take a look. In this photo, there are dirty tabletops with bottles of beer, a hideous wallpaper that contributes absolutely nothing to the story, a very visible fire alarm, and people who are not engaged with the story. So the answer to this question is a resounding "No!" Everything in this scene distracts the viewer from the story.

Depth and Walls: There is a wall in the background, which is an awful choice for a first dance photograph. Why? In Chapter 5, the section "The Pros and Cons of Using Depth" states that one of the great benefits of using depth in photos is to create a sense of romance. The moment the bride and groom walk onto the dance floor in front of their loved ones to have their first dance is arguably one of the most romantic moments in their lives. If I had read Chapter 5 at the time I was photographing this wedding, I would never have chosen that shooting angle to capture the first dance. I would have wanted as much depth as possible to make this moment as romantic as it could be.

Compositional Elements: There is nothing in this image that contributes to a pleasing composition.

Luminosity Levels: Early in my career, I did not have a good handle on how to use my flash properly to create mood. Therefore, I would simply put the flash on my camera and fire. The results are so bad it hurts to look at them. Direct on-camera flash will completely flatten the entire scene, and it will hardly look romantic. Instead of isolating your subjects through a strategic and careful use of light, you end up having everything in the scene lit just as brightly.

PEOPLE TECHNIQUES

No people components were applied.

APPROACH TECHNIQUES

This first dance photo must be taken using a photojournalistic approach. But, I still could have moved and changed my angle to include meaningful context, not busy wallpaper.

EXPERT TECHNIQUES

No expert components were applied.

FIGURE 18.33

Example 4B: First Dance—A Successful Application of the Wedding Storyteller Skill Components

See **Figure 18.33** for this example.

LOCATION TECHNIQUES

Context and Clutter: Going back to the decision points in Chapter 4, we can ask ourselves the question, "Does the scene or context add to the visual story or setting in the photograph, or does it distract the viewer from the story?" In this photo, everything in the scene is symbolic and meaningful to the bride and groom. This is what I call a homerun—when I create meaningful context in wedding photographs. Before you press the shutter, it is my hope that these skill components make you ask yourself this question: "Am I maximizing the inclusion of meaningful objects or people within the context of my photograph?" If your answer is, "No, most of the items included in my frame are useless clutter," then stop and look around. Zoom in or zoom out. Do whatever you have to do to increase the inclusion of meaningful context in your photos.

Depth and Walls: This photo was taken with depth. But unlike the previous photo, the depth consists of the couple's family and friends, as well as the band. Do you see how much more romantic it is to use depth in your composition rather than walls? Walls are dynamic, but depth is romantic.

Compositional Elements: The composition that I chose was to center the dancing couple, surrounded by their guests. I included the ceiling in my composition because the couple paid for its graphic lighting. I also waited as the bridal couple turned during their dance to capture both of them in profile; otherwise, one person would have blocked the other.

Luminosity Levels: Most of the frame is quite dark and moody except for the couple, who are the brightest part of the frame. I did not have to use my own helper light to achieve this effect since there were three videographers shining their LED lights on the couple at the same time. I told my assistant to have an LED light of our own ready to go, in case the video team shut them off after they captured their footage.

PEOPLE TECHNIQUES

No people techniques were applied.

APPROACH TECHNIQUES

This photo was taken with the photojournalistic approach.

EXPERT TECHNIQUES

Emotionally Valuable People (EVP): There are multiple EVP surrounding the couple from every direction.

Isolation and Priorities Through Lens Choice: The ultra-wide 16–35mm lens at f/3.2 was used to ensure that the entire room would be included in the composition.

Helper Light: As previously mentioned, helper light was a critical part of the success of this photo, and fortunately the light was provided by the video team. Without helper light, the couple would have been lit the same as their guests and the rest of the room. The photo would have lost its romantic charm, and your eyes would have not been automatically drawn to the couple.

Unique Perspective and Higher-Skilled Composition: This expert technique allowed for the spacious and romantic feel of this photograph. Capturing this moment with beautiful lighting is one thing, but capturing it from a bird's eye view takes this photo to a completely different level! Before the reception, when I was taking the table setting photos, I looked around the room to see if perhaps there was some sort of balcony that I could use as a great vantage point. I asked the hotel manager, and he informed me that there was a balcony, but they also had a way to reach a high point near the ceiling that was designed for the lighting maintenance crew. I had to literally crawl through a maze of pipes to get to this vantage point. I had my second shooter taking photos from the floor in case I missed the first dance trying to reach my chosen vantage point area. It was not easy, but it was well worth it!

ON YOUR OWN EXERCISE PHOTOS

As discussed at the beginning of the previous section, what follows in **Figures 18.34–18.75** are several more pairs of images. Your challenge is to analyze what is wrong and what is right for each of the applicable skill components for each photo.

FIGURES 18.34–35

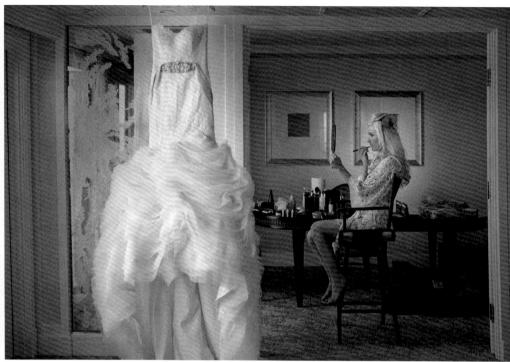

FIGURES 18.36–37

FIGURES 18.38–39

FIGURES 18.40–41

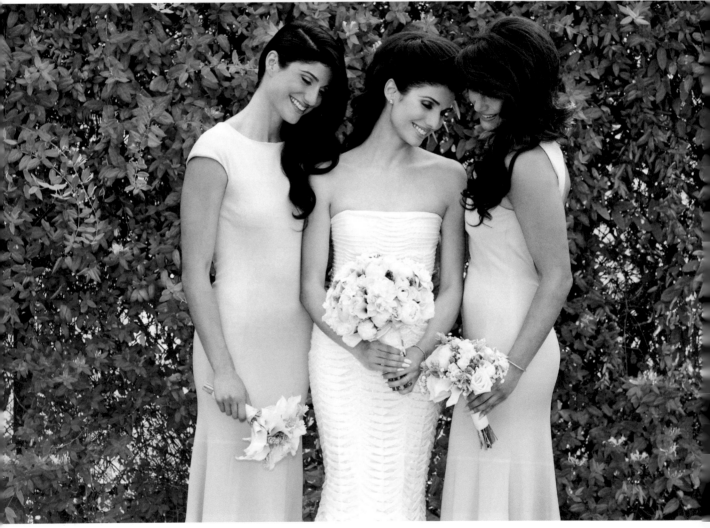

FIGURES 18.42–43

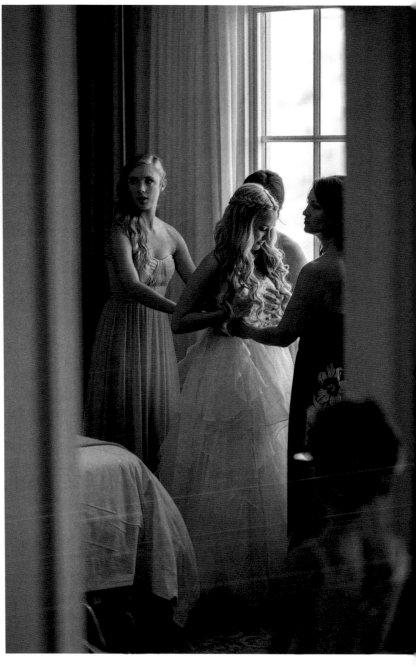

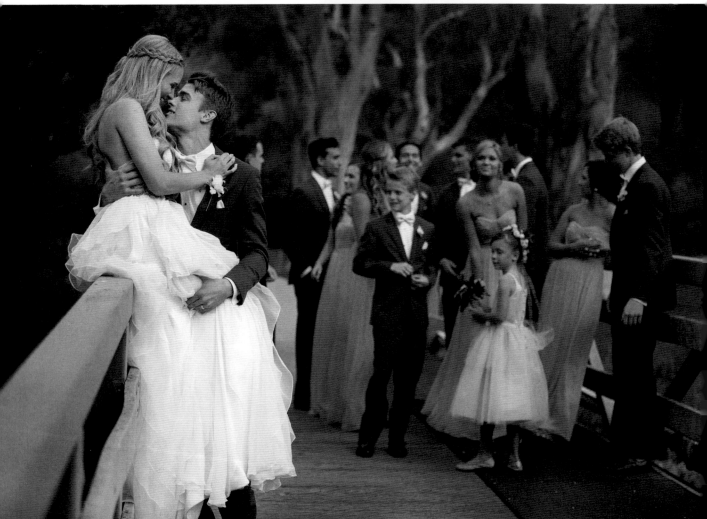

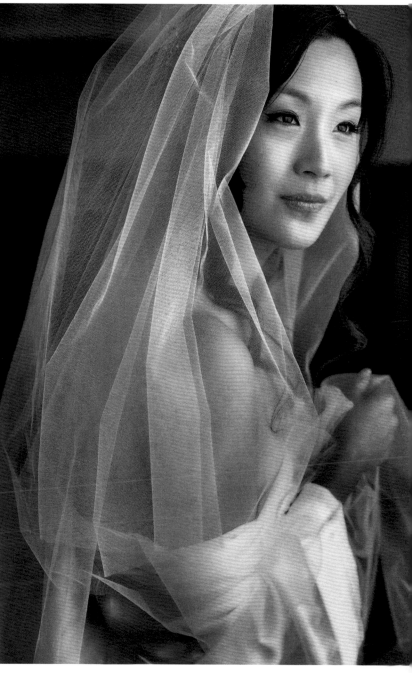

FIGURES 18.46–47

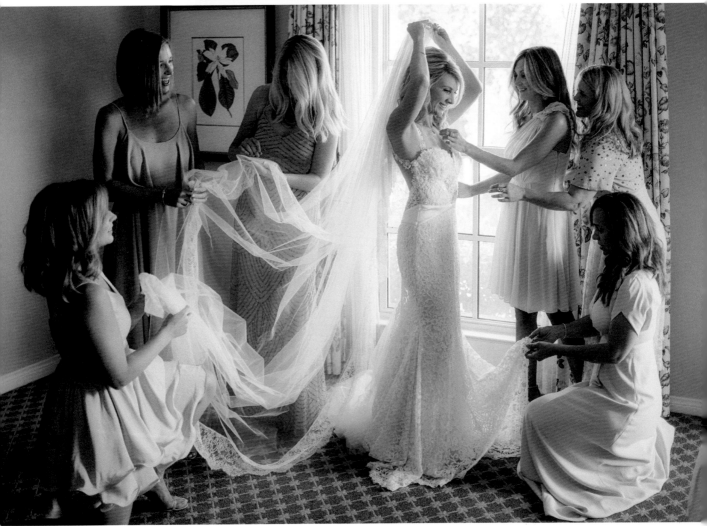

FIGURES 18.50–51

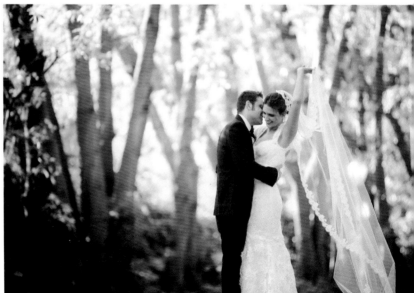

FIGURES 18.52–53

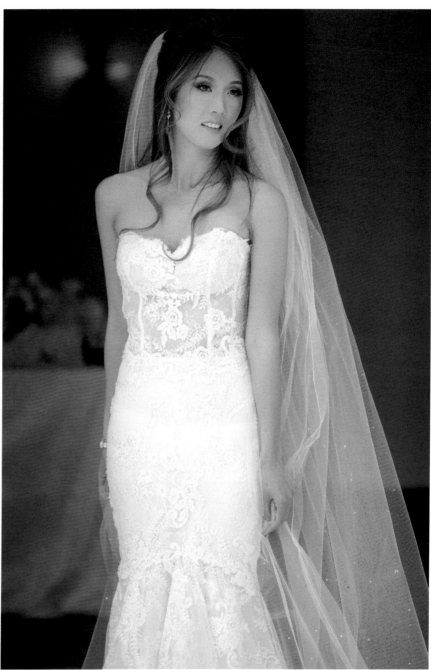

FIGURES 18.54–55

FIGURES 18.56-57

FIGURES 18.58-59

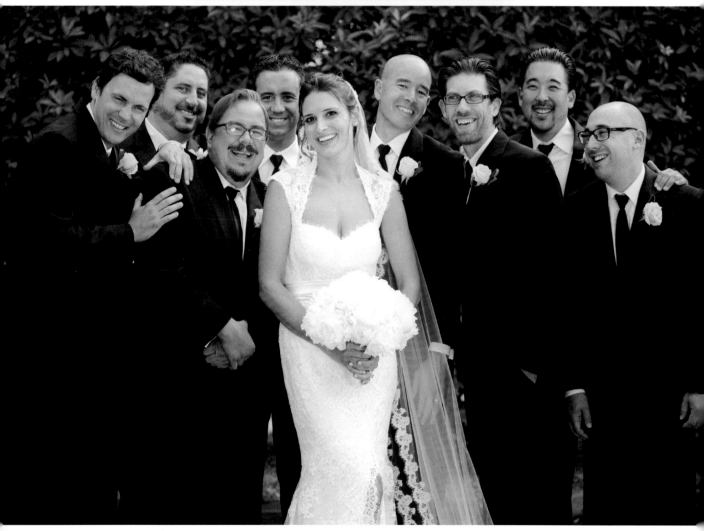

FIGURES 18.66–67

FIGURES 18.68–69

FIGURES 18.70-71

FIGURES 18.72–73

CONCLUSION

Speaking from the heart, this book has been an unexpected challenge to write. Wedding photography is very personal to me, and I care very much about the profession. I want wedding photographers to thrive and to be considered highly respected professionals. I want the public to perceive us as highly trained artists who are experts in our field. And, in particular, I want wedding photography to be considered a storytelling art form rather than a commodity. I'm very passionate about this subject because I believe that wedding photography is the best training any people photographer can have. To be a prominent wedding photographer requires considerable effort. To be an average wedding photographer, all you need is a basic camera, a website, and a phone to call friends who are getting married.

I find it interesting that, since there are no barriers or requirements to becoming a wedding photographer, this genre of photography often attracts the least trained photographers in the industry. Yet, at the same time, there is nothing more difficult or more demanding than to photograph every aspect of a wedding. I have photographed countless fashion shoots, portrait shoots, boudoir shoots, pet photography shoots, engagement shoots, child shoots, even commercial shoots for popular TV shows. So far, I have not met any match to the demands that successfully shooting a wedding requires.

In addition, a wedding is a one-time event. Screw up, and there are no redos. To add to the mountain of stress, a wedding day is one of the most—if not *the* most—anticipated and important days of a person's life. It is by far the most coveted rite of passage in most parts of the world, and it marks the beginning of a new family. My point is this: a wedding is never to be taken lightly! The wedding photographer bears the full responsibility of documenting every aspect of the most important day in a couple's life; this should require a Ph.D. in Photography and People Skills! In a single day, we are required to be a photojournalist, portrait photographer, family photographer, fashion photographer, commercial photographer, a storyteller, part wedding coordinator, therapist, motivational speaker, cheerleader, task master, media manager, lighting expert, posing expert, technical master, and weight lifter (camera gear is not light)—all while working so fast and hard that in a 14-hour day it's difficult just to take a short break. All of this activity is happening in a place that is not of your choosing and at a time of the day that is also not of your choosing. There is unpredictable weather and unrealistic time constraints. Furthermore, you are expected to predict the photographic needs of people you have never met, while being told what to do by the couple, the groom's mother, the grandma, the "expert" bridesmaid, the guests who have had too much tequila, and the wedding coordinator who wants the photos yesterday. I am exhausted and overwhelmed just from writing that! But the sad thing is, I'm not exaggerating. This is a typical day in the life of a wedding photographer.

As you can see, wedding photography does not exactly benefit from a linear thinking process. There is no Step One, Step Two, Step Three, and so on. One minute you are a photojournalist, and the next minute you are posing the bride and her mother for a quick portrait. You must think of flattering light and be aware of their poses to avoid distractions and help them look their best. Immediately after that, you are photographing the wedding party, which is then interrupted by an unanticipated moment happening behind you that is worthy of capturing. There is no linear thinking here. For this reason, I began this book by saying that wedding photographs do *not* have to be perfect. You don't have time for perfection. How could you, when you are constantly in survival mode?

But what you can do is be very skilled at the wedding storyteller skill components. The great thing about these skill components is that no matter how experienced you may be, you can always execute them differently and with more finesse than you did at the last wedding. Regarding the expert components, there is a mediocre way of applying them, and there is a mind-blowing way of applying them. It all depends on your decisions.

If you think about it, what separates one wedding photographer from another is the decisions they make throughout the course of a wedding. After all, most weddings all have the same parts. There is the bride and groom getting-ready segment, the ceremony, the bride and

groom photos, family photos, cocktail hour, and finally, the reception. Naturally, there are some differences depending on religion, culture, etc., but simply stated, all weddings are made up of the same parts. It is how you photograph these parts that separates you from other photographers. Chapter 18 is proof that the most subtle decisions can have a great impact on a photograph. A decision as small as changing perspective can turn an ordinary photo into something truly memorable. Crazy, right? Having the forethought to place or include meaningful objects—such as a photo of a loved one who has passed away—within your composition of the bride getting ready can evoke powerful emotions from clients.

People say that their wedding photos are their most precious possession. Physically, a photo may be little more than a piece of paper, but the memories that the photo captured are very real to the person holding it. As time goes by, those memories you so carefully photographed will become more and more cherished. The emotional value of a physical photograph increases with time. So please, out of respect for what we do and the life-long value our work has, insist on printing your work for your clients. Do not let clients just walk away with an electronic version of their photos. That is truly a shame. It is our duty as photographers to ensure that people feel the emotional power of holding a physical print of their loved ones in their hands. Digital files on a USB stick just do not compare.

I want to tell you a story. Wedding photography has completely changed my life. Because of wedding photography, I have traveled the globe photographing the most amazing weddings imaginable. I have met wonderful people and have been exposed to great food, cultures, and most importantly, people's lives. When I started this adventure, I remember crying at the sight of master wedding photographers' slideshows. I felt a deep wave of desperation and frustration when I was photographing a wedding and, for reasons unknown to me at the time, I couldn't achieve a single photograph that was nearly as beautiful as the photos of those masters. I would return to my computer after every wedding and create a folder with all my "bad" photos. It was disheartening to see that the number of images in my "bad photos" folder far exceeded the number of photos in the "good photos" folder. Some problems were technical, while others were due to the pose or the lighting. There were so many issues with my photos that I felt overwhelmed. The most elusive aspect of wedding photography that gave me the most trouble to figure out was the ability to take photos that contained great emotional impact. I yearned for the day when I would witness my clients experience a powerful surge of emotion when they gazed at a photo I had taken. That goal kept me motivated and on a never-ending quest to improve my skills as a wedding storyteller.

I want you to know that all the storyteller skill components in this book were created by discovering, through much tenacity, the nuances that confront any wedding photographer during the course of the day. With hard work and dedication, I began to discover a better way of counterpunching the countless challenges by using every element within the expert components.

This book will continue to grow with you as your skills improve. There are always more creative ways to execute an expert component, and later to combine multiple well-executed expert components in a single photograph. The journey must start somewhere, but it never ends. The photographs you capture for your clients throughout your journey will

become more and more marvelous! Take a look at the following three photographs, which demonstrate my continuing progress over a period of 10 years. The images contain similar subject matter but are taken with progressively better skill and more subtle decision making.

Figure C.1: I took this photo when my decision-making and ideas were very primitive. The groom holding up the bride is a classic pose, but some photos of this pose are executed far better than others. The devil is in the details. I saw this golf course and thought that it would be a good location for a photo. Why? Because I didn't know any better. No one had taught me about meaningful context, posing, or lighting. I also did not notice how uncomfortable the groom was from bending his back so much to lift his bride or how the bride's right arm was blocking half their faces. I was also completely clueless that the lighting was terrible. It was just flat, ugly lighting. The white limousine on the right side of the frame was their getaway car. I had no idea what to do with it, so I did nothing. There were some trees on the left side of the camera, but they are just trees, right? What am I supposed to do with them? Little did I know then that the unused getaway car and the trees would become elements I could use to create a truly magical photograph using that very same pose!

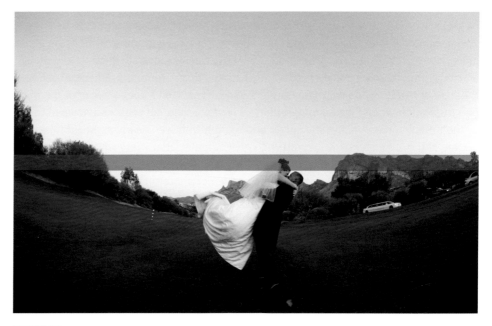

FIGURE C.1

Figure C.2: Some time went by and I tried the pose again at another wedding. Because I took the time to analyze the pose from the first photo and noted what was bothering me about it, I was excited that this time I would be able to better address the pose. I instructed the groom to lift the bride from beneath her bottom so that he could gain much needed leverage. Due to that decision alone, he was able to keep his back in a much more natural position. I also remembered that the last time the bride's arm was blocking part of their faces. That led me to my next decision, to ask the bride to always keep her elbows directed

toward the ground. This is much better, right? My lighting knowledge was still quite primitive. However, I did notice and use the building light above the couple, which led me to discover how lovely her head looked when backlit by a light source. You can easily see the rim light around her head, and it looks beautiful. It is too bad that the light wasn't powerful enough to create that rim light around their entire bodies from head to toe. The green branches on the left side of the frame didn't add much to my composition, but I was still happy with the progress I had made.

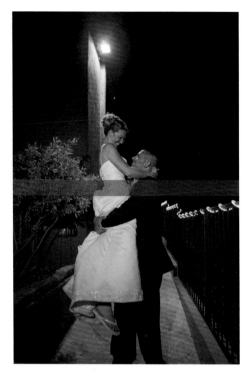

FIGURE C.2

Figure C.3: Some ten years had gone by, and I was asked to photograph a wedding in Sarasota, Florida. The bride was incredibly friendly and sweet, and I jumped at the chance to work with such wonderful people. I flew from Beverly Hills to Sarasota only to find out that there was a hurricane warning for the day of the wedding. It rained fiercely all day. The weather was so bad that everyone had to move inside for safety, not just to avoid getting wet. The bride was in great spirits but sad that her beautiful outdoor wedding was completely blown by a hurricane-level storm. I was determined to make it up to her!

I may not be able to control the weather, but I can summon the skills I worked tirelessly for years to develop. It was the end of the reception, and the rain was still relentless. I noticed that the getaway car driver was outside under some cover smoking a cigarette. Then it hit me! Remember the first photo with the white limo getaway car that I did not use? I ran up to the driver and asked him if he would move the car and park it in front of this specific tree. Confused, he asked me, "Why that tree?" I responded, "Because the tree will work well as a compositional element that will add visual interest to the photo. Without that tree, there would just be empty darkness." Actually, the main reason I wanted the car parked specifically in front of the tree was because, by utilizing my circumstantial light skills, I recognized that the giant white tent that had been erected to shield the guests from the rain would also be an amazing natural reflector if it was struck by a strong light source.

So now I needed a strong light. Helper light for the win! By this time, using off-camera flash was a breeze. The driver had left, so we couldn't turn on the car's headlights. Solution: I decided to use two off-camera flashes. One flash would backlight the bride, groom, and rain; the other would be pointed toward the car's headlights to give the appearance that it was the car illuminating the couple and not some fancy off-camera flash technique. This gives the viewer the impression that the light is actually coming from the car. My assistant stood behind the coupe with both flashes pointed in their respective directions. When the flash illuminating the couple fired, it would send the light all the way to the giant white tent and then reflect beautiful, soft light back at the couple.

Then I noticed that the car had a wooden "Just Married" sign in the window facing the tree. That gave me the idea to implement the "Story Framing and Meaningful Object Placement" expert technique. I grabbed the sign and moved it to the window facing my camera knowing that the reflected light from the tent would be strong enough to illuminate it.

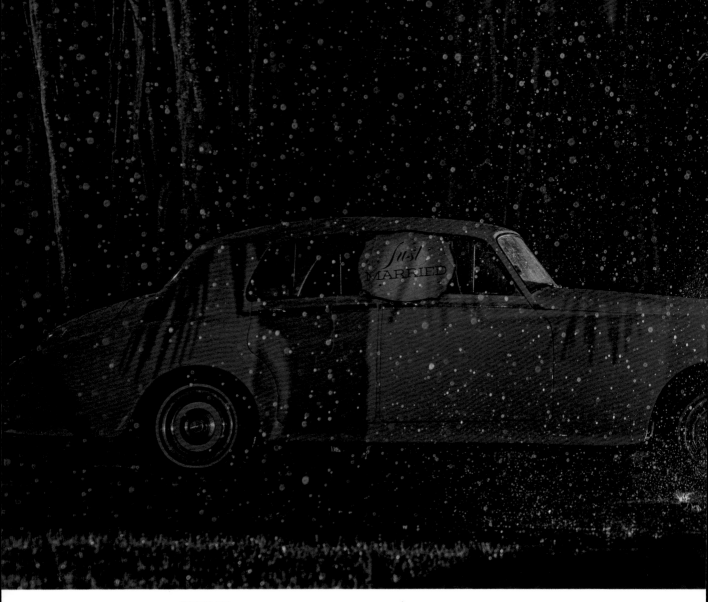

FIGURE C.3

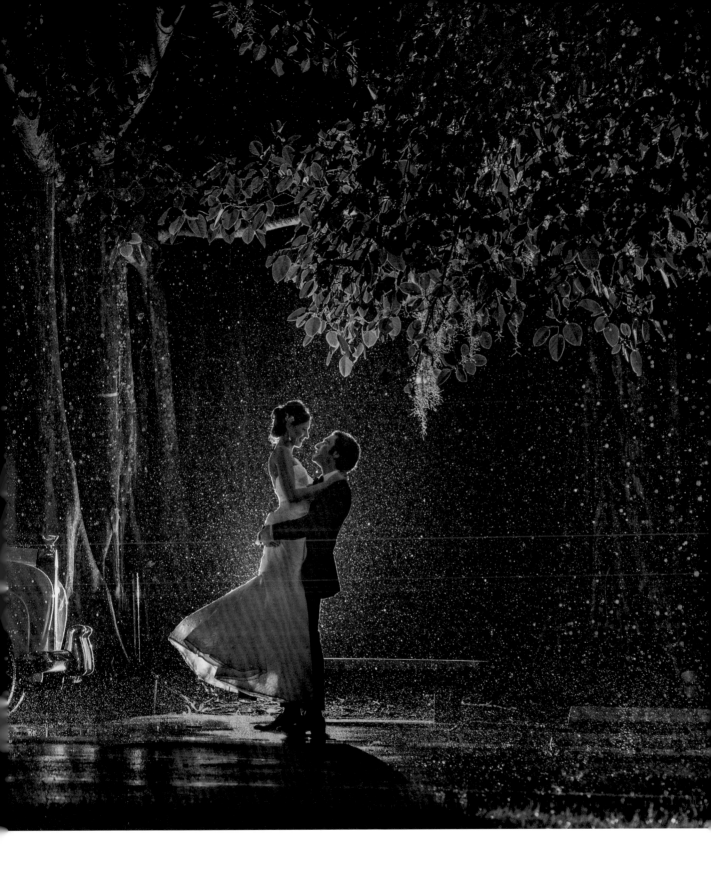

Finally, I remembered all my notes from the previous examples about how to create a beautiful version of this pose without crazy elbows or unflattering postures. Once everyone was in position, the groom lifted his bride up perfectly according to my instructions, and they smiled. Magic had happened! The flashes fired at the perfect moment to capture their loving expressions. The tent reflected light back to the car, the couple and the rain were beautifully backlit, and I had created the most magical photo of my entire career!

Figure C.4: Imagine how I felt when I received a call from Dan Neri from Canon USA, informing me that Canon wanted to place this photograph on the homepage for Canon USA. All those years of hard work, trial and error, and a deep desire to continually learn and improve rushed through my head along with feelings of overwhelming joy, honor, and gratitude. Who knew that this young 26-year-old high school business teacher who had never owned a camera would one day be honored with his photograph on the front page of the largest imaging company in the world?

FIGURE C.4

The pursuit of learning never ends. Regardless of where I am in my photography career, I will always be a motivated student of photography. No matter how well you can execute the expert components, there will always be new, more innovative ways to do so, ones that haven't been thought of before. Come tomorrow, we will all become even better wedding storytellers!

Stay curious.

— Roberto Valenzuela, Canon Explorer of Light

INDEX

style development chart, 209
styles
 developing your own, 16, 209–210
 photo-taker and photo-maker, 16–17
stylized aware posing, 198–201
stylized unaware posing, 202–204, 274
sunlight
 direct, 38, 43, 63–64, 70, 112
 horizontal light from, 38
 shadows caused by, 37–38
 window light and, 25, 26

T

tack-sharp focus, 235
targeted luminosity levels, 113–116
team interactive photojournalism, 189, 194–197
technical issues
 expert techniques related to, 229–269
 prioritizing expressions over, 72
technical virtuosity, 179
telephoto lenses, 64, 73, 150, 241, 244, 277
texture, directional light and, 36
tilt, camera, 71, 92
timelines, wedding, 129–130
touch and affection, 286–289
touching moments, 57, 104, 183
traditional group photos, 158
training exercises
 on skill components, 316–329
 on your own photo analysis, 330–347
trust, instilling, 127–131

U

uncooperative grooms, 139
unexpected moments, 187

V

Vanity Fair-style group portraits, 158, 168
vantage points, 188
variety in group photos, 168

W

walls, 69, 75–87
 characteristics provided by, 76
 color/size contrast using, 81
 drawings/paintings on, 82–83
 graphic elements used on, 82–87
 light and shadow designs on, 84–85
 modifying light utilizing, 78–79
 as monochromatic color palette, 80
 pros and cons of using, 75–86
 shadow silhouettes created on, 86–87
 simplicity of using, 76
Wedding and Portrait Photographers International (WPPI) convention, 9
wedding ceremony photos
 lenses for indoor, 238–241
 lenses for outdoor, 241–245
wedding dresses
 brides interacting with, 29–30
 EVP photos involving, 223, 224
 story development around, 205–206
 strategic placement of, 97, 108, 192, 298, 299
wedding party
 dealing with an uncooperative, 139
 group posing of, 158–169
 lenses for portraits of, 246–248
 meeting for the first time, 121–122
 responding to photo ideas by, 135
 See also bridesmaids; groomsmen
wedding photography
 author's personal journey into, 6–10
 challenging scenarios in, 135–139
 circumstantial light in, 23–45
 composition in, 89–101, 291–301
 context and clutter in, 47–67
 depth and walls in, 69–87
 effort and learning required for, 349–356
 emotionally valuable people in, 213–228
 group posing in, 157–176
 helper light used in, 255–269
 lens choice in, 229, 230–254
 luminosity levels and contrasts in, 103–116